MYSTERIES OF
THE ALPHABET

First Edition
10 9 8 7 6 5 4 3 2 1

Library of Congress Cataloging-in-Publication Data
Oauknin, Marc-Alain.
 [Mystères de l'alphabet. English]
 The mysteries of the alphabet: the origins of writing / Marc-Alain Ouaknin.
 p. cm.
 Includes bibliographical references.
 ISBN 0-7892-0523-8. — ISBN 0-7892-0521-1 (pbk.)
 1. Alphabet—History. 2. Writing—History. I. Title.
P211.0913 1999
411—dc21 98-44840

Marc-Alain Ouaknin

MYSTERIES OF
THE ALPHABET

THE ORIGINS OF WRITING

Translated from the French by
Josephine Bacon

ABBEVILLE PRESS PUBLISHERS
NEW YORK LONDON PARIS

BY THE SAME AUTHOR

"Introduction à la littérature talmudique et midrachique," in *Aggadoth du Talmud de Babylone*. Verdier, 1981.

Pirqé de Rabbi Eliézer.
Translation, presentation, and annotation.
Verdier, 1983.

Le Livre brûlé: Lire le Talmud.
Lieu Commun, 1986, and Seuil, coll.
"Points Sagesses," new edition, 1993.
English translation: *The Burnt Book: Reading the Talmud.* Princeton University Press, 1994 and 1998.

Lire aux éclats: Éloge de la caresse.
Lieu Commun, 1989, and Seuil, coll. "Points," new edition, 1994.

Ouvertures hassidiques.
Jacques Grancher, 1990.

Concerto pour quatre consones sans voyelles.
Balland, 1991.

Méditations érotiques: Essai sur Emmanuel Lévinas. Balland, 1992.

Tsimtsoum: Introduction à la méditation hébraïque. Albin Michel, 1992.

Bibliothérapie: Lire c'est guérir.
Seuil, 1994.

Les Voyelles du désir.
Fata Morgana, 1995.

Symboles du judaïsme, with photos by Laziz Hamani. Assouline, 1995.
English translation: *Symbols of Judaism.*
Assouline/Rizzoli, 1996.

Le Colloque des anges.
Fata Morgana, 1995.

La Plus belle histoire de Dieu (in collaboration with J. Bottéro and J. Moingt). Seuil, 1997.

C'est pour cela que l'on aime les libellules.
Calman-Lévy, 1998.

Abraham, Abraham!
A Novel.
Edition du Rocher, 1999.

IN COLLABORATION WITH DORY ROTNEMER

Le Grand Livre des prénoms bibliques et hébraïques. Albin Michel, 1993.

A toi je donne mes histoires.
Gallimard Jeunesse, 1994.
English translation: *I'll Tell You a Story.*
Creative Education, 1997.

Le Promeneur de Jérusalem.
Ramsay, 1995.

La Bible de l'humour juif, volume I.
Ramsay, 1995.

La Bible de l'humour juif, volume II.
Ramsay, 1997.

I dedicate this book to the memory of two beloved people
who have always been with me and always will be with me
in my passion for books:
my grandmother, Alice Ehrlich,
who helped me to take my first steps in reading
under the affectionate and encouraging eye of my grandfather,
Charles Ehrlich . . .

I dedicate this book to the memory of my father-in-law,
Daniel Rotnemer, who was an enthusiast for the history of languages
and surprising linguistic connections,
who would have loved to read this long history of the letters
of the alphabet, while greatly enjoying the fun side of
these sometimes disconcerting discoveries . . .

I also dedicate this book to the memory of my uncle
Claude Ehrlich, a brilliant philosopher,
who taught me that serious thought can only be channeled,
and is best deployed, under cover of humility and discretion,
like the subterranean springs that well up at a distance
and much later in an unexpected place . . .

Finally I dedicate this book to the memory of my cousin
David Ehrlich, who left us too soon,
after a long and hard struggle for life . . .

C O N T E N T S

INTRODUCTION, 11

PART ONE
ORIGIN & DEVELOPMENT, 15

Chapter I : A Short History of Writing, 17
Chapter II : Pictogram, Ideogram, and Phonogram, 77
Chapter III : The Lady of the Turquoise:
Proto-Sinaitic Script, 87
Chapter IV : The Example of the Letter *Aleph,* 99
Chapter V : When *Aleph* Became *Alpha,* 105

PART TWO
THE ALPHABET, 113

PART THREE
THE ARCHEOGRAPHIC REVOLUTION, 349

BIBLIOGRAPHY & ACKNOWLEDGMENTS, 371

"*Human society, the world,*
the whole of mankind is in the alphabet. . . .
The alphabet is a source."

VICTOR HUGO

"*The magical alphabet, the mysterious hieroglyphic,*
merely reach us incomplete and distorted, either by time
or by those very people
who have a vested interest in our ignorance;
let us find the lost letter or obliterated sign,
let us re-create the dissonant scale and we shall gain strength
from the world of the mind."

GÉRARD DE NERVAL

INTRODUCTION

In the beginning, God created the alphabet! Only then were heaven and earth created.

"Twenty-two letters did he engrave and carve, he weighed them and moved them around into different combinations. Through them, he created the soul of every living being and the soul of every word. . . . Twenty-two basic letters, fixed upon a wheel consisting of 231 gateways. And the wheel rolls forwards and backwards . . . How will he weigh them and make them move?

The *aleph* was associated with all the other letters and all the other letters were associated with the *aleph*. The *beth* was associated with all the other letters and all the other letters were associated with the *beth*. And the wheel turns, again and again. . . . The whole of creation and all of the words emerged from this single name 'The Alphabet'!"

The Book of Creation or *Sefer Yetsira*

Twenty-two basic letters that turned into the twenty-six letters of the alphabet of western European scripts. Twenty-six letters of ancient lineage, the origins of which date back many thousands of years, a lineage transmitted from generation to generation quite unconsciously, which even today lies buried deep beneath the layers of our cultural unconscious.

What does the word *alphabet* mean? Why is A called an A? Why is O round? Why does the word *mom* begin with the letter M?

Is E white, as the French poet Rimbaud believed? And is I the tipsy laughter issuing from beautiful red lips? Why is B the second letter of the alphabet? Is L light enough for flight? And is R relaxing?

This book is divided into three parts:

PART ONE, entitled "Origin & Development," explains the general process of birth and development of a letter, starting from a picture. This part explains the crucial discovery of PROTO-SINAITIC, the oldest source of modern alphabets. We also indicate how scripts evolved from Phoenician into Greek and the connections between the most important scripts.

PART TWO is the nucleus of this book. It is set out like a dictionary, and explains the history of each of the twenty-six letters of the western European alphabet, the ways in which they evolved and their hidden and revealed meanings from Egypt right down to the present day, via Ancient Hebrew, Phoenician, Greek, Etruscan, and Latin. Each letter is dealt with individually and the way in which it evolved is shown by means of reproductions of various inscriptions, of which a number are used several times, in order to familiarize the reader with the archeological source material. The letter in question is shown in red on the inscriptions, so that it can be easily and quickly identified.

The shape of each letter has been a subject of philosophical, and even poetic, meditation. The horizontal bar of an A and the roundness of an O, for instance, have been themes around which historians, philosophers, and poets have met and mingled.

Each chapter ends with a section entitled "Summary Table," which is like an index card summarizing all of the information presented about a particular letter.

This dictionary is the starting point for an experience, a journey to the center of the script we use today, an "archeographic adventure" that can be applied to every word and every name in our language. We designed this book in such a way as to make it readable on various levels. Children and adults alike will discover a world of images and shapes that, quite surprisingly, are reminiscent of the paintings of Joan Miró or Paul Klee.

The curiosity aroused by this first glimpse will no doubt lead to further investigation, whether the approach is historical, ethnological, philosophical, or whatever, depending on your sphere of interest.

The book ends with PART THREE, an introduction to archeography, the new method of investigating and analyzing scripts.

ORIGIN
&
DEVELOPMENT

CHAPTER I
A SHORT HISTORY OF WRITING

How can speech, which is in essence ephemeral, be preserved, noted down, and transmitted? This question has been fundamental to every culture and every civilization. A very wide range of solutions has been offered, from tying knots in a piece of string through scratches on bark and drawings and engravings on stone, to (finally) the letters of the alphabet. Numerous ways of transmitting messages have existed for tens of thousands of years, using drawings, signs, or pictures. Twenty thousand years before the common era (B.C.E.), human beings were producing their first drawings on the walls of a cave in Lascaux, in the south of France.

These signs and pictures could not yet be considered writing. They might have recalled a few important and significant moments in history, be it the record of an event such as war, victory, or plague, the signing of a treaty, or the forming of an alliance, but they were not yet sufficiently organized to acquire the status of writing.

DEFINITION

Writing only started when an organized system of signs or symbols was created that could be used to clearly record and fix all that the writer was thinking, feeling, and capable of expressing. Such a system cannot be created in a day. It is a long, slow, and complex process, a fascinating history whose development mirrors the development of the human race. It is wonderful story from which a few vital pages are still missing.

REMARK

Writing does not require an alphabet! There are many forms of writing in which anything can be expressed by means of a large number of signs, without using an alphabet. Examples include the

cuneiform script of the Sumerians, Egyptian hieroglyphics, Chinese ideograms, and perhaps the Mayan and Aztec glyphs. All of these scripts consist of signs and symbols, and can be used to express the entire range of human thought, although they do not use an alphabet!

DEFINITION

The **alphabet** can be defined as a system consisting of a limited number of signs expressing the basic sounds of the language, through which it is possible to record in writing whatever the user wishes to express. The word *alphabet* derives from the Latin *alphabetum,* which is formed from the first two letters of the Greek alphabet — *alpha* and *beta* — themselves borrowed from the Semitic letters *aleph* and *beth*.

REMARK

Mesopotamian cuneiform script, Egyptian hieroglyphics, and Chinese characters all share the ability to transcribe either whole words or syllables, rather than basic sounds. Reading and writing using these systems involves learning a very large number of signs or characters. Reading and writing were thus the prerogative of sages or a privileged class (often the priests), who spent their lives doing little else but writing. An alphabet works entirely differently because the fact that only about thirty signs (it varies between twenty-two and thirty) need to be learned makes it possible for anyone to write and read anything and everything.

The twenty-six letters of the English alphabet, for instance, are far fewer than the thousand characters (based on the 214 traditional root characters) that the young Chinese student has to learn. It is certainly less than the hundreds of hieroglyphics that the young Egyptian student had to memorize, and less than the six hundred

signs that the student scribe in Mesopotamia needed to acquire. It can truly be said that the birth of the alphabet marks the real beginning of the democratization of knowledge.

Two major groups of scripts can thus be distinguished: alphabetic scripts and nonalphabetic scripts.

Nonalphabetic Scripts

CUNEIFORM: THE SCRIPT OF SUMER AND AKKAD

Cuneiform is the oldest known form of writing. It was invented by the Sumerians who lived in Mesopotamia in the fourth and fifth millennia B.C.E. Mesopotamia is the area between the river Tigris and the river Euphrates, a region of fundamental importance because it is here that the Bible places the Garden of Eden, the birthplace of Adam and Eve. It is the birthplace of human civilization, which according to Hebrew tradition began 5,758 years ago. The term *cuneiform* was used to describe this writing by the first discoverers of the inscriptions at Persepolis, and it means "wedge-shaped" (from the Latin *cuneus*) because the signs consist basically of wedges with short and long tails.

REMARK

Although this was the final stage in the development of the system, rather than the beginning, the word cuneiform *has traditionally been applied to this whole system of writing, which was the most widely used in the ancient Near East. Before depicting long and short wedges whose shapes are abstract, cuneiform writing consisted of drawings or* pictograms *charting various elements in life, nature, animals, or the human body. These signs evolved into abstract forms in which it is often impossible to identify the original shapes on which they were based.*

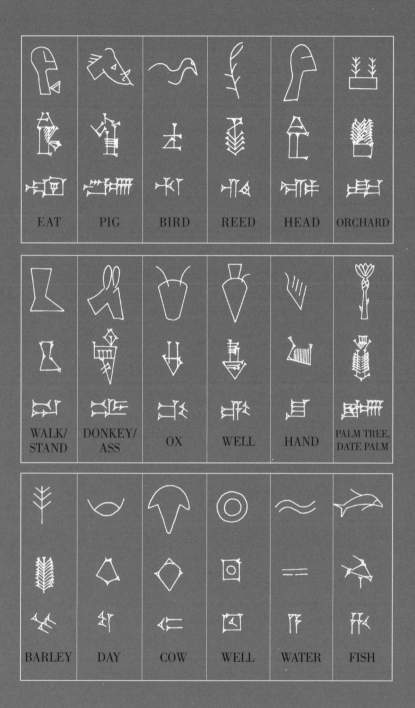

EAT	PIG	BIRD	REED	HEAD	ORCHARD
WALK/STAND	DONKEY/ASS	OX	WELL	HAND	PALM TREE, DATE PALM
BARLEY	DAY	COW	WELL	WATER	FISH

1.
2.
3.
4.
5.
6.
7.
8.
9.
10.
11.
12.
13.
14.
15.
16.
17.
18.

1. STARS
2. EARTH
3. MAN
4. WOMAN (PUBIS)
5. MOUNTAINS
6. SLAVES
7. HEAD
8. MOUTH
9. PIECE OF BREAD
10. FOOD
11. WATERWAY
12. DRINK
13. FOOT
14. BIRD
15. FISH
16. (HEAD OF AN) OX
17. (HEAD OF A) COW
18. EAR OF WHEAT

Facing page: the development of cuneiform writing

We know the Sumerians were not native to Babylonia, but where had they come from? China, Central Asia, Turkestan, India, the Caucasus? The question remains open. . . . Their language, Sumerian, belongs neither to the Indo-European nor to the Semitic language group. Sumerian cuneiform writing was adopted in the middle of the third millennium B.C.E. by another people then living in Mesopotamia, the Akkadians, who used it to write down their own language, which was a Semitic one. This caused a complex situation because the same sign could be used but read differently, depending on whether the language was Sumerian or Akkadian. Akkadian was spoken in northern Mesopotamia and Sumerian in southern Mesopotamia.

Akkadian borrowed the cuneiform system and spread it to other nations such as the Elamites and the Hittites. After the fall of the last Sumerian empire (c. 2000 B.C.E.), Sumerian ceased to be spoken and was replaced by two Akkadian (Semitic) dialects — Assyrian in the north of the region and Babylonian in the south. Subsequently, Babylonian became the language of educated people for both the north and south of the region (in the middle of the second millennium B.C.E.). It was the lingua franca of the Near East, just as English is the lingua franca of today, an international language. Sumerian became a dead language, but remained the language of scholars, like Latin in the Middle Ages. The next chapter will contain some comments about the development of cuneiform writing, in order to show how script evolved from images (pictograms) into syllabic phonetic signs (phonograms).

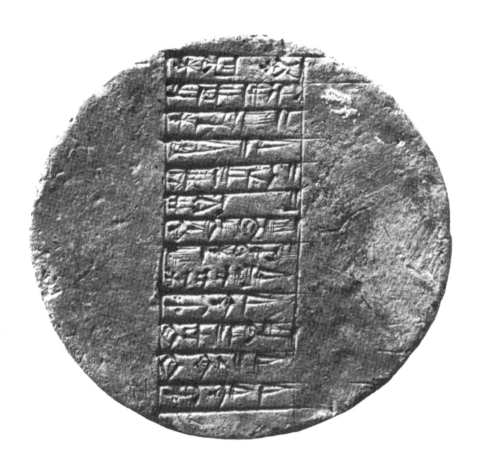

*Circular brick from a monument to Gudea, governor of the Sumerian city
of Lagash in the 21st century B.C.E.*

EGYPTIAN WRITING

The other ancient system of nonalphabetic writing in the world of antiquity is Egyptian writing. The most ancient and the most typical form of it is called hieroglyphics. Hieroglyphics were engraved signs of religious significance (from the Greek words *hieros,* sacred; and *glyphein,* to carve or engrave). They began as a word script; that is, each sign represented a word. The script later began to represent sounds as well, becoming a phonetic script. The language recorded in hieroglyphics is related to the Semitic group of languages. Unlike Sumerian and Akkadian writing, which spread the use of cuneiform characters, hieroglyphics remained restricted to usage in the Egyptian language and land. The oldest trace of Egyptian hieroglyphic writing dates from the start of the third millennium (the First Dynasty). It was during the Third Dynasty that the script reached its brilliant perfection and hardly varied thenceforward until it fell out of use in the fifth century C.E.

Side by side with the signs engraved on stone, there are signs whose shapes were simplified—these are called **linear** hieroglyphics—which were painted in ink on wooden sarcophagi or on papyrus. The signs were written from top to bottom, from right to left, or from left to right. There is even a third form of Egyptian writing whose characters were drawn more freely and quickly, for everyday use. This writing is known as **hieratic,** from the Greek *hieraticos*, sacred, since it mainly became the writing of the priests.

At the most advanced stage of its development, the writing became even more stylized and less figurative. This is called **demotic** writing, from the Greek *demos*, the people. In the Ptolemaic era (330–30 B.C.E.), demotic became the script used in Egyptian literature and for administration. This script continued to be used until the fifth century C.E.

An advanced exercise in hieratic script, containing a passage praising the life of the scribe.
The master's corrections are written above, Nineteenth Dynasty.

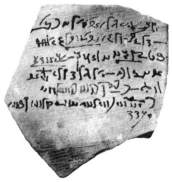

Demotic ostracon, a receipt for delivery of wine dating from the year 10
of the reign of the Emperor Antoninus Pius, 145 C.E.

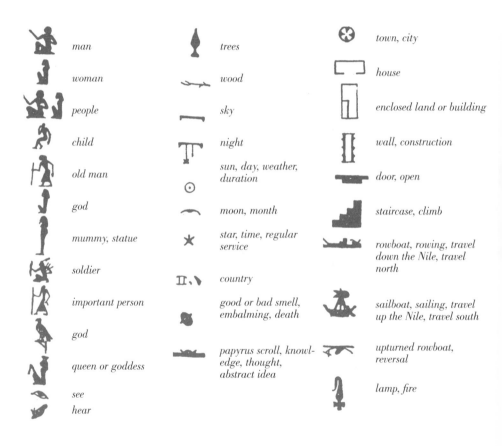

	man		trees		town, city
	woman		wood		house
	people		sky		enclosed land or building
	child		night		wall, construction
	old man		sun, day, weather, duration		door, open
	god		moon, month		staircase, climb
	mummy, statue		star, time, regular service		rowboat, rowing, travel down the Nile, travel north
	soldier		country		sailboat, sailing, travel up the Nile, travel south
	important person		good or bad smell, embalming, death		upturned rowboat, reversal
	god		papyrus scroll, knowledge, thought, abstract idea		lamp, fire
	queen or goddess				
	see				
	hear				

A variety of Egyptian determinative signs

Selection of signs
Common signs

Graffiti by
Hatnoub (c. 2000 B.C.E.)

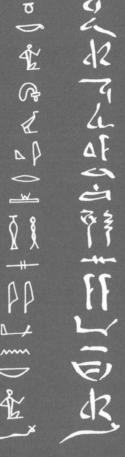

Unusual signs

The owl = M

5th Dyn. 11th Dyn. 18th Dyn. 21st Dyn. Roman
era

Various types of script
(with hieroglyphic transcription)

"HITTITE" HIEROGLYPHICS

Hittite hieroglyphics

Alongside Egyptian hieroglyphic script there exist Hittite hieroglyphic writings. Under Hittite domination of Asia Minor and northern Syria, from the eighteenth through the seventeenth century B.C.E., the cuneiform writing of Sumer and Akkad were used alongside a form of picture-writing known as Hittite hieroglyphics. These hieroglyphics were used to write down a Hittite, Indo-European language that was different from the language written in cuneiform. The signs are ideographic and phonetic. The direction of the writing was boustrophedon (alternating between right to left and left to right). Sites where these hieroglyphics have been discovered are Carchemish and Karatepea in Cilicia.

PROTO-INDIAN SCRIPT

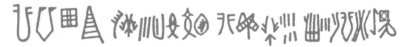

Examples of inscriptions on seals at Haroppa

A proto-Indian civilization was developing in India at the same time as the Babylonian and Egyptian civilizations, toward the middle of the third millennium B.C.E. This civilization bequeathed us a script that has been found on numerous seals and steatite amulets. This writing (from the Mohajo Dao and Haroppa excavations) is very difficult to decipher, and no one has yet succeeded in doing so.

CRETAN SCRIPT

In the third and fourth millennia B.C.E., an advanced and original civilization flourished in Crete and the Aegean Basin; this civilization was then totally lost and forgotten. In both art and writing, the ancient Cretans did not lag behind the other peoples of the Near East. Sir Arthur Evans did for Cretan script what the Frenchman Champollion did for hieroglyphics. Sir Arthur distinguished four types of script, which developed successively over time: (1) pictorial A or archaic (2100–1900 B.C.E.); (2) pictorial B (1900–1750 B.C.E.); (3) linear A (1660–1450 B.C.E.); (4) linear B (1450–1200 B.C.E., when the Mycenean civilization collapsed). Cretan pictorial writing represents people, animals, parts of the human body, objects in current use, plants, houses, a ship. According to Evans, there were 150 of the earliest signs. They were drawn using a stylus on a clay tablet, which was later baked. Linear A contains seventy-five syllabic signs and a certain number of ideograms. Linear B contains eighty-seven or eighty-four signs. Linear B was also used for writing in Greek.

CHINESE SCRIPT

At the same time as the two great systems of writing, cuneiform and hieroglyphics, began to evolve, Chinese script was being introduced. It is an extremely important script because it is still used today by a group of peoples who between them make up almost one-fifth of the population of the earth. Chinese script dates from the third millennium B.C.E., but the oldest documents discovered all date from the second half of the second millennium, the Yin dynasty. Chinese script has evolved very little. It has remained pictographic and ideographic and never became phonetic, so it is not used for recording sounds; in fact it has no real alphabet. In

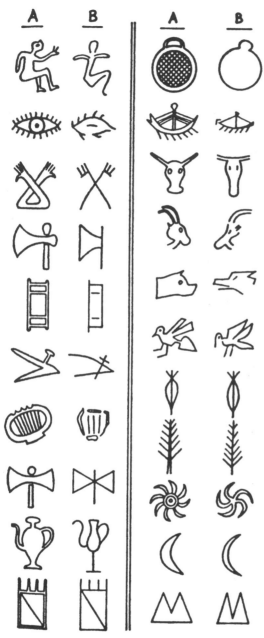

Examples of Cretan pictorial A and B

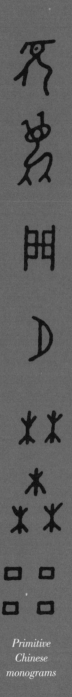

Primitive Chinese monograms

長你不肯来罷咧　既是肯来　我還喜之
煩的日子有啊　豈有此理　我只恐怕兄
姓你家行走的広　只是走長了教阿哥厭
還想着要往兄長的根前領教去　果然不
一行走　你說的狠是　自然要行走　我
兄長你若是不棄想念　求祈姓我家行走
見尊面　今日萬幸　既然一遭認識了
久矣听見了兄長的大名馨　就只没淂會

Example of K'ni chu writing

ㄱ	k	ㅊ	čh	ㅗ	o
ㄱ	kh	ㅅ	s	ㅏ	ā
ㅇ	ṅ	ㅎ	ḥ	ㅜ	u
ㄷ	t	ㅎ	b	ㅓ	e
ㅌ	th	ㅇ		ㅛ	yo
ㄴ	n	ㄹ	r	ㅑ	yā
ㅂ	P	△	ż	ㅠ	yu
ㅍ	ph	╲	a	ㅕ	ye
ㅁ	m	―	o̤		
ㅈ	č	ㅣ	i		

Korean alphabet dating from 1446

ヽ	ă,ŭ	ㅜ	u	ㅈ	tj
ㅣ	i	ㅠ	yu	ㅊ	tch
―	u	ㄱ	k	ㅌ	th
ㅏ	ā	ㄴ	n	ㅍ	ph
ㅑ	ya	ㄷ	t	ㄲ	kh
ㅗ	o	ㄹ	l,r	ㆁ	
ㅛ	yo	ㅁ	m	ㆆ	h
ㅓ	ŏ,ŭ	ㅂ	p		
ㅕ	yŏ,yŭ	ㅅ	s,d		

Modern Korean alphabet

Chinese, the word is a sort of irreducible atom. In most cases, it could be verb, noun, or adjective. There is a character to represent each word, which consists of a single syllable. Each word is monosyllabic.

Until the third century B.C.E., Chinese writing consisted mainly of inscriptions on tortoiseshell, bronze, and stone. The paintbrush, ink, and paper only came into use in the first century C.E. The characters became more flowing and less heavy. Two hundred and fourteen keys are used as determinatives, indicating the category to which the word belongs.

Several neighboring peoples have adopted Chinese writing in order to record their own language, for instance, the Japanese and the Koreans. Chinese script contains a very large number of word-signs or ideograms — fifty thousand (Sumerian only has twenty thousand!).

PRE-COLUMBIAN AMERICAN SCRIPTS

No discussion of nonalphabetic scripts would be complete without mentioning the scripts of the pre-Columbian civilizations of central America. The scripts, which represent words or symbols, emerged in about the second century C.E. and stopped developing in the sixteenth century.

A few signs in Aztec writing

Alphabetic Scripts

"If such a wide range of nonalphabetic scripts emerged in diverse forms in such different locations and at such different times (Mesopotamia, Egypt, China, Crete, central America, etc.), there is good reason to believe that the alphabet must have a single source and that it is a Semitic invention of the second millennium B.C.E. It was invented in a region which today covers Syria, Lebanon, Israel, Jordan, and the Sinai Desert."[1]

While the word *alphabet* appears to be a Greek one, formed from the first two Greek letters, *alpha* and *beta,* the principle behind it is far older. To be present at its birth, we need to go back to about 1500 years B.C.E. in the region in which only Semitic lan-

Egyptian	Cretan (linear)	Phoenician	Stele from Byblos	Egyptian	Cretan (linear)	Phoenician	Stele from Byblos	Egyptian	Cretan (linear)	Phoenician	Stele from Byblos	
𓃾	ᵾ	ʞ ʞ '			⊗	⊕	⊕ *t*		◠	◇	⌐ *p*	⟩
⊓	⊓⊏	99ᵦ	⟋			2 ,y		⌐	ᒐ	⟨7		
⌐	⟍	⟍⁸	⋀		⁂	↓ *k*			⊖	φ φᵩ		
▷	△	⊿ *d*		⌐	⟨7	⟨⟋			⟨⟨	99ᵣ	4ᴬ	
	E	⫣ *h*		'᠆᠆᠆		⟨ *m*				W ᵴ	W	
		⌶⌶w		⟋	⟩2	⟨ *n*		+	+	× *t*	X	
	⌶	⌶ *z*		⌶	≠≠	ⵏ *s*	ⵏ					
	⊟	⊟ₕ		◉	⊻	○ *ᶜ*	⟩					

Comparison of Egyptian, Cretan, and Phoenician signs

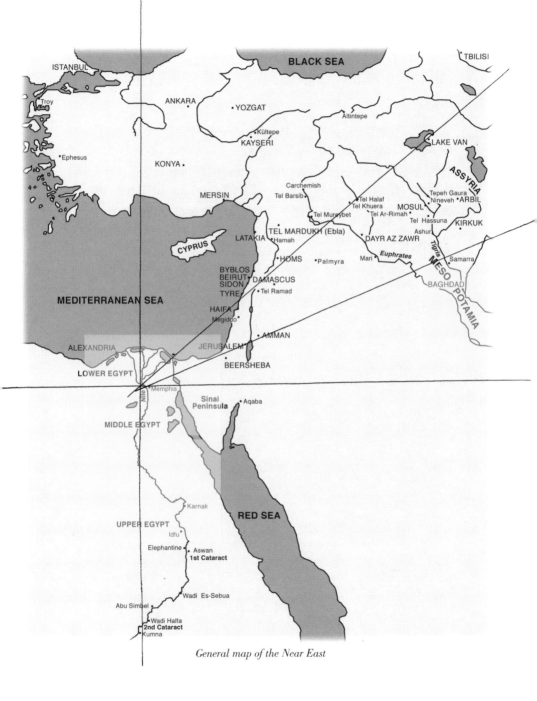

General map of the Near East

guages were spoken. The region is located geographically between the two main writing systems that existed at the time — **hieroglyphics** to the west and the **cuneiform** of Sumer and Akkad to the east.

Each nation spoke a **Semitic dialect**, whose grammatical structure, syntax, and vocabulary are preserved in Modern Hebrew and Arabic. Akkadian was the lingua franca, the universal language of diplomacy and business, for all of the peoples of the Near East and their closest neighbors, with whom they traded and negotiated.

Ugaritic Characters	Phonetic equivalent	Ugaritic Characters	Phonetic equivalent
	a		n
	b		z̧
	g		s
	h		ʻ
	d		
	h		p
	w		ṣ
	z		q
	h		r
	t		t̲
	y		ǵ
	k		g̀
	š		t
	l		i
	m		ủ
	ś		ś

Ugaritic alphabet (from Ras Shamra) in original letter order

41

Two systems of alphabetic script would emerge under the respective influences of hieroglyphics and cuneiform writing. They were used to write down the official language, Akkadian, and the various dialects spoken throughout the region.

UGARITIC SCRIPT

The first alphabet of which we have a definite historical record is the Ugaritic alphabet, which emerged in the fourteenth century B.C.E. The excavations at Ras-Shamra, on the coast of what is now Syria, made possible this fundamental discovery. Ugaritic belongs to the Canaanite Semitic language group. The script looks like cuneiform, but the signs, drawn with a sharpened reed on clay tablets, only bear an outward resemblance to the script of Sumer and Akkad. The simplified line is an artificial creation, and the fact that there are only thirty characters makes this script different from any other system of writing up to that time. Each sign records only a consonant or one of the three vocalized sounds, *a*, *e*, and *u*. We are in the presence of a true alphabet of consonants, arranged in more or less the same **order structure** that we know today in our Western alphabets — a, b, c, d, e, f, g, h, etc. However, it is not the **shapes** of these letters that were to be transmitted into the shapes of the letters of our modern alphabet.

PROTO-SINAITIC

At the same time that Ugaritic script was emerging, another alphabetic experiment was being conducted, but this time it emerged from another existing major system of writing, Egyptian hieroglyphics. This new alphabet was discovered during archeological excavations at Serabit el Khadim in the Sinai desert, hence its name — **proto-Sinaitic.**

This alphabet was used for writing a Semitic language, no doubt the language of the Hebrew workers or slaves in Egypt in a period that corresponds to the end of the enslavement of the Hebrews and the exodus from Egypt, as well as the revelation on Mount Sinai. The order of the letters can be reconstituted to produce an alphabet consisting of consonants that is very similar to the Ugaritic alphabet. Proto-Sinaitic consists of pictograms, the explanation of which is the main theme of this book.

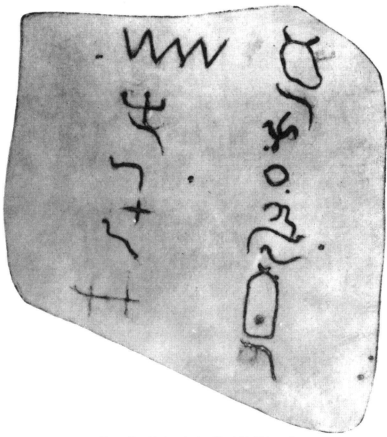

Proto-Sinaitic inscription No. 356 (Grimme)

This is the alphabet from which the Canaanite or "Phoenician" (as the Greeks called it), Aramaic, paleo-Hebrew and Hebrew, Nabatean, Greek, and Arabic scripts were derived, right down to the modern European alphabets, via Etruscan and Latin. This book is dedicated to this original alphabet, called proto-Sinaitic, which is also known as proto-Semitic.

REMARK

The constant reference to Hebrew in analyzing proto-Sinaitic and its development is due to the fact that this alphabet was used to record the Semitic dialect spoken by the workers in the turquoise mines of Serabit el Khadim, a dialect that may well have been Hebrew or a very similar language. It is because the archeologists were familiar with Hebrew that they were able to decipher this alphabet by applying the theory that the sound that each picture represented was the initial sound of the Hebrew nouns for the objects represented by the characters. So, for instance, the outline of a house, for which the Hebrew word is bayit, *would denote the sound "b"; the outline of a camel or a camel's hump, called* gamal *in Hebrew, would produce the sound "g"; the outline of a door,* deleth *in Hebrew, would produce the sound "d." The proof positive for reading the alphabet in this way is the fact that the names of the letters of the Hebrew alphabet still refer to the same images found in the proto-Sinaitic inscriptions. The names of the letters still continue to be "ox," "house," "camel," "door," etc.:* aleph, beth, gimmel, daleth . . . *and so on. These Hebrew and Semitic names can be found in Canaanite, then in Greek in the barely concealed form of* alpha, beta, gamma, delta. . . . *If it is true to say that writing was born in Sumer, then it is also true to say that the alphabet was born in Sinai . . .*

Sound	Ahiram	Mesha	Classic
'(a)	𐤀	𐤀	𐤀
b	𐤁	𐤁	𐤁
g	𐤂	𐤂	𐤂
d	𐤃	𐤃	𐤃
h (e)	𐤄	𐤄	𐤄
w	𐤅	𐤅	𐤅
z	𐤆	𐤆	𐤆
ḥ	𐤇	𐤇	𐤇
ṭ	𐤈	𐤈	𐤈
y	𐤉	𐤉	𐤉
k	𐤊	𐤊	𐤊
l	𐤋	𐤋	𐤋
m	𐤌	𐤌	𐤌
n	𐤍	𐤍	𐤍
s	𐤎	𐤎	𐤎
'(o)	𐤏	𐤏	𐤏
p (ph)	𐤐	𐤐	𐤐
ṣ		𐤑	𐤑
r		𐤓	𐤓
ḳ	𐤒	𐤒	𐤒
š	𐤔	𐤔	𐤔
t	𐤕	𐤕	𐤕

Phoenician or Canaanite alphabet

45

FROM PROTO-SINAITIC TO PROTO-PHOENICIAN OR PROTO-CANAANITE

The transformation of proto-Sinaitic into proto-Hebraic (which has been confused with proto-Phoenician, a synonym for proto-Canaanite) is the result of several complex factors, one of which is particularly important. The discovery of monotheism, and the revelation and the giving of the law on Mount Sinai, introduced a new and important psychological element that may have produced a profound cultural change.

The second of the Ten Commandments states: "Thou shalt have no other gods before Me. Thou shalt not make unto thee any graven image, or any likeness of any thing that is in the heavens above or that it is in the earth beneath . . ."[2] This prohibition on the image forced the Semites, who still wrote their language in a pictographic writing, to rid themselves of images. The birth of the modern alphabet created from abstract characters is linked to the revelation and the civing of the law. In his book *Naissance et renaissance de l'écriture* (Birth and rebirth of writing), Gérard Pommier wrote: "To make the jump from the hieroglyphic to the consonant, from polytheism to monotheism, a frontier had to be crossed. An Exodus was necessary and it needed other peoples, the Phoenicians and Aramaeans, to blindly seize upon this discovery, in order to assure its widespread diffusion.

"Egyptian writing was both pictorial and consonantic. At the very time that Akhnaton was inventing monotheism, hieroglyphics were in the process of being destroyed in writing, beginning with those which featured divinities in the Egyptian pantheon."

The Hebrews left Egypt and received the tablets of the law in Sinai, the law that enabled them to create a social structure, the law of which one of the consequences was the birth of a nonpicto-

graphic alphabet. After forty years of wandering in the desert, the Hebrews reached the promised land, the land of Canaan. The conquest and settlement by the Hebrews strongly influenced the native Canaanites, who appear to have adopted the monotheistic idea quite rapidly, and took on rituals and liturgies from the Hebrews. Pommier clearly shows that the invention of the Ugaritic alphabet occurred after the advent of monotheism. As soon as Ugaritic texts are consulted, it emerges quite clearly that the Hebrews had inhabited the region for long enough to be able to contribute to its literature. There are many similarities between the religious practices of the Hebrews and those of the Canaanites.

Pommier asks: "Who copied whom?" and answers that "there is every reason to believe that it was the Canaanites who, impressed by the novelty of the particularly revolutionary idea of monotheism, first started to imitate it in a number of ways, rather than the reverse."

On the basis of the above remarks, the succession would appear to have occurred as follows. Under the influence of monotheistic expression, hieroglyphics began to shed some of its images, resulting in the first attempt at an alphabet, known as proto-Sinaitic. This alphabet emigrated with the Hebrews to the land of Canaan and an attempt was made to adapt the twenty-six-consonant Semitic alphabet to the cuneiform shape; thus the Ugaritic alphabet was born. It eventually fell out of use at the time of the invasion of the Peoples of the Sea, in the year 1200 B.C.E. Proto-Sinaitic, which had become proto-Hebraic and proto-Canaanite or proto-Phoenician, continued to evolve into Phoenician, then into Aramaic and its descendants (Modern Hebrew, Arabic, and the scripts of central Asia — Uighur, Mongolian, Siberian, Armenian, Georgian) and Greek and its descendants (Latin and our Western alphabets), as

well as Brahmi and its descendants (the Indian, Khmer, Thai, Burmese, and Javanese scripts).

PROTO-SINAITIC	PROTO-PHOENICIAN	PALEO-PHOENICIAN
□ □	◲	
8	8	
⌐ ၇	∂	∠ (႒)
∿ ∿	⧢	⧢ (႒)
⌇	⌐	
👤 👤	👤	
∽	⧢	W (ʊ)
+	+	+ (႒)
👁 ◇	O	O (ʋ)
🐂 🐂	⋖	⋉ (ℵ)
ᗐ ᗑ	ᗐ	

Comparative table of some of the signs found in proto-Sinaitic inscriptions and so-called proto-Phoenician texts

The descent of the alphabet can thus be traced as follows:

EGYPTIAN (3000 B.C.E.)
PROTO-SINAITIC (1500 B.C.E.)
PROTO-PHOENICIAN (1300 B.C.E.)
PALEO-PHOENICIAN (1100 B.C.E.)
PHOENICIAN OR
 PALEO-HEBRAIC (1000 B.C.E.)
GREEK (800 B.C.E.)
ETRUSCAN (800–700 B.C.E.)
LATIN (600 B.C.E.)

THE MODERN ALPHABET BETWEEN THE
THIRD CENTURY C.E. AND THE INVENTION
OF PRINTING (FIFTEENTH CENTURY)

It is this line of descent that is explained in this book.

The real number of languages and scripts is actually much greater. The facing page shows a general table of the development of writing.

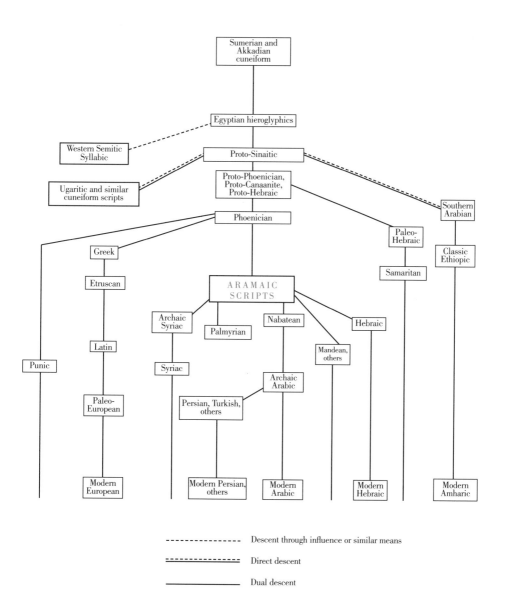

Sumerian and Akkadian cuneiform

Egyptian hieroglyphics

Western Semitic Syllabic

Proto-Sinaitic

Ugaritic and similar cuneiform scripts

Proto-Phoenician, Proto-Canaanite, Proto-Hebraic

Phoenician

Southern Arabian

Greek

Paleo-Hebraic

Classic Ethiopic

Etruscan

Samaritan

A R A M A I C
S C R I P T S

Archaic Syriac

Palmyrian

Nabatean

Hebraic

Latin

Mandean, others

Punic

Syriac

Archaic Arabic

Paleo-European

Persian, Turkish, others

Modern European

Modern Persian, others

Modern Arabic

Modern Hebraic

Modern Amharic

- - - - - - - - - - - - - - - Descent through influence or similar means

================ Direct descent

———————— Dual descent

A Note about Modern Hebrew Writing

Modern Hebrew writing is based on paleo-Hebraic via Aramaic. The Aramaeans were nomadic Semitic tribes who lived in the Syrian desert and traded throughout the Near East. If it was the Phoenicians who caused the alphabet to spread beyond the confines of the Near East thanks to their international overseas trading contacts, it was the Aramaeans who spread the alphabet throughout the Near East thanks to their extensive travel and the movements of their caravans.

The Aramaeans created small nation-states around Damascus, Hamat, and Aleppo, where they fell first under Assyrian then under Persian domination, while retaining their privileged status as traders and spreaders of culture.

When the Hebrews were deported to Babylonia after the destruction of the First Temple, in 586 B.C.E., they adopted Aramaic writing, which was squarer than their own Hebraic script. When they returned to the land of Israel, seventy years later, under the leadership of Ezra and Nehemiah, they brought this "new" writing back with them. In fact, the Talmud actually calls it *ktav-ashuri* or Assyrian writing.

The Aramaic script is also used in the writings of the Nabateans and Palmyrians, who were also nomadic folk who traveled in caravans, and in the Syriac writing that was used from the first century C.E. in various forms and is closely linked to the development of Eastern Christianity.

| | Paleo-Phoenician | Moabitic | Hebraic Ostraca (4th century B.C.E.) | Paleo-Aramaic | Papyri in Late Aramaic | Palmyrian Aramaic | Monumental Nabatean tAramaic | Printed Square Hebrew |
|---|---|---|---|---|---|---|---|---|
| ' | 𐤀 | 𐤀 | 𐤀 | 𐤀 | 𐤀 | 𐤀 | 𐤀 | א |
| b | 𐤁 | 𐤁 | 𐤁 | 𐤁 | 𐤁 | 𐤁 | 𐤁 | ב |
| g | 𐤂 | 𐤂 | 𐤂 | 𐤂 | 𐤂 | 𐤂 | 𐤂 | ג |
| d | 𐤃 | 𐤃 | 𐤃 | 𐤃 | 𐤃 | 𐤃 | 𐤃 | ד |
| h | 𐤄 | 𐤄 | 𐤄 | 𐤄 | 𐤄 | 𐤄 | 𐤄 | ה |
| w | 𐤅 | 𐤅 | 𐤅 | 𐤅 | 𐤅 | 𐤅 | 𐤅 | ו |
| z | 𐤆 | 𐤆 | 𐤆 | 𐤆 | 𐤆 | 𐤆 | 𐤆 | ז |
| ḥ | 𐤇 | 𐤇 | 𐤇 | 𐤇 | 𐤇 | 𐤇 | 𐤇 | ח |
| ṭ | 𐤈 | 𐤈 | 𐤈 | 𐤈 | 𐤈 | 𐤈 | 𐤈 | ט |
| y | 𐤉 | 𐤉 | 𐤉 | 𐤉 | 𐤉 | 𐤉 | 𐤉 | י |
| k | 𐤊 | 𐤊 | 𐤊 | 𐤊 | 𐤊 | 𐤊 | 𐤊 | כ |
| l | 𐤋 | 𐤋 | 𐤋 | 𐤋 | 𐤋 | 𐤋 | 𐤋 | ל |
| m | 𐤌 | 𐤌 | 𐤌 | 𐤌 | 𐤌 | 𐤌 | 𐤌 | מ |
| n | 𐤍 | 𐤍 | 𐤍 | 𐤍 | 𐤍 | 𐤍 | 𐤍 | נ |
| s | 𐤎 | 𐤎 | 𐤎 | 𐤎 | 𐤎 | 𐤎 | 𐤎 | ס |
| ' | 𐤏 | 𐤏 | 𐤏 | 𐤏 | 𐤏 | 𐤏 | 𐤏 | ע |
| p | 𐤐 | 𐤐 | 𐤐 | 𐤐 | 𐤐 | 𐤐 | 𐤐 | פ |
| ṣ | 𐤑 | 𐤑 | 𐤑 | 𐤑 | 𐤑 | 𐤑 | 𐤑 | צ |
| q | 𐤒 | 𐤒 | 𐤒 | 𐤒 | 𐤒 | 𐤒 | 𐤒 | ק |
| r | 𐤓 | 𐤓 | 𐤓 | 𐤓 | 𐤓 | 𐤓 | 𐤓 | ר |
| š | 𐤔 | 𐤔 | 𐤔 | 𐤔 | 𐤔 | 𐤔 | 𐤔 | ש |
| t | 𐤕 | 𐤕 | 𐤕 | 𐤕 | 𐤕 | 𐤕 | 𐤕 | ת |

Aramaic script and its derivatives

Modern Hebrew writing is called "square script" and is derived from Aramaic. It became the official script for daily use and for the transcription of sacred texts. The Dead Sea scrolls, for instance, were written in that script.

However, for private use, there is a different script, the cursive script, which in numerous points is actually derived from paleo-Hebrew, the twin sister of paleo-Phoenician.

Liturgical Hebrew *Square Modern Hebrew characters*

Cursive Modern Hebrew

55

Arabic Script

Arabic script and square Hebrew are the only consonantic scripts still in common use. Arabic writing spread as a result of the Islamic conquests of much of the world, and today, along with Latin script, it is one of the world's major forms of writing.

"The emergence of the Arabic alphabet is typical of the history of writing. It originated with a nomadic people who traveled in caravans from oasis to oasis, from market to market, speaking a language which had no written form. When they needed to write, the Arabs used Nabatean, an alphabet derived from Phoenician, but they wrote in Aramaic, the business language of the time. Aramaic, written in the Nabatean alphabet, was gradually adapted by the Arabs until the Arabic alphabet took its present form," wrote L.-J. Calvet in his *Histoire de l'écriture*.

The development of Arabic writing introduced diacritical signs that helped to distinguish between letters whose shapes were very similar and which tended to be confused with each other; vocalization was also introduced. Three vowels were expressed in writing, six if their long form is included.

Like the other Semitic scripts, Arabic is written from right to left. From the Nabatean alphabet it has inherited the ligatures that link most of the letters to each other. The letters are shaped differently depending on whether they come at the beginning, in the middle, or at the end of a word. The alphabet consists of twenty-eight letters, six more than in the ancient Semitic alphabet.

However, this alphabet has a serious flaw. Since it only annotates three vowels, it is very poorly equipped for languages that use numerous vowel sounds. That is probably the reason why the Turks abandoned Arabic script and replaced it with Latin script.

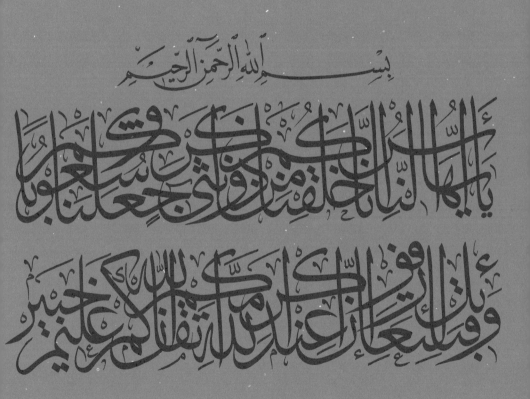

بِسْمِ اللهِ الرَّحْمٰنِ الرَّحِيمِ

يَا أَيُّهَا النَّاسُ إِنَّا خَلَقْنَاكُم مِّن ذَكَرٍ وَأُنثَىٰ وَجَعَلْنَاكُمْ شُعُوبًا وَقَبَائِلَ لِتَعَارَفُوا إِنَّ أَكْرَمَكُمْ عِندَ اللهِ أَتْقَاكُمْ إِنَّ اللهَ عَلِيمٌ خَبِيرٌ

Arabic calligraphy

| NASKH (THE ARABIC OF AVICENNA) | | | | ARABIC OF THE MARGRAVE | | | | Phonet |
|---|---|---|---|---|---|---|---|---|
| Isolated | Final | Middle | Initial | Isolated | Final | Middle | Initial | |
| ا | ا | ا | ا | ا | ا | | | ' |
| ٮت | ٮ | ـ | ٮ | ٮ | ٮ | ٠ | ٠ | b |
| ت | ٮ | ٠ | ٮ | ت | ٮ | ٠ | ٠ | t |
| ث | ث | ـ | ٮ | ٮ | ٮ | ٠ | ٠ | ṯ |
| ج | ح | ح | ح | ع | | | ٠ | j (dž) |
| ح | ح | ح | ح | ح | | | ٠ | ḥ |
| د | د | د | د | ٠ | ٠ | | | h |
| د | د | د | د | ر | ر | | | d |
| ر | ر | ـ | ر | ر | ر | | | ḏ |
| ز | ز | ـ | ر | ز | ز | | | r |
| س | س | ـ | س | ش | ش | ـ | ـ | z |
| ش | ش | ـ | ش | ش | ش | ـ | ـ | s |
| ص | ص | ـ | ص | ص | ص | ـ | ـ | š |
| ض | ض | ـ | ص | ص | ص | ـ | ـ | ṣ |
| ط | ط | ط | ط | ط | ط | ـ | ـ | ḍ |
| ظ | ظ | ظ | ظ | ظ | ظ | ـ | ـ | ṭ |
| ع | ع | ـ | ع | ع | ع | ـ | ـ | z̧·ġ |
| غ | غ | ـ | غ | ف | ف | ـ | ـ | f |
| ق | ق | ـ | ق | ف | ف | ـ | ـ | q (ḳ) |
| ك | ك | ك | ك | ك | ك | ـ | ـ | k |
| ل | ل | ل | ل | ل | ل | ـ | ـ | l |
| م | م | م | م | م | م | ـ | ـ | m |
| ن | ن | ـ | ن | ن | ن | ـ | ـ | n |
| ه | ه | ه | ه | ه | ه | ـ | ـ | h |
| و | و | و | و | و | و | | | w |
| ى | ى | ـ | ى | ى | ى | ـ | ـ | y |

The spreading of Arabic script through Islam, with the Koran as the basic and universal text of the religion, was a unifying factor for the various nations because it became the vehicle for the classical Arabic understood by all literate people, while the spoken language was diversified into a multiplicity of dialects.

Arabic script gave birth to calligraphic art of astonishing beauty.

Calligraphy by Massoudy

Facing page: Arabic alphabets

Other Alphabetic Scripts

To complete this survey of the history of writing, here is a list of the other main alphabetic scripts, all of them derived from Phoenician or its descendants.

Greek Script and Its Derivatives

The Greeks adopted Phoenician script but introduced a fundamental change by creating representations of vowel sounds. The Greek alphabet was more or less fixed by the middle of the eighth century B.C.E. and gave rise to all the modern European alphabets, including:

- Etruscan (seventh century B.C.E.)

- Italic alphabets

- Coptic alphabet (second–third century C.E.)

- Gothic alphabet (fourth century C.E.)

- Armenian alphabet (fifth century C.E.)

- Georgian alphabet

- Glagolitic alphabet (ninth century C.E.)

- Cyrillic alphabet (ninth century C.E.)

| Example of alphabet | Ancient inscriptions (7th–5th century B.C.E) | Later inscriptions (4th–1st century B.C.E) | Transcriptions and their phonetic equivalents |
|---|---|---|---|
| A | A | A | a |
| 8 | | | (b) |
| ٦ |) | Ɔ | c (= k) |
| ᑎ | | | (d) |
| Ⴈ | Ⴈ | Ⴈ | e |
| ٦ | ٦ | ٦ | v |
| I | I | ⱶⱶ | z (= ts) |
| 日 | 日 | 日⊘ | h |
| ⊗ | ⊗○ | ⊙○ | θ (= th) |
| I | I | I | i |
| ᐅ | ᐅ | | k |
| ↓ | ↓ | ↓ | l |
| Ɑ | Ɑ | Ɑ | m |
| Ⴁ | Ⴁ | Ⴁ | n |
| ⊞ | | | (s) |
| ○ | | | (o) |
| ٦ | ٦ | ٦ | p |
| M | M | M | ś |
| ♀ | ♀ | | q |
| ٩ | ٩ | ◁ | r |
| ⟨ | ⟨ | ⟨ | s |
| T | T | ↑�1 | t |
| Y | Y | V | u |
| X | X | | ṡ |
| Φ | Φ | Φ | φ (= ph) |
| Ψ | Ψ | Ψ | χ (= kh) |
| | (88) | 8 | f |

Etruscan alphabets

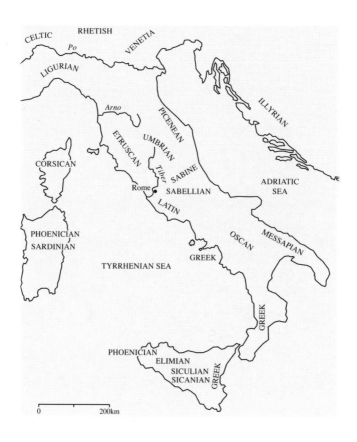

The languages of ancient Italy

| Equivalent | Messapian | Siculian | Picenian | Novilaran | Oscan | Umbrian |
|---|---|---|---|---|---|---|
| | ⇨ | ⇨ | ⇨ | ⇦ | ⇦ | ⇦ * |
| a | A Δ | A Λ | A ΛΛ | A | Λ | AΔ |
| b | B | B | B ? | 8 | 8 | 8 |
| g = c | Γ | | < |)C | > | |
| d | D D Δ | D D Δ | R | Я | ЯR | ٩ ५(r̆) |
| e | F F E | E E E E | F E E E | Ⴈ | Ⴈ | Ⴈ E |
| v (digamma) | F F C | C C | C | Ⴈ | ⊐ | ⊐ |
| z | I | I | I ۥ | | I | ‡人 |
| h | H ⴎ | | 8 □ Ⴈ 5 | | 8 | ⊖ |
| Θ | O | | ⊠ ◇ | ⊗ | | ⊙ |
| i | I | I | I ├ F | I | I | I |
| k | K K | K | K K C | ⅄ | ⅄ | ⅄ |
| l | Λ | Γ | L L1 | ⅃ | ⅃ | ⅃ |
| m | ʌʌM | M | W | ᴡ | m | ᴍΛᴍ |
| n | N Ν | Ν | N Ν | Ⴘ | И | ИИ |
| s (samék) | + × | | ⊞ ? | | | |
| o | O | o | ◇ | O | | |
| p | Γ Γ | Γ | Γ П Γ ⌐ | 1 | П | 1 |
| s (san or sadi) | Ⴘ ? | | M ⋈ | M ? | | M |
| q | ٩ φ | | | ٩ | | |
| r | P P P P | P | P b b | ◁D | ᗡ | ᗡ |
| s | ʃ Ʒ ʃ | Ʒ ʃʃʃ Ʒ ʃ | Ʒ ʃ | M ? | Ʒ | Ʒ 2 |
| t | T T | T T T | T ۥ | × T T ↑ | T | × Ⴘ |
| u | | Λ | Λ Λ Λ | Ⴘ ? | V | V |
| χ | ×(: K ?) | | | | | |
| f | | | ⋖ 8 | | 88 | 8 |
| h ? | Ⴘ ႸႨ | | | | | |
| ù | | | | | V | |
| t ? | Ⴘ | | | | | ԁ (: δ) |

Italic alphabets
(Arrows indicate the direction of the strokes)

| Ⲗ | a | Ⲓ, ï | i | Ⱃ | r |
|---|---|---|---|---|---|
| Ⲃ | b | Ⲕ | k | Ⱄ | s |
| Ⲅ | g | Ⲗ | l | Ⲧ | t |
| Ⲇ | d | Ⲙ | m | Ⲩ | w |
| Ⲉ | e | Ⲛ | n | Ⲫ | f |
| Ⲩ | q | Ⳝ | y | Ⲭ | ch |
| Ⲍ | z | Ⲡ | u | Ⲟ | hw |
| Ⱨ | h | Ⲡ | p | Ⱉ | o |
| Ψ | þ | Ч | | Ⲧ | |

Gothic alphabet
(The last letter is only used to represent a number = 900)

| Capital letters | Lower-case letters | Equivalent | Capital letters | Lower-case letters | Equivalent |
|---|---|---|---|---|---|
| Ⲁ | ⲁ | a | Ⲣ | ⲣ | r |
| Ⲃ | ⲃ | b | Ⲥ | ⲥ | s |
| Ⲅ | ⲅ | g | Ⲧ | ⲧ | t |
| Ⲇ | ⲇ | d | Ⲩ | ⲩ | y |
| Ⲉ | ⲉ | e | Ⲫ | ⲫ | ph |
| Ⲍ | ⲍ | z | Ⲭ | ⲭ | kh |
| Ⲏ | ⲏ | i, è | Ⲯ | ⲯ | p̱s |
| Ⲑ | ⲑ | t̠ | Ⲱ | ⲱ | ō |
| Ⲓ | ⲓ | i | Ϣ | ϣ | š |
| Ⲕ | ⲕ | k | Ϥ | ϥ | f |
| Ⲗ | ⲗ | l | Ϧ | ϧ | ḥ |
| Ⲙ | ⲙ | m | Ϩ | ϩ | h |
| Ⲛ | ⲛ | n | Ϫ | ϫ | ž |
| Ⲝ | ⲝ | x | Ϭ | ϭ | ǧ |
| Ⲟ | ⲟ | o | Ϯ | ϯ | ti |
| Ⲡ | ⲡ | p | | | |

Coptic alphabet

| upper-case | lower-case | equiv. | upper-case | lower-case | equiv. | upper-case | lower-case | equiv. |
|---|---|---|---|---|---|---|---|---|
| А | а | a | Т | т | t | **BULGARIAN** | | |
| Б | б | b | У | у | u | Ѫ | ѫ | eu |
| В | в | v | Ф | ф | f | | | |
| Г | г | g | Х | х | kh | **SERBIAN** | | |
| Д | д | d | Ц | ц | ts | Љ | љ | ly (soft i) |
| Е | е | ié, é | Ч | ч | ch | Њ | њ | gn (soft n) |
| Ж | ж | j | Ш | ш | sh | Ћ | ћ | tch |
| Э | э | z | Щ | щ | shch | Ђ | ђ | dy (soft d) |
| И | и | i | Ъ | ъ | silent e | Џ | џ | dj, dch |
| І | і | i | Ы | ы | hard y | | | |
| К | к | k | Ь | ь | sign making preceding consonant soft | | | |
| Л | л | l | | | | | | |
| М | м | m | Ѣ | ѣ | ié, ê | | | |
| Н | н | n | Ѳ | ѳ | é | | | |
| О | о | o | Ю | ю | yoo | | | |
| П | п | p | Я | я | ya | | | |
| Р | р | r | Ѳ | ѳ | th | | | |
| С | с | s | Ѵ | ѵ | i | | | |

Cyrillic script

Indian Scripts and Their Descendants

Proto-Indian, which has already been mentioned, disappeared without leaving descendants. In the third century B.C.E., long after the disappearance of the proto-Indian scripts from the Indus Valley, two new scripts appeared, the **Brahmi** and the **Kharoshthi** scripts. Their advent followed the passage of Alexander the Great through the Indus Valley (fourth century B.C.E.), which would point to a Semitic origin for these alphabets.

Kharoshthi, a script used in northwestern India between the third century B.C.E. and the fifth century C.E., disappeared without leaving any descendants.

The Brahmi script is also doubtless of Phoenician origin; proof of the similarity between certain letters can be seen from the following table:

| Phoenician eleventh century B.C.E. (reading from right to left) | Equivalent | Brahmi third century B.C.E. (reading from right to left) | Equivalent |
|---|---|---|---|
| ᚲ | A | Ӈ & Ӈ | A short and A long |
| ᛒ | B | □ | B |
| ᐱ | G | ᐱ | G |
| △ | D | D & Ҍ | D |
| ⊗ | Ṭ | ⊙ & ○ | ṬH & ṬK |
| ᚳ | K | ＋ | K |
| ᒋ | L | ↲ | L |
| ᒐ | P | ᑎ | P |

Brahmi script gave rise to three major groups of alphabets:

First, the northern scripts, the descent and chronological relationships of which are shown in the following diagram:

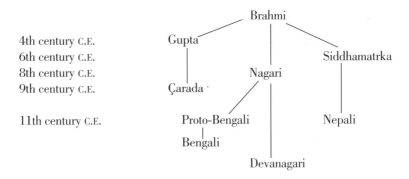

| | | |
|---|---|---|
| 4th century C.E. | Gupta | Brahmi |
| 6th century C.E. | | Siddhamatrka |
| 8th century C.E. | | Nagari |
| 9th century C.E. | Çarada | |
| 11th century C.E. | Proto-Bengali | Nepali |
| | Bengali | |
| | Devanagari | |

Second, the script of central Asia: Tibetan:

Tibetan alphabet

And finally, the southern scripts: Sanskrit, Tamil, Telugu, Kannada, etc.:

| | | | | | | | | | |
|---|---|---|---|---|---|---|---|---|---|
| अ | a | क | ka | ञ | ña | न | na | श ⎫ |
| आ | ā | ख | kha | ट | ṭa | प | pa | श ⎬ śa |
| इ | i | ग | ga | ठ | ṭha | फ | pha | ष ⎭ |
| ई | ī | घ | gha | ड | ḍa | ब | ba | ष | ṣa |
| उ | u | ङ | ṅa | ढ | ḍha | भ | bha | स | sa |
| ऊ | ū | च | ča | ण | ṇa | म | ma | ह | ha |
| ऋ | r̥ | छ | čha | त | ta | य | ya | ळ | la |
| ॠ | r̥ | ज | ja | थ | tha | र | ra | : | ḥ (sisarga) |
| ऌ | /r̥ | क ⎫ jha | | द | da | ल | la | | |
| ॡ | /r̥ | झ ⎭ | | ध | dha | ब | va | | |
| ए | e | | | | | | | | |

Devangari script (the form of Sanskrit that has remained in common use)

Oriental or Pali scripts: Burmese, Bugis, Javanese, Khmer, and Thai:

Bugis script

Consonants in Bugis script

Vowels, in this case associated with L

The Thai alphabet

CONCLUSION

This is a broad outline of the history of writing and the main scripts that you may encounter or which once existed in ancient or recent history. If you are interested in this subject, I recommend the following books: David Diringer, *A History of the Alphabet*, Gresham Books, 1977, 1983, and Albertine Gaur, A *History of Writing*, The British Library, 1984.

A study of the development of proto-Hebraic/proto-Phoenician into the modern alphabet via Greek and Latin is offered for each letter in the dictionary that comprises the second part of this book.

The following chapters will repeat a few essential points of the mechanisms at work in the development of writing in general, taking as an initial example cuneiform while adding a few remarks about Chinese writing.

1. Louis-Jean Calvet, *Histoire de l'écriture* (Plon, 1996).
2. Exodus xx, 3–4.

Above and following pages: Hebrew calligraphy by Lalou

PICTOGRAM, IDEOGRAM, AND PHONOGRAM

There are three stages in the evolution from an image to a letter, from a series of drawings to an alphabet. **The first stage is pictographic.**

The signs used for written communication are images or drawings that imitate an actual event as faithfully as possible. The drawing or pictogram immediately reproduces a material object, a concrete reality. This is "writing with things": a tree, a house, bread, a bull, etc. This form of writing is taken directly from the plastic arts.

Note was taken in the introduction to this book of the striking similarity between the works of the artists Joan Miró and Paul Klee and proto-Sinaitic inscriptions.

Cuneiform Writing

In the first chapter, we showed how the wedge-shaped charac-
ters of cuneiform developed from pictures. Picture-writing poses a
major problem. It involves a considerable number of signs or draw-
ings. You need to have almost one drawing per object: one for a cow,
another for an ox, another for a calf, and so on. As J. Bottéro so
rightly said, "In such a case, in theory you would need thousands of
signs and thus the usage and knowledge of such writing would be,
if not beyond human capacity, certainly beyond the possibility of
making any practical use of it."[1]

To avoid an infinite multiplicity of signs, certain procedures
needed to be perfected. The most important reform was to enrich
the relationship between the sign and everyday objects. That is to
say that the pictogram, "apart from being the first object drawn,
could be used to relate to other things that were connected with this
particular object by using mental processes which were more or
less based on reality or absolutely conventional thinking."[2] ·

Thus, the pictogram of mountains ⌂ might depict not only
an actual "mountain," but also "the border," and by extension "a
foreign country," since Mesopotamia is hemmed in by mountain
ranges to the east and north. The image of a man carrying the sign
for a mountain would thus signify that this man had come from
beyond the mountains: "He is a foreigner" (or a slave!). In another
example, the drawing of an ear of wheat not only means the object
itself, "wheat," but also "agricultural labor." The outline of a lion,
his head, or his claw might be used to represent such abstract con-
cepts as "strength," "ferocity," "carnage," "terror," or "tyranny."
Thus a foot becomes a symbol for walking, of the verbs to go, to walk,
and to stand. The fact that a sign could be used to indicate an
abstraction, an idea, transforms the **pictogram** into an **ideogram**.

An ideogram is generally a set of various images grouped together, such as the pubic triangle + mountains = female slave: ▽ + ◿◺ ; mouth + bread = to eat;[3] mouth + water = to drink.

Chinese Characters

Chinese writing also consists of pictograms that have been transmuted into ideograms. Several ideograms can also be grouped together to be given more and more sophisticated meanings. Thus, the character for "man" combined with the character for "word" may express the concept of trusting someone.

The word for "no" *(bu)* consists of the character that means "plant" with a horizontal line drawn through it to express negation metaphorically: *The plant tries to grow, but we are preventing it from doing so.*

Let's take the example of the word for "yes." In Chinese, it is *shi.* The word means both "yes" and "to be." *Yes = an affirmation of being. Saying yes to life and to existence.*

"Yes/to be/shi" is written 是 . This character consists of two subcharacters: 日 = the sun and 疋 = to walk.[4]

The whole signifies: "The sun that gives energy to those who are down below so that they have the strength to walk." Each word becomes a poem and a profound philosophical reflection.

From the Ideogram to the Phonogram

"The writing of things," which is what a pictogram is, is still not "the writing of words." Of course the words *walk, mountain, buy, bread, woman* undoubtedly convey information; there

81

艻　二一

茊　九

茻　九

莪　〇

蓙　杂

藏　杂

藏　雜

廿　是

芷　是

芦　趸

芦　題

芦　題

芷　題

　　題

一 门 内 内

二 十 艹 芦 芎 梦

夢 蒡 蒡 蒙 蒙

丶 亠 言 言 言 言

| complex | 木 | wood | | | |
|---|---|---|---|---|---|
| Tibetan | 艹 | grass | Mongol | 艹 | grass |
| internal | 门 | pregnant | tongue | 言 | tongue |

Breakdown of signs from simple lines to complex ones

is walking, a mountain, a purchase, bread, and a woman. But who is doing the walking and the buying? And when? And how much is at stake?

Does the walk start or end at the mountain? Is the woman buying the bread or is it being bought for her? On the other hand, if it was I who had had this adventure, if I traveled through mountainous country, and during the trip I had purchased for cash one or more types of bread, in order to take it back to my wife, I would only need five words to remind me about it all if I had forgotten any part of the events. Thus pictographic writing, picture-writing, writing of things, was not and cannot be anything but a reminder message. A new type of sign needed to be invented that would make it possible to indicate not only things, the extralinguistic realities, but also the internal realities of the language itself. The initial relationship between the sign and an object needed to be broken in order to halt it at a phoneme, that is to say not in the realm of reality outside the mind but in the spoken language, the intralinguistic reality. The sound of the initial sign was preserved, but it no longer referred to an image and an object. The sound merely represented itself. Such a sign became a **phonogram**; it represented and recorded a phoneme. The system of writing no longer consisted of "the writing of things" but had become "the writing of words." It no longer transmitted a single thought but could now convey speech and language. Although it meant that one now needed to know the language of the person who had written it in order to understand it, at least the sign was capable of capturing whatever the spoken language conveyed. Writing was no longer reserved for commemorating important events, but could be used to inform and instruct. It was no longer a simple reminder message but had become writing in the fullest sense of the word.

Birth of the Letter and of the Alphabet

In a phonogram, the image still exists but it no longer refers to an image. Take the pictogram-image of a foot ⋎ , which is pronounced "du." It now refers only to the sound "du"; the idea of a foot has completely disappeared. It's just like a rebus, where the picture of a "car" followed by that of a small dog ("pet") has nothing to do with the vehicle, which we could also call "automobile," nor with the animal, who could be called "dog" or could represent a breed of dog; but the two symbols together are supposed to be read as "carpet"! The image of an eye followed by that of a housefly has nothing to do with anatomy and an insect but should be read as "I fly."[5] In this system, the image is too prominent. To abolish the image completely, you only need retain a part of it, the basic part that captures its total sound. For instance, in the example of the *foot,* I will only retain the "f" to which I can continue to give the name of *foot* but which refers neither to the *foot-sound,* nor to the *foot-picture.* This principle, which is called **acrophonic**, gave rise to the system of signs known as an alphabet.

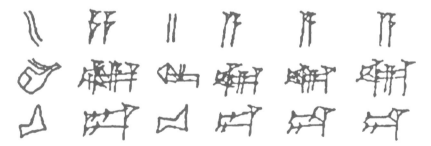

1. Jean Bottéro, *Mésopotamie, l'écriture, la maison et les dieux* (Gallimard, 1987).
2. Ibid.
3. Ibid., see table on p. 93.
4. See Philippe Kantor, *L'Écriture chinoise, les idéogrammes trait par trait* (Assimil, 1984), pp. 283, 288.
5. J. Bottéro, *Mésopatamie,* p. 104.

CHAPTER III

THE LADY OF THE TURQUOISE

Proto-Sinaitic Script

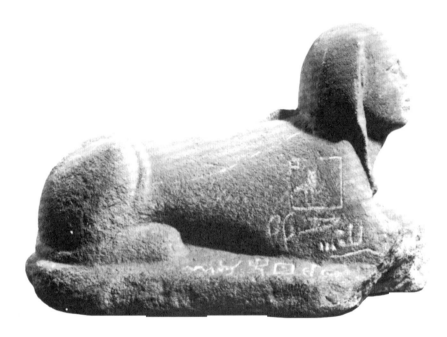

Sandstone statuette of a sphinx with inscriptions in Egyptian hieroglyphics and proto-Sinaitic

Proto-Sinaitic or Proto-Semitic Writing

The basic thesis of this book is to show that the alphabet that we know today in our Western languages is derived from an alphabet that was created more than 3,500 years ago and which is known as proto-Sinaitic.[1] This writing is considered to be the first alphabetic script, although it consists solely of consonants. It was discovered by Sir Flinders Petrie[2] in 1905 and dates from the sixteenth–fifteenth century B.C.E. Petrie first found this writing engraved on a little sandstone sphinx in the Temple of Hathor on the plain of Serabit el Khadim in the Sinai Peninsula,[3] the site of some ancient turquoise mines.

The Turquoise-Colored Woman: Petrie's Discovery

In this temple dedicated to the goddess Hathor, the principal deity of the mining areas of Sinai, Petrie discovered a large number of inscriptions, many of which paid homage to the goddess. Most were written in Egyptian, but a few items, eleven in all, bore inscriptions in a writing that contained "a mixture of Egyptian hieroglyphics . . . although no word of Classical Egyptian could be read." One of the artifacts, the statuette of a sphinx, was of particular interest, because it bore text written in ordinary Egyptian writing and in proto-Sinaitic writing.

The texts in Egyptian are inscribed between the paws and on the right shoulder, and say "Beloved of Hathor, Lady of the Turquoise." The proto-Sinaitic texts are engraved on the plinth, on either side of the sphinx. Petrie was incapable of offering any suggestion as to how this writing could be read but made some important observations. For instance, he deduced that in view of the limited number of signs in this new script it was probably alphabetic, and that in view of the geographical and historical

context it might well be a transcription of the Semitic language spoken by the "Asiatic workers" employed by the Egyptians. These "Asiatic workers" were, according to the most probable theory, Hebrews who had settled in Egypt and who were mainly laborers or slaves, as the biblical tradition and other historical sources have reported.[4] Petrie dated the material from the middle of the Eighteenth Dynasty, 1400 B.C.E.[5] In the light of comparative history, this is an interesting dating because it coincides exactly with the biblical period of the exodus from Egypt and thus with the event of the revelation on Mount Sinai. According to W. V. Davies,[6] the style in which the sphinx is sculpted would indicate an even earlier period, apparently the end of the Middle Kingdom, or the Second Intermediary Period.[7]

According to Février,[8] three possible dates could be attributed to the proto-Sinaitic inscriptions:

- the period of the Eighteenth Dynasty, 1500 B.C.E. (which is what Petrie and Grimme believed)
- the Thirteenth or Fourteenth Dynasty, 1700 B.C.E. (Sethe's theory)
- the Twelfth Dynasty, 1800 B.C.E. (Butin's theory)

Février suggested a date that is favored by most modern researchers, that of 1400 B.C.E., the Eighteenth Dynasty. The proto-Sinaitic script consists of about thirty separate signs of which nearly half have clearly borrowed their shape from Egyptian hieroglyphics.

Like hieroglyphics, the signs are arranged either in columns or in horizontal lines, but generally seem to be read from left to right.

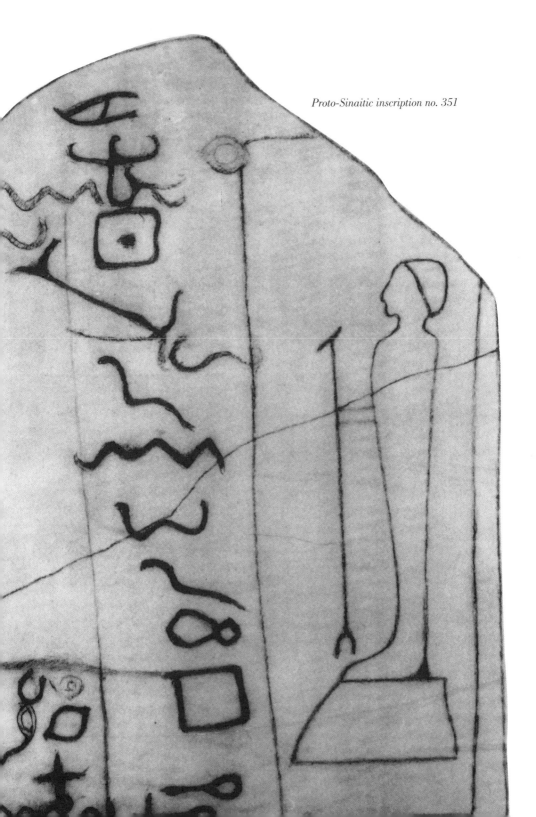

There seems to have been no strict rule as to the direction in which the signs were to have been written, although they are all written in the same direction in a particular text.

Two Names for a Goddess: Gardiner's Interpretations

The first step in deciphering the script system was taken in 1916 by the English scholar A. H. Gardiner.[9] He noted that a certain number of signs represented objects, whose Semitic names corresponded to the names of letters in later alphabets such as Phoenician and Hebraic. This made him realize that the Phoenician and paleo-Hebraic characters were directly derived from proto-Sinaitic pictograms and that the transition from one shape to the other was fairly easy to discern in many cases. Gardiner realized that the proto-Sinaitic consonant sign was pronounced like the first letter of the Hebrew name of the object represented. For example, ∿∿∿ , which represents water, *mayim*, is pronounced "m"; ꙮ, a drawing of a head, *rosh*, is pronounced "r," etc. That is how Gardiner managed to decipher from the few proto-Sinaitic inscriptions engraved on the Sphinx the Hebraic Semitic word *BaaLaT*, "mistress." These inscriptions had been engraved on statues found in the Temple of Hathor, the Lady of the Turquoise, to whom they must have been votive offerings. The Hebrews must thus have used the so-called acrophonic method, on which consonantism is based.[10]

Acrophony is a word of Greek origin. *Akron* is the Greek word for "extremity," "summit," "top." Acrophony is the pronunciation of a word reduced to the first consonant or the first syllable. In Western languages, sets of initials may be turned into acrophony. For example, the words *SOund NAvigation*

Ranging produce the word *sonar* when read acrophonically. Such a word is called an acronym.

Thus the signs ⬜ 👁 ⌒ ✝ represent respectively a house, an eye, an ox goad, and crossed pieces of wood—the Hebrew words *bayit, ayin, lamed, tav,* whose initials are B(A)LT, pronounced *ba'alat,* which means "mistress." In another example, there is an inscription at the bottom right on the sphinx, catalogued at No. 345, which contains the signs: ∿ ⵁ 𓏲 ⬜ 👁 ⌒. In Hebrew and ancient Semitic these letters are: *Mayim, Aleph, Heh, Bayit, Ayin, Lamed* respectively, representing the following objects: water, ox, prayer, house, eye, and an ox goad. Using acrophony, this produces the initial letters MAHABAL(T). According to Martin Sprengling[11] this reads as: *MeAHayVBaaLaT,* that is to say, "beloved of the Mistress [Baalat]."[12]

From Proto-Sinaitic to Paleo-Phoenician: Albright's Conclusions

Ever since Gardiner made his first discoveries, numerous scholars have produced a multiplicity of writings about proto-Sinaitic. One could not possibly begin to list all the attempts that have been made at deciphering these languages.

However, a few are worthy of note, and Février has listed the studies of K. Sethe[13] and the attempts by H. Grimme,[14] both of which are the fruits of enormous erudition and a creative imagination. The conscientious endeavors of Butin,[15] A. E. Cowley,[16] and Martin Sprengling[17] are also worthy of note. Some scholars, however, such as J. Leibovitch,[18] H. Bauer,[19] and J. Friedrich,[20] completely rejected Gardiner's theories.

Recent archeological discoveries have made it possible to trace the outline of the prehistory of the alphabet. Since Gardiner's

| Proto-Sinaitic | Egyptian | | Proto-Sinaitic | Egyptian | |
|---|---|---|---|---|---|
| | | Ox | | | Water |
| | | House | | | Snake |
| | | Throwing stick (?) | | | Eye |
| | | Fish | | | ? |
| | | ? | | | ? |
| | | Man with raised arms | | | ? |
| | | Load or oar | | | ? |
| | | Door | | | Head |
| | | Braided linen | | | Pond with lotus flowers |
| | | Hand | | | ? |
| | | Palm | | | Crossed planks |
| | | Hook (?) | | | |

Proto-Sinaitic signs and their Egyptian prototypes

time, the number of available texts has more than tripled and now contains provenances other than Sinai. However, the texts are invariably short and have sometimes been crudely inscribed.

The work of William F. Albright[21] and his students has shed the greatest light on the deciphering of proto-Sinaitic writing. After spending decades on research, Albright published the results in his book *The Proto-Sinaitic Inscriptions and Their Decipherment*. In the first place, Albright dates the proto-Sinaitic texts to the reign of the Egyptian queen Hatshepsut and Thothmes III, c. 1500 B.C.E. This is in the middle of the Eighteenth Dynasty, "precisely" between 1508 B.C.E. and 1450 B.C.E.[22] These are important dates, since they coincide with the Hebrew settlement in Egypt and the exodus that led them to Sinai and the giving of the law.[23] Albright created a comparative table showing the twenty-three proto-Sinaitic signs he chose and their "Egyptian prototypes." If his interpretations are not perfectly accurate, they are at least close, that is to say, they open the way to thinking along the right lines and producing more relevant research on the topic.

F. M. Cross used Albright's work as a starting point in his attempt to definitively link proto-Phoenician writing (thirteenth century B.C.E.), which he called proto-Canaanite, back to proto-Sinaitic and forward to paleo-Phoenician (eleventh century B.C.E.).

The difference between Phoenician, paleo-Hebraic, and Hebrew is minimal, so we offer a simpler diagram on page 111 to show more clearly the affiliation of forms between Ancient Hebrew and Ancient Greek as well as between Ancient Hebrew and the alphabets of modern Western languages.

1. The following reference material on proto-Sinaitic and the development of the alphabet was consulted:

F. W. M. Petrie, *The Formation of the Alphabet* (London, 1912);

Martin Sprengling, *The Alphabet* (Chicago, 1931);

J. Leibovitch, *Mémoire présenté à l'Institut d'Égypte* (1934);

I.C. Gelb, *Pour une théorie de l'écriture* (Flammarion, 1973);

J.-G. Février, *Histoire de l'écriture*, Payot, 1984 (republication), p. 179 et seq.; see note 24, p. 202;

J. Naveh, *Early History of the Alphabet*, 1987 (in English and Hebrew);

Gérard Pommier, *Naissance et renaissance de l'écriture*, PUF, 1993;

La Naissance des écritures: Du cunéiforme à l'alphabet (several authors), Seuil, 1994.

2. William Matthew Flinders Petrie (1853–1942), British archeologist and founder of the Egyptian Research Account (1894), which in 1906 became the British School of Archaeology.

It is significant that this period is so close to that of Freud (1856–1939). The work of Petrie and his successors can be said to be a revelation of the deeper, concealed layers of human culture and its origins just as the deeper concealed layers of the human psyche were being exposed in Western society at the same time.

3. Hence the name proto-Sinaitic.

4. Exodus, chapters 1 through 17. Cf. A. and R. Neher, *Histoire biblique du peuple d'Israël* (Maisonneuve, 1982).

5. Historians divide Egyptian history into eleven periods:

Thinic Period (1st–2nd Dynasties), 3100–2650 B.C.E.

Ancient Kingdom (3rd–8th Dynasties), 2650–2135 B.C.E.

First Intermediate Period (9th-10th Dynasties), 2135–1950 B.C.E.

Middle Kingdom (11th–12th Dynasties), 1950–1785 B.C.E.

Second Intermediate Period (13th–17th Dynasties), 1785–1400 B.C.E.

New Kingdom (18th–20th Dynasties), 1400–1000 B.C.E.

Third Intermediate Period (21st–24th Dynasties), 1000–700 B.C.E.

Late Period (25th–30th Dynasties), 700–400 B.C.E.

Greek Period, 400 B.C.E.–1 C.E.

Roman Period, 1–500 C.E.

Arab Period, 500–

6. See W. V. Davies, "Les Hiéroglyphes égyptiens," in *La Naissance des écritures*, Seuil, 1994, pp. 106, 107.

7. On the dating of the exodus from Egypt and the revelation on Mount Sinai, see the various theories presented by André and Renée Neher in *Histoire biblique du peuple d'Israël*, p. 93 ff. Three possible dates have been chosen: 1240 B.C.E., 1440 B.C.E., 1450 B.C.E.

8. See note 1.

9. A. H. Gardiner, *The Origin of the Semitic Alphabet*, 1916, JEA no. 3, 1961.

10. Ibid.

11. See note 1.

12. If Sprengling's theory is correct, as it would appear to be, the pictogram pronounced "v" or "b" is used twice: (a) as the last letter of *Meahayv* (beloved of…); (b) as the first letter of *Baalat:* "Mistress."

13. K. Sethe, *Nachrichten von der Gesellschaft und Jugendbildung*, 1916, p. 87 et seq., 1917, p. 437 ff.

14. Hubert Grimme, *Die altsinaïtischen Buchstaben-Inschriften, auf Grund einer Untersuchung der Originale* (Reuther und Reichard Verlag, 1929). A very important book as regards the quality of the documentary evidence and the analyses.

15. Butin, *Harvard Theological Review*, 21, 1928, p. 1 ff.

16. A. E. Cowley, *Journal of Egyptian Archeology*, 15, 1929, p. 200 ff.

17. Martin Sprengling, *The Alphabet: Its Rise and Development from the Sinai Inscription*, Chicago, 1931.

18. See note 1.

19. H. Bauer, *Das Alphabet von Ras Shamra*, 1932.

20. J. Friedrich, *Zeitschrift der deutschen morgenlandischer Gesellschaft* 91, 1937, p. 319 ff.

21. 1891–1971.

22. W. F. Albright, *The Proto-Sinaitic Inscriptions and Their Decipherment* (Harvard University Press, 1966).

23. Cf. A. et R. Neher, *Histoire biblique du peuple d'Israël*, p. 84.

On the problem of dating the exodus, the giving of the law, and its relationship to writing, see G. Pommier, *Naissance et renaissance de l'écriture*, pp. 156–166 and our remarks in Chapter I.

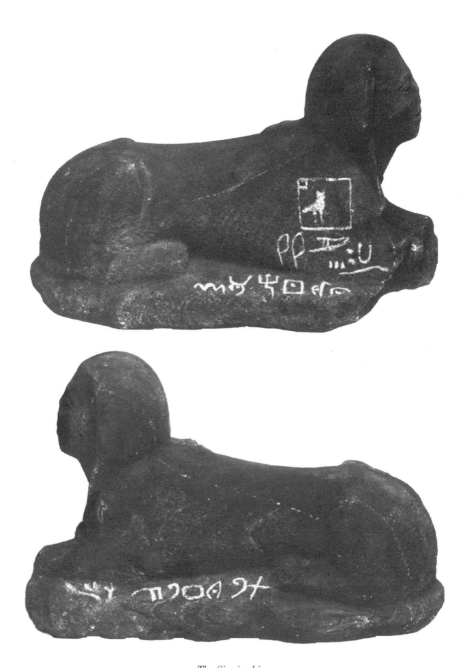

The Sinai sphinx

CHAPTER IV

THE EXAMPLE OF
THE LETTER *ALEPH*

To render this account less abstract, here are examples of the letter *aleph*, the first letter in the proto-Sinaitic alphabet, the ancestor of our letter A.

In the Beginning There Was the Ox

How was the original alphabet, which we now call proto-Sinaitic, first created and how did it give rise to the Hebrew, Phoenician, Greek, and Latin alphabets, in other words, almost all the ancestors of the alphabet we use in most of the Western languages today? Even if we could show the line of descent between Egyptian hieroglyphics and proto-Sinaitic, the latter differs from the former in two fundamental ways:

- proto-Sinaitic does not contain any voiced signs (it lacks vowels)
- the signs do not relate to images but to sounds, using acrophony[1]

In the beginning, there was the ox! In fact, the first letter of the proto-Sinaitic alphabet represents an ox. In Akkadian the ox is called *alpu;* in Phoenician, *aleph;* and in Hebrew it is *aleph* or *aluph.*[2]

Why the ox? Apparently, for the ancients it represented strength and energy in general; the moving force, the reproductive force, economic energy, domestic energy, agricultural energy. . . . Without this basic energy, society and the individual would remain blocked in a inherently static state, unchanging and unmoving. Who would pull the plow? Who would draw the great quantities of water needed for irrigating the fields? Who would enable "vehicles" to move? etc.

This primal energy was thus put at the beginning of every-thing; the ox thus became the inaugural symbol through which what we have called the Law of Laws began: the alphabet.

The Iconic Paradox

So the alphabet begins with an ox! Let us follow the destiny of this animal, this *aleph*. What happens to him in the evolution that starts with the drawing and ends in a letter of the alphabet? In the initial phase, the image of the ox represents the ox and only the ox—it is a pictogram. The image is whole, it shows head and body: . Initially, the ox becomes the embodiment of strength, vigor, energy—it is an ideogram. The people who used these signs probably said to themselves that representing the whole animal was a lot of work and not really necessary for conveying the mes-sage, that of strength, force, energy, etc. So we can see how this drawing becomes reduced, until only the head of the ox is retained to be used as the sign. Representing the whole with a part is called metonymy. The transition from pictogram to ideogram, from "writ-ing a thing" to "writing an idea," contains two elements, the reduc-tion of the image and the expansion of the meaning behind the image—*iconic reduction* and *semantic expansion.*

Some authors call this dual, inverse, and paradoxical move-ment "iconic augmentation."[3] We prefer to call it an iconic para-dox, since it more accurately reflects the dual inverse movement, the intricate crossover of the image and the meaning. The less accurate the representation of the image, the more free and open it becomes and the more its meaning expands. The "hermeneutic difference of a sign," the difference between the "wanting to say" of a sign and being able to say it, is in inverse proportion to the specificity of the relationship between the image and the real-

ity of the sign. However, as was shown in the introduction, a return
to the image several centuries after it had been forgotten is a new
method of semantic amplification.

The Destiny of a Horned Head

A metonymic reduction merely retains the most characteris-
tic features of the image of the ox, namely the head and horns. The
second phase of the *aleph* is thus marked by the following image:
𐤀. The texts that have been discovered show small variations
in this image. Some of them contain a dot to show the presence
of an eye, others have a line for the mouth, and in still others, the
head is empty, showing no dot or line, and facing right or left
𐤀 𐤀 𐤀 𐤀 . The third phase is due to a complex mental proc-
ess that culminates in the rejection, prohibition, and suppression
of the image.

Why did the image disappear? Was it simply due to a concern
for making writing easier and more efficient? It would seem that
the passage from a pictorial form to a nonpictorial form is the result
of the giving of the law on Mount Sinai and the prohibition on mak-
ing representations: the image became impossible.

"Thou shalt not make any graven images": the Second
Commandment led to a cultural revolution that deleted the image
and produced the invention of the letter as a more-or-less abstract
sign. The third phase continues the progressive erasure of the image
so that only the essential traces are retained; the head became a
mere line on which the horns rest very visibly: ∪ . Here again,
there are several variations. The horns may be more or less rounded
or angular at the base: ∪ ∨ . The fourth phase is a dual one.

It consists of rotating the letter 90° to the right while intruding the head into the horns, of a bar inside the U or V: ⟋ ⤚ . (This intrusion might even be part of the third phase.) There are a great many variations on this shape. The "bar of the head" may be sunken into the horns to a greater or lesser extent, and may be higher or lower: ⟋ ⤚ ⤚ .

Turning this shape around completely produces the Greek *alpha* and the Latin A, which we have inherited in our western European scripts: A .

1. Regarding acrophony, see above in Chapter II.

2. In Hebrew there are other words to denote an ox or bull, such as *shor* or *tor* or *tura*.
The term *aleph* to mean "ox" is encountered several times in the Bible, for instance in the expression *sh'gar alphekha*, "the increase in thy kine" (Deuteronomy vii:13 and xxviii:4). In the book of Psalms (144, 14), we find the expression *alufékha mesubalim:* "that our oxen may be strong to labor." *Aleph* also means to learn, to study, a leader, a champion; and in Modern Hebrew, it is the army rank of general.

3. See Dagognet, *Ecriture et iconographie* (Vrin, 1973); Nelson Goodman, *The Languages of Art: An Approach to a Theory of Symbols* (Indianapolis: Bobbs-Merrill, 1968); and Paul Ricœur, *Du texte à l'action* (Seuil, 1986), p. 222.

CHAPTER V

WHEN *ALEPH* BECAME *ALPHA*

βχδφλεγηφμπθρ

The Greek alpha in calligraphy

Proof of a Line of Descent

The Greek alphabet, which subsequently gave rise to the Latin alphabet, is directly derived from the proto-Sinaitic alphabet via Phoenician and Ancient Hebrew. The oldest trace of the Greek alphabet dates from the eighth century B.C.E. Four basic points indicate the basis for this descent:

1. According to Greek tradition, the letters of the alphabet are called *phoinikeia grammata*, meaning Phoenician letters, or *kadmeia grammata*, the letters of Kadmos.

The alphabet was introduced with other arts by the Phoenicians, who traveled to Greece with an important figure named Kadmos.

The Phoenicians were great travelers and traders. Their relationship with the other peoples of the Mediterranean basin, and especially with the Greeks, was a major influence in every sphere of life and in particular as regards writing, which the Greeks adopted to use for their own language.

2. The names of the letters—*alpha, beta, gamma, delta*, etc.— have no meaning in Greek, except as names of the letters of the alphabet. They are quite simply the phonetic equivalents of the Semitic letters *aleph, beth, gimmel, daleth*, etc., each of which has its own meaning, as will be explained in the second part of this book in the form of a letter-by-letter dictionary.

3. The sequence of the letters of the Greek alphabet is basically the same as that of the proto-Sinaitic and Phoenician, Hebrew, and Aramaic alphabets.

4. The shape of the letters in Ancient Greek is very similar and sometimes even identical to the shapes of letters in the Semitic alphabets such as proto-Sinaitic and Phoenician, Hebrew, and Aramaic.

If we use the example of the *aleph* again, the graphic line of descent is obvious. Thus we have ⟨ꝩ⟩ (proto-Sinaitic), ⟨ꓘ⟩ (Phoenician), ⟨A⟩ (Greek).

The Principal Characteristics of Ancient Greek

The principal characteristics of the Ancient (or Archaic) Greek script can be summarized in five points:

1. The oldest known Greek inscription dates to the eighth century B.C.E.

2. Archaic Greek writing uses the twenty-two letters of the Western Semitic alphabet (Phoenician, paleo-Hebrew), some of which are turned into vowels. Four additional letters were gradually introduced: first the Y, then F, X, and finally W.

3. Archaic Greek is not written uniformly. Several variations in the shapes of the letters are encountered.

4. Archaic Greek is written in a lapidary style (as if it were being engraved on stone).

5. The direction of the writing is not set in Archaic Greek. It is written horizontally, sometimes from right to left and sometimes from left to right and sometimes even in alternate directions, one line being written from right to left and the next from left to right; this last form of writing is called a **boustrophedon.**

ADDITIONAL REMARKS

The oldest Greek sources that we currently know date from c. 740–730 B.C.E.[1] As regards the manner in which the alphabet reached the Greeks, there is an almost complete consensus among scholars, who all take Phoenicia as the starting point. The meeting place was not necessarily in mainland Greece, and the context may

well have been a trading environment. The Greeks added a new dimension to alphabetic writing. A number of Phoenician letters[2]— similar or identical to Ancient Hebrew letters—for which there was no use in the various Greek dialects were used to represent vowels.

The ayin, *written in the form of a circle and representing a gutteral sound that did not exist in Greek, was used to represent the vowel /o/* (omicron).

The heh *was transposed into /e/ (E)* (epsilon).

The yod *became /i/ (I)* (iota).

The aleph, *the sign representing the glottal stop, was used to represent an /a/ (A)* (alpha).

The het *was used to transcribe the long e /ee/, the Greek H* (eta).

Another Phoenician sign was adapted for /u/, the Greek Y (upsilon).

The ayin, *which had already been turned into an O* (omicron), *opened at the bottom to give a* Ω.

Some of these changes were originally restricted to Ionic dialects, but eventually they spread throughout the land. That is how the basic series of vowels came into existence: a, e, ee, i, o, u.

Thus for the first time there was a "real" alphabet, an alphabet in which not only the consonants were represented, but the vowels as well. It was not a matter of only using the consonants to indicate the vocalic sound but actual new letters that were signs representing the vocalic sounds (eighth century B.C.E.). In addition to the Ω *sign, the Greeks also invented special signs to represent /ph/, /kh/, and /ps/, and put them, along with Y and W, right at the end of their alphabet.*

There were a few variations at the birth of the Greek alphabet that developed in certain archaic dialects. But after a series of transformations and developments, the Ionian alphabet of Miletus was officially adopted in Athens in 403–402 B.C.E. and has been handed down to us as the Classical Greek alphabet, in which writing from left to right became the standard. It was Archinos, under the archontate of Euclid, who made the decisions that made it possible for Greek script to become uniform. The other variations eventually fell into disuse.

1. On the question of Greek script, see J. Naveh, *Early History of the Alphabet* (Jerusalem, 1987), p. 175 ff.

2. I. J. Gelb, *Pour une théorie de l'écriture* (Flammarion, 1973).

TABLE OF EQUIVALENTS:

| HEBREW | GREEK | LATIN |
| --- | --- | --- |
| Aleph | alpha | A |
| Beth | beta | B |
| Gimmel | gamma | C |
| Daleth | delta | D |
| Heh | epsilon | E |
| Vav | upsilon | F, U, V, W, |
| Zayin | zeta | G, Z |
| Het | eta | H |
| Tet | theta | T |
| Yod | iota, Greek i | I, J, Y |
| Kaf | kappa | K |
| Lamed | lambda | L |
| Mem | mu | M |
| Nun | nu | N |
| Samekh | xi | X |
| Ayin | omicron, omega | O |
| Peh | pi | P |
| Tsadeh | san | *Ts* and *Ch* in Russian |
| Qof | qoppa | Q |
| Resh | rho | R |
| Shin | sigma | S |
| Tav | tau | T |

THE
ALPHABET

*"In the land in which men
are never wrong about anything,
Flowers do not bloom
in the Spring."*

YEHUDA AMICHAI

In the *second part* of this book, which we are now *starting,* we are going to show how each of the *letters* has a clear line of descent from proto-Sinaitic down to the *modern alphabets,* going via Phoenician, Greek, Etruscan, and Latin. . . .

Happy reading.

A

The A

The letter aleph
The ox

*"The word is man,
his memory
and his future."*

E. Jabès

The letter A, first letter of the alphabet, is derived from the first letter of the proto-Sinaitic alphabet: the *aleph,* which means an ox in Semitic languages. So in the beginning, the ox appeared!

The ox is the premier sign, because it represents "strength," the energy that is so important for living, for agriculture, for transport, the elemental energy that sets everything in motion, which changes from *being* to *existence.* All the letters have changed in the same way. The change from the graphic image to the letter is made, through reduction, where a small part represents the whole. A drawing of an ox or a bull existed in Egyptian hieroglyphics.

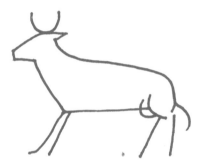

In Egyptian, this drawing is a **determinative.** After the phonetic signs used for writing them, most Egyptian words have one or more signs known as determinatives, which give an approximate indication of the semantic category to which the words belong. The drawing of an ox is a determinative of "cattle." The drawing of an ox or bull is soon reduced merely to the head, with or without an eye and a mouth. This is the graphic form that is found in proto-Sinaitic inscriptions. The drawing of the head soon became simplified into the graphic form ▽ or ⊻ or ✗ or ⩮.

But the most frequently used form is ⚔ .

Top part of proto-Sinaitic inscription No. 352

Stele of Mesha, king of Moab (ninth century B.C.E.)

The Transition from Phoenician and Hebrew to Aramaic

There is an interesting phenomenon that would explain the change from the ancient shape of the ⟨ (tenth century B.C.E.) to the new form, as found in Classical and Modern Hebrew א (from the first century B.C.E.), which is based on Aramaic forms.

Based on the classic shape, the angle of the horns may disappear and be replaced by two parallel lines ⟨ .[1] From the shape ⟨ the following shape is obtained after a shift to the left: ⟨ . Two centuries later, the lower parallel bar detaches itself from the head bar: ⟨ . Several changes then follow, the simplest of which is the disappearance of the lower bar, which has already become detached. We thus obtain an "x," of which several forms have been found: ⟨ ⟨ ⟨ . In the fifth century, the ⟨ becomes ⟨ .

The semidefinitive shape of the *aleph* is encountered in the fifth century: ⟨ , which eventually turns into its definitive shape: א . The definitive shape restores the median bar, "the head bar" of the ox, and the two horns, one having moved to the top and the other to the bottom of the letter.

Modern Cursive Hebrew and Proto-Sinaitic

In Modern Hebrew, alongside the printed letter and liturgical script there is a cursive script that is used for handwriting, for school, and for correspondence. In this script, the *aleph* has retained its original shape: ⟨ . The two horns of the ox are clearly visible. The letter has merely been pivoted by 90°, changing it from the horizontal to the vertical: ⟨ → ⟨ .

NOTE

It is in the cursive script of Modern Hebrew that one frequently finds traces of the original proto-Sinaitic script.

The Transition to Greek Script

In the earliest Greek scripts, the *aleph* that had become *alpha* is always shown with a line representing the head, and the two horns. But the *alpha* changed the direction; it was written: ⋌ or ⋌ or ⋋ or ⋋ or △ or A . In Etruscan script (which is very similar to Greek), it is the following forms which are found: A or ◁ or ⊣ or ⊓; and these turned into the Latin and European letter: A .

So in the course of its history, the *aleph* has gradually turned a 180° circle. The horns, which originally pointed upward, were then rotated 90° to the right or left, and finally found a stable and definitive position pointing downward. However, the Greek *alpha*, when written in cursive script, becomes ∝. That is to say, the horns point to the right. Some interpreters see this reversal and the various directions as being symbolic of the relationship between man and the surrounding world. The horns are like "antenna" directed at the outside world, making it possible to capture energy and information. Where the horns point upward, this indicates the transcendental dimension in man's position in the world. It is the vitality of the finite, drawing his strength from the infinity of the creator, God, or the celestial powers. This relationship can be called vertical and theological. The 90° turn directing the horns horizontally to the right or left indicate the change from theological to anthropological. It is from one-to-one relationships with other human beings, that is, in social and ethical relationships, that man draws his strength of being. To put it in contemporary terms,

A

ethics take precedence over metaphysics. Turning a full 180°
circle introduces an even more earthbound dimension. Now man
is an earthling who draws his strength and energy from the forces
of the earth. The horns become legs on which man finds his stabil-
ity and contact with the soil of terra firma. This becomes the tran-
scendent mode, which accords a separate place to higher things
and to contact with fellow men.

A

1. See J. Naveh, *Early History of the Alphabet* (Magnes, 1987).
2. See *Even-Shoshan Dictionary (Hebrew-Hebrew)* (Jerusalem, Kiriyat Sefer Ltd., 1987).

SUMMARY TABLE OF "A" DERIVED FROM *ALEPH*

NAME
A is the first letter of the word *aleph*, which means "ox" or "bull" in Semitic languages and in Hebrew.[2]

ORIGINAL FORMS IN PROTO-SINAITIC
Ox, head of an ox, horns of an ox or bull.

**CLASSIC FORMS OF THE *ALEPH*
IN CLASSICAL AND MODERN HEBREW**
א Square script *אc* Cursive script

ORIGINAL MEANING
Primal energy.

DERIVATIVE MEANING
Strength, being, human being, living being, man, possibility, beginning.

**ACQUIRED MEANING PERPETUATED
BY THE HEBREW LANGUAGE**
• ox, kine, cattle
• prince, champion
• to teach
• 1,000

NUMERIC VALUE
1

**CORRESPONDING LETTER
IN WESTERN ALPHABET**
The *aleph* becomes an *alpha* in Greek and is the A of western European languages. The concept of the bull has come down to us by the sign of the horns, which never disappeared from the letter, however much it was changed.

A

Facing page: aleph *in cursive Hebrew. Above: the A of Western alphabets.*

B

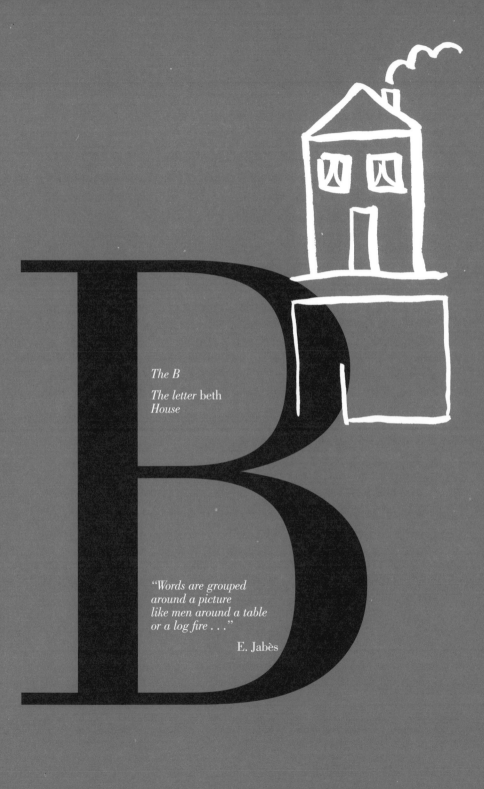

The B
The letter beth
House

*"Words are grouped
around a picture
like men around a table
or a log fire . . ."*

E. Jabès

The letter B, second letter of the alphabet, is derived from the second letter of the proto-Sinaitic alphabet. There is a sign in Egyptian hieroglyphics that is a single-letter phonogram and which produces the "h" sound (as in *hot*). It represents the plan of a building, viewed from above ⌐⌐.[1]

The entrance and corridor can be seen. In his Egyptian grammar, Champollion[2] suggested several variations: ⌐⌐ ⌐⌐ ⌐⌐ ⌐⌐ ⌐⌐. Champollion noted that the color of these shapes of buildings was blue.

In proto-Sinaitic script, the house or *bayit* or the letter *beth* is at first a simple square ⌐⌐. Sometimes there are several dots in the middle, which probably represent a fire burning in the hearth: ⌐⌐, ⌐⌐, or ⌐⌐.

The square opens up, a door appears . . . ⌐⌐ or ⌐⌐ or ⌐⌐ or ⌐⌐ or ⌐⌐ or ⌐⌐ or ⌐⌐.

The next shape will become the matrix for the most common form of the letter. This represents a perfect balance between the inside and the outside of the house: ⌐⌐ or ⌐⌐. This shape would undergo a 90° rotation, to become ⌐⌐.

Thus the letter passes from proto-Sinaitic into Ancient Hebrew and Phoenician, which offer a range of variations based on the preceding shape: ⌐⌐ or ⌐⌐ or ⌐⌐.

B

128

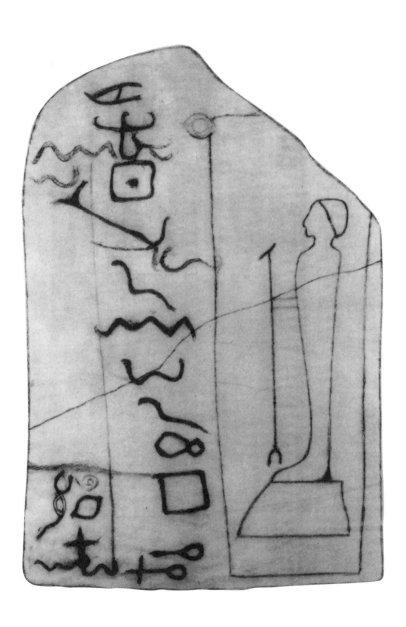

Proto-Sinaitic inscription No. 351

Inscription from Karatepe

The Transition to Greek Script

The transition from Phoenician and Hebrew to Greek, in other words the change from *beth* to *beta,* was performed in several stages by turning the letter round in various ways and accentuating the curve of the loops and lines. In the Thera inscription (eighth–seventh century B.C.E.) the following form is found: ⌐. This is the classic house shape, with an entrance whose top line is curved. The curve in the line is then closed into a loop: ⌐.

Nora inscription (9th century B.C.E.)

We thus have a loop and a triangle; in order to retain some sort of graphic uniformity, the scribes later chose to make both parts into a loop or both into a triangle: ꓷ (Archaic Greek, Crete, seventh century B.C.E.) or ◁ (Etruscan alphabet primer from Marsiliana). Like all the other letters of the alphabet, the *beta* changed direction and became B (eastern alphabet, Miletus), or ꓭ (western alphabet, Boeotia).

REMARKS

The following forms are also found in the Eastern Greek alphabet from Corinth: ꓶ *or* ꓡꓵ.

The B in our modern alphabet thus derives directly from the Greek B, which is identical to the Roman: B.

B

1. Pierre Grandet and Bernard Mathieu, *Cours d'égyptien hiéroglyphique* (Khéops, 1990), vol. 1, p. 14.

2. Champollion, *Principes généraux de l'écriture sacrée égyptienne* (Institut d'Orient, 1984), p. 11.

SUMMARY TABLE OF "B" DERIVED FROM *BETH*

B

NAME

B is the first letter of the word *bayit*, which, in Hebrew and the ancient Semitic languages, means "house."

**ORIGINAL FORMS
IN PROTO-SINAITIC**

Plan of dwelling, large room with or without a hearth, door open to some extent to the outside

**CLASSIC FORMS OF THE *BETH*
IN CLASSICAL AND MODERN HEBREW**

ב Square script ב Cursive script

In the definitive form of square Hebrew, the idea of the proto-Sinaitic script is retained: the plan of a house with the opening turned toward the letters to come, an opening into the future and the stranger who may come to the door. The cursive form is merely a stylization of the same shape.

ORIGINAL MEANINGS

Internalization; making room for the primal energy represented by *aleph* or A, the first letter.

DERIVATIVE MEANINGS

Inside, home, hearth, interior, intimate, nutrient, food, shelter, chamber, celestial vault, family life, married couple.

**ACQUIRED MEANING PERPETUATED BY
THE HEBREW LANGUAGE**

House, receptacle, family, dynasty, nation, tribe, school (of thought), metaphor for the womb.

The letter *beth* has the grammatical meaning of:

• inside, within
• when . . .
• with
• between, among
• because of, for
• according to

NUMERIC VALUE

2

B

Facing page: beth *in cursive Hebrew. Above: the B of Western alphabets.*

C

The C

The letter gimmel
Camel

*"The opposite sidewalk
calls to us. . . . It is the
most negative thing to
ignore the call of the
sidewalk opposite."*

Roberto Juarroz

The letter C, third letter of the alphabet, is derived from the third letter of the proto-Sinaitic alphabet: *gimmel.* The word *gimmel* comes from the word *gamal,* which means "camel." Thanks to its hump, the camel can retain water and cross the desert, the frontier. It is the vehicle that carries one into the beyond. It makes it possible to travel, and implies geographical separation and a psychological rift. As with the *aleph*-ox, the *gimmel* is primarily the drawing of a whole animal. It is a pictogram representing a camel. By reduction, the most important part of the drawing replaces the whole. The original artist/scribe chose the part of the drawing that was most representative of the camel. Was it its neck? Its hump? The commentators are divided on this issue; those who favor the neck extrapolate from the pictogram of the whole animal to the abbreviated pictogram, claiming to see the camel's neck in it: ⟍ ⟋⟍. Others see this as representing the hump.

C

Warrior carrying a boomerang

Février[1] expresses reservations about the camel, since he claims that it was only introduced into Semitic tradition and culture at a late date. Biblical texts clearly invalidate this claim. The camel is an animal that plays a full part in the Semitic landscape and has done so for a very long time, if one studies the proto-Sinaitic alphabet.

On the other hand, G. R. Driver[2] sees this letter as a "boomerang" of the type seen on Egyptian bas-reliefs. For our part, we cannot see any boomerang and we opt for the camel, and more particularly for its hump. This is a much more basic attribute than the neck and thus justifies the metonymy, meaning the taking of a salient feature to represent the whole. However,

according to many outlines of the letter, the elongation of the vertical line is more reminiscent of a camel's neck. In inscriptions 352 and 353 in proto-Sinaitic, we find the following form, which is neither neck nor hump: ⌞ ⌶ .

Benveniste[3] suggests that the *gimmel* can refer to either the hump or the neck. At any event, the original pictogram depicted a camel. From the paleographic point of view, an analysis of the documents shows that *gimmel* was not used very often in proto-Phoenician texts, with the exception of the Byblos inscription, which displays the complete twenty-two-letter alphabet. The graphic transformation of the *gimmel* is quite simple. After the proto-Sinaitic ⌐ or ⌞ or ⌶ the proto-Canaanite form of the thirteenth century B.C.E. is as follows: ∧, which eventually turns into ∧, then ⌐.

The Transition to Greek Script

The transition to Greek follows another reversal process: *gimmel* becomes *gamma*. The ⌐ (Hebrew *gimmel*) becomes Γ (Greek *gamma*), then Γ (Eastern Greek alphabet, Miletus), then ＜ or ⊂ or | (Corinth); this becomes Ρ (Western Greek alphabet, Boeotia), and then Γ (Classical Greek alphabet).

REMARK

It is easy to make the connection between the Archaic Phoenician and the Greek, but the transition from Greek to Roman Etruscan is more involved in the case of gamma. *The Etruscans did not use the "g" sound. They were incapable of pronouncing the voiced explosive "g." That is why they gave the third letter of the Greek alphabet,* gamma, *Γ, ＜, or ⊂, the phonetic value of K. Consequently, they used three signs to represent the sound "k": K in front of A (kay), C ＜*

in front of E and I (ca), and Q ♀ *in front of U (queue). This usage passed into archaic Latin, which is almost identical to Etruscan. The original K from primitive Latin survived in front of an A in a few words such as* kalendar, *the origin of the word* calendar. *The same three letters continue to represent the "k" sound in English: K, C, Q.*

The Etruscan influence on the Latin alphabet can be seen in the way that the Latins continued to use the Greek gamma, *written in the form of a C (as in the Greek alphabet of Corinth) to represent the "k" sound* (cena, cura, catena, civis, corium), *just as the Etruscans had done.*

Originally, the Latin letter C was pronounced "k," as in caesar, *from which the German word* Kaiser *and the Hebrew word* kessar *derive, but it could also be pronounced "g" as in* Caius, *pronounced "Gaius." In c. 250 B.C.E., the Romans introduced a new letter, the G, which was merely a modified C, in order to be able to give the voiced explosive G a letter of its own. To avoid changing the order of the alphabet, the new letter G replaced the Greek letter Z (zeta), which the Latins had inherited but did not use, so that there was a gap. Later, sometime in the first century B.C.E., when closer contact with the Greeks made it necessary to transcribe Greek words, the Latins once again incorporated the Z into the alphabet.[4] Since it had lost its place, it was added at the end, where it remains to this day.[5] That is how the* gimmel *evolved from the proto-Sinaitic camel's neck or hump,* ∧ *or* ⟍ *, via the Archaic Phoenician* ⟍ *, then through the Greek* gamma, *Γ or ⟨ or C, which became C (pronounced "k") in Etruscan C. It then became "gu" again in Latin, written with a slight modification to distinguish it from "ka" (a little bar and a curve were added):* Ǥ G *.*

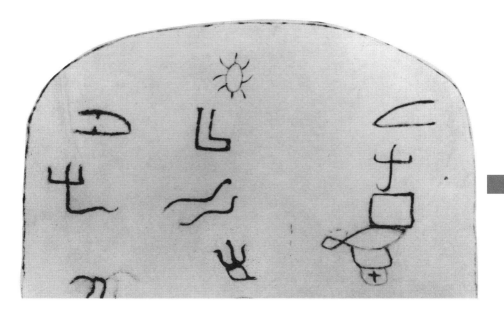

Proto-Sinaitic inscription No. 353 (according to Grimme)

141

C

1. J.-G. Février, *Histoire de l'écriture* (Payot, 1984).
2. G. R. Driver, *Semitic Writing, from Pictograph to Alphabet* (Oxford University Press, new edition, 1976), p. 163. Albright makes the same suggestion.
3. Léon Benveniste, "L'écriture est née au Sinai," photocopied thesis, 1966.
4. In relation to the Hebrew alphabet, the new letter G occupies exactly the same place as the *zayin*, which is pronounced "zee" or with phonetic distortion like the French J or like the S in "leisure" or "pleasure."
If there is any logic in the sequence of letters and if the fourth letter is a fish, as some authors maintain, the third letter might be a sort of fishing pole or harpoon that could be used to catch fish by striking the fish with the instrument in the water.

In fact, Modern Hebrew transcribes the "j" sound using a *zayin* with a small diacritical mark like an apostrophe. Modern Hebrew represents the soft "g" or English "j" using a *gimmel* with the same diacritical sign. Neither of these sounds exist in Hebrew, but they are needed to represent sounds in foreign words.
5. On the Etruscans, see Larissa Bonfante, "L'étrusque," in *La Naissance des écritures*, Seuil, 1994, p. 405–482. See also J.-G. Février, *Histoire de l'écriture*, Chapter XI, "Les Alphabets étrusques et italiques," pp. 440–73 (Payot, 1984).

SUMMARY TABLE OF "C" DERIVED FROM *GIMMEL*

NAME

C was once a G, the first letter of the word *gimmel*, derived from *gamal*, which means "camel" in Hebrew.

**ORIGINAL FORMS
IN PROTO-SINAITIC**

Camel, camel's neck, camel's hump.

**CLASSIC FORMS OF THE *GIMMEL*
IN CLASSICAL AND MODERN HEBREW**

ℷ Square script ᴳ Cursive script

This definitive form of the square writing shows the link with proto-Sinaitic in the following manner: the camel's hump ⌒ is written by extending the first upward stroke ∟ or ∖, which produces ⋋ or ∖.

ORIGINAL MEANINGS

Carrying the primal power beyond, outside the domestic setting.

DERIVATIVE MEANINGS

Outgoing, break, carry to another, do good, return a favor.

**ACQUIRED MEANINGS PERPETUATED
BY THE HEBREW LANGUAGE**

• ripen, wean, enable to ripen
• release oneself, break away from
• reward, give like for like, do good, compensation
• pension, retirement, superannuation (this meaning is directly derived from the idea of the camel, which drinks a lot before going into the desert, where it will not be able to find water). Payment toward retirement is a "camel-like" behavior
• severance, weaning

After the primal strength (the *aleph*) and the place made for it (the *beth*), this strength must be given the possibility of expressing itself, going out, deploying itself, going beyond itself, opening up to the outside, crossing the expanses of the desert in order to discover new lands, leaving the autarky of the house, breaking the ties of the family home, the womb, finding one's own way. . . . This important plan may be put into action through the third letter of the alphabet, the *gimmel*.

NUMERIC VALUE

3

C

Facing page: gimmel *in cursive Hebrew. Above: the C of Western alphabets.*

D

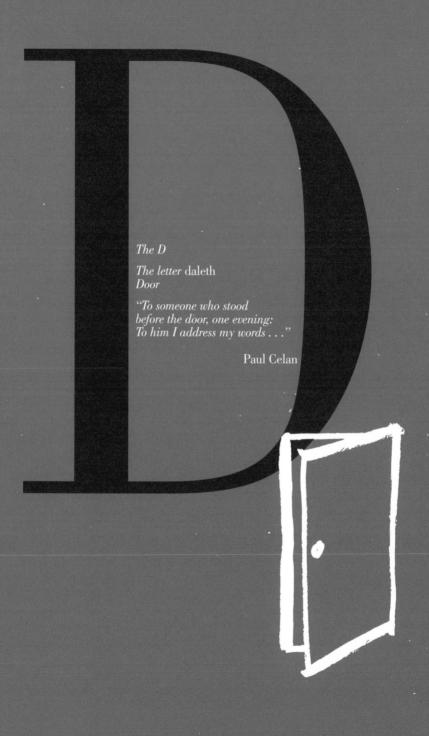

The D

The letter daleth
Door

*"To someone who stood
before the door, one evening:
To him I address my words . . ."*

Paul Celan

The letter D, the fourth letter of the alphabet, is derived from the fourth letter of the proto-Sinaitic alphabet, *daleth,* which means "door" in Hebrew.

The letter *daleth* represents a door. Some commentators[1] see it rather as a woman's breast (*dad* in Classical Hebrew). The Egyptian glyph for a door is encountered in the following forms: ⟨ or ⟨⟨ .

This letter rarely appears in proto-Sinaitic script, but it is used on an inscription on a sphinx[2] meaning "reserved for Baalat."

Proto-Sinaitic inscription No. 345

D

The frame and leaf of the door can be seen, but the circle, the ring at the far left of the drawing, looks more like a key. The Egyptian and proto-Sinaitic forms are found in south Semitic alphabets[3] such as Sabean (ᛉ), Thamudean (ᛋ), and Safaitic (ᛏ). The difference between the rectangular ⟼ and the triangular △ form is probably explained by the difference in the architecture of the sedentary city dweller, whose door is a square or rectangle on a doorframe, and the nomad, whose "door" is a triangular tent-flap made of skin. Some people see the triangle as representing a fish head, *dag,* whose acrophony also offers the "d" sound: ⬟, ◁, ◁. Door, woman's breast, or fish head? The memory of the language transmits the idea of a door, *deleth,* which has given its name to the letter. The inscriptions at Gebal (Byblos)[4] represent it as ⟨ or ⟨ or ⟨ or ⟨ or △.

The axis of the doorway is still present, but the door itself has become triangular. By reduction, the axis has disappeared and only the leaf remains, which is subject to the following variations[5] in proto-Canaanite (1200–1050 B.C.E.): △ or ▽ or ▷ or ◁; sometimes turning into: ◁ (Hebraic ostraca of the sixth century B.C.E.), △ (archaic Aramaic).[6]

REMARKS

We agree with most of the commentators that the letter daleth, delta, *D, represents a door, as the Hebrew name implies. However,*

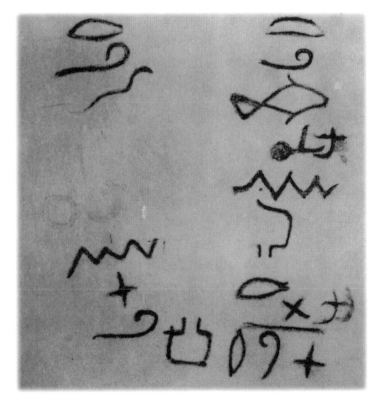

Proto-Sinaitic inscription No. 345 (after Grimme)

the daleth*–female breast hypothesis, or some connection with the female gender, cannot be ruled out. For instance, there is the similarity of shape between the* daleth *and the cuneiform sign of the pubic triangle, the sign for a woman,*[7] *which also developed by changing its orientation:* ◁. *Incidentally, there is a basic connection between writing and the female principle. The marks made by the "nails" of cuneiform script all reproduce the pubic triangle:* ▷— *(the basic shape of cuneiform writing is a triangle + a line).*

One can even see a connection between the triangle and the line, between the pubic triangle and the phallus. It should also be noted that the Ugaritic alphabet (cuneiform dating from the fourteenth century B.C.E.*)*[8] *contained three letters shaped respectively like a nail, a triangle plus a line, and a triangle on its own:* ⊤ *(letter G);* ◁ *(letter* ayin*);* ▷— *(letter T);* ⊤ *(word separator).*

The relationship between the daleth *and the female principle is evident in a text such as the* Song of Songs, *which uses the metaphor of the opening and the lock to designate the sex of the beloved:* "I rose up to open to my beloved; and my hands dropped with myrrh and my fingers with sweet smelling myrrh, upon the handles of the lock."[9]

The female genitalia are depicted, no doubt by displacement, in the image of the breasts. The pubic triangle, which is pronounced ayin, *"eye" in Ugaritic, no longer being visible, is rounded and the* ▽ *becomes* ▽, *the nourishing breast of the woman. The Greek* △ *or* △ *becomes the Etruscan* ◁ *and the Roman* D, *i.e., in Latin. The representation of parts of the body is not unusual in proto-Sinaitic, as will be seen in the case of the hand, eye, and mouth. Egyptian hieroglyphics has a sign representing the male genitalia* ⌒[10], *which is a biliteral phonogram (denoting two consonants and pronounced* met*). There is also a sign representing a woman's breast* ▽

150

as well as a uniliteral phonogram for the placenta ⬤ *and another for the vulva of a cow* ✳︎⟜ .[11]

The verb "to suckle" is written like this: ⌒ ⩙ △ ▽ .

The "nipples" are written like this: ⊔ ⌣⌣ ◺ .

The ▽ *sign is a determinative that indicates the semantic category to which the word in question belongs.*[12]

So that "wet-nurse" is written: ⊔ ⌒◦ ∿∿∿ ▽ .[13]

The Transition to Greek Script

The Greeks inherited their letter *delta* directly from the proto-Canaanite *dalet*, though they first hesitated about the direction and whether to make the shape more rounded, as in △ or ◁ or ◁, finally settling on a triangle with the point upward: △ .[14]

Etruscan, as can be seen from the alphabet primer from Marsiliana[15] in which the writing is still left-facing, contains a *delta* that uses the same shape as the Greek before its direction was changed in the script: ◁ (Etruscan *delta,* Marsiliana).

The transition to Latin was made while again changing the direction of the script, as had been done in Greek, and we thus obtain the D we know today: ⅅ .

D

1. For example, P. Lidzbarski quoted by J.-G. Février, *Histoire de l'écriture* (Payot, 1984), p. 227.

2. Numbered 345 in the proto-Sinaitic inscriptions.

3. The name of South Semitic Alphabet has been given to a group of consonantic scripts that were used during the first millennium B.C.E. to record dialects that were similar to Modern Arabic.

Cf. J.-G. Février, *Histoire de l'écriture*, p. 280 ff., and table, p. 279.

4. Driver, *Semitic Writing from Pictograph to Alphabet* (Oxford University Press, new edition, 1976), p. 142 (table).

5. Cf. Naveh, *Early History of the Alphabet* (Magnes, 1987), p. 180 (table).

6. Cf. J. F. Healey, *Early Alphabet (Reading the Past*, vol. 9) (University of California Press, 1991), p. 284 (table).

7. See the table by S. N. Kramer, *L'histoire commença à Summer,* Paris, Arthaud, 1957, p. 296, used again by J. Bottéro, *Mésopotamie, l'écriture, la raison et les dieux,* Gallimard, 1984, p. 93; see also *Naissance de l'écriture,* Éditions de la Réunion des Musées Nationaux, Paris, 1982, p. 97.

8. In 1929, the French digs at Ugarit (Ras Shamra) on the Syrian coast led to the unexpected discovery of a new cuneiform script dating from the fourteenth century B.C.E., which was different from the Sumerian and Babylonian. It is clearly alphabetic and consists of thirty signs and a word separator. It was deciphered in one year by H. Bauer, E. Dhorme, and C.Virolleaud, and proved to be a language similar to Hebrew. The order of the alphabet is known from a few tablets on which teachers or students had copied out their letters in the correct order, which is practically identical to Hebrew and Phoenician. This alphabet was the origin of a shorter, twenty-two-letter cuneiform alphabet.

9. The Song of Songs, v:5.

10. See Pierre Grandet and Bernard Mathieu, *Cours d'égyptien hiéroglyphique,* p. 27.

11. Ibid., p. 14.

12. Champollion, *Principes généraux de l'écriture sacrée égyptienne*, pp. 93, 539.

13. Ibid., p. 80.

14. Cf. Naveh, *Early History of the Alphabet,* p. 142 (table); Février, *Histoire de l'écriture*, p. 396 (table); and J. F. Healey, *Early Alphabet,* p. 334 (table).

15. Cf. Bonfante, "L'étrusque," in *La Naissance des écritures* (Seuil, 1994), p. 409 (map) and 420 (table); see also p. 416.

Etruscan appears to have used a right-to-left direction for writing for longer than Greek. The transition from Etruscan to Latin produces a reversal in all cases.

SUMMARY TABLE OF "D" DERIVED FROM *DALETH*

D

NAME
D is the first letter of the word *daleth*, which in Hebrew means "door," "opening."

ORIGINAL FORMS IN PROTO-SINAITIC
The leaf of a door on a vertical axis, key, triangular opening, door, female genitalia (the pubic triangle), or woman's breast.

CLASSIC FORMS OF THE *DALETH* IN CLASSICAL AND MODERN HEBREW
ד Square script ך Cursive script
In this definitive form, the *daleth* depicts a door, with a vertical frame and top lintel. The cursive is similar but more rounded.

ORIGINAL MEANINGS
Door and opening. The two forms, door and breast, articulate with the letter *gimmel*, which expresses the concept of weaning, leaving the breast to open the door to independent being.

DERIVATIVE MEANINGS
Circulation, flowing, resulting from, descent, abundance, to disseminate, to pour, to draw (water), flux, enter, leave, bucket, pail, humility.

ACQUIRED MEANINGS PERPETUATED BY THE HEBREW LANGUAGE
Opening, door, corner of the mouth, poor, indigent, weak, thin *(dal)*, weaken, diminish *(dillel)*, unravel, detach *(dildel)*, plebian, braid and curl *(dala)*, to draw (water), withdraw, remove *(dola)*, issue, save, branch *(dalit)*, to be impoverished, reduce, dilute *(dalal)*.

NUMERIC VALUE
4

D

D

Facing page: cursive Hebrew daleth. *Above: the D of Western alphabets.*

E

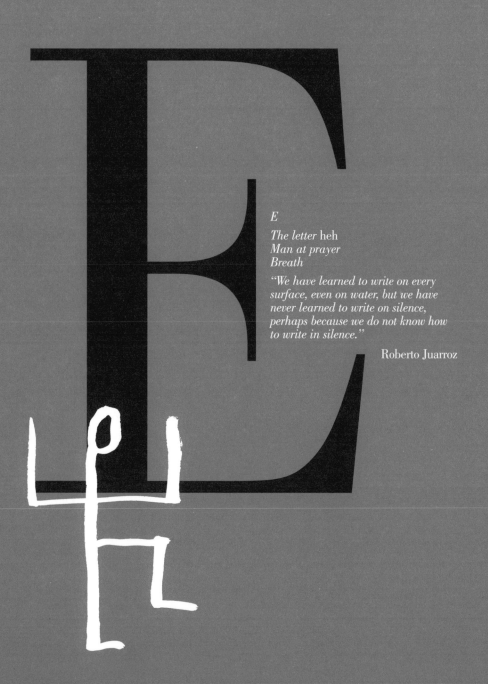

E

The letter heh
Man at prayer
Breath

*"We have learned to write on every
surface, even on water, but we have
never learned to write on silence,
perhaps because we do not know how
to write in silence."*

Roberto Juarroz

E is the fifth letter of the alphabet and is directly derived from the fifth letter of the proto-Sinaitic alphabet: the *heh*. The letter *heh* originates from the following proto-Sinaitic pictogram: ҷ, which declines into ҷ or ҷ and even into ҷ or ҷ or ҷ.

Breath and a Man at Prayer

The variants of this pictogram all represent a man at prayer, standing, sitting, or walking, his arms raised heavenward. Prayer is translated by an invocation whose melody becomes the natural sound of breath and breathing, "heh" . . . hence the name of the letter: *heh*.

From Proto-Sinaitic to Hebrew and Phoenician

The letter *heh* evolved in the same way that was explained earlier, that is, by "iconic reduction," switching over and reversing the direction of the script. Thus the man at prayer retains the essential meaning of his shape — the arms raised heavenward, imploring or praising . The lower part of the body is no longer indicated. The form ҷ or ҷ becomes Ш, then the "head" disappears as well: Ш.

In the tenth century B.C.E., Phoenician script had already shifted to the left, and this is where the ancient form of Hebrew writing known as *ktav ivri* originates; the three lines for the arms and head are still clearly recognizable. However, an additional line appears at the bottom of the letter, extending the vertical one, producing the following shape: ヨ; then the *heh* leans to the left: ⅄. In later centuries the lower lines tended to become detached, especially in Phoenician and Aramaic, to produce the shapes: ⅄ ⅄

In the eighth century B.C.E. there is a development that changes the letter from the original ⅄ to the ancestor of the classic Hebrew

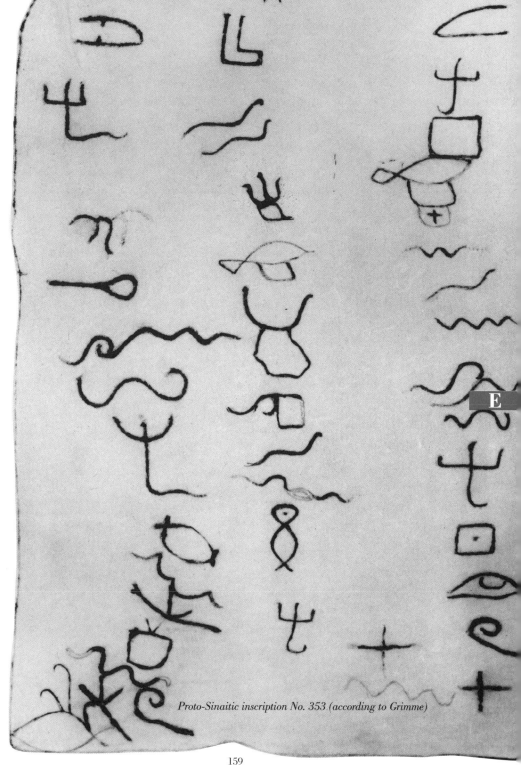

Proto-Sinaitic inscription No. 353 (according to Grimme)

square writing of today: 🗚, which sometimes becomes 🗚 🗚, which could be confused with the letter *het.*

In general, Hebrew has retained the classic form of the *heh:* 🗚. The major change occurred during the First Temple period, between the eighth and seventh centuries B.C.E.; the top bar was elongated to the right: 🗚.

From Hebrew and Phoenician to Greek

In the oldest known Greek inscriptions, which date from the eighth century B.C.E., the *heh* becomes an *epsilon* but retains exactly the same shape as in Ancient Hebrew and Phoenician: 🗚. But a Greek writing a boustrophedon, that is to say one line going from right to left and the next in the reverse direction, would also turn the *heh-epsilon* into 🗚. This shape then stabilized in the fifth century B.C.E. into its classic form, by losing the lower line: E. This is the shape that passed into Latin and the alphabets of the western European languages that we use today.

Seal from the City of David

REMARK

Etruscan, which is written from right to left, contains a heh *with a line at the top and offers the following variations:*

| Equivalent letter | Marsiliana (1) | Viterbo | Caere | Formello (a) | Ruselle | Chiusi (b) | Chiusi (c) | Bomarzo | Nola (b) | Nola (a) |
|---|---|---|---|---|---|---|---|---|---|---|
| e | ⅄ | E | ቶ | ቶ | ⅂ | Ƹ | Ƹ | Ⅎ | Ⅎ | Ⅎ |

| | Subalpine Alphabets | | | | Felsinian | | Venetian | Archaic Etruscan alphabet from Marsiliana |
|---|---|---|---|---|---|---|---|---|
| | Bolzano | Magrè | Sondrio | Lugano | Fonderia | Corneto | (Este) | |
| e | ⅄⅂Ⅎ | Ⅎ⅂Ƴ | ⅂ Ⅎ | ⅄⅁Ⅎ | ɯ E | Ƹ. | Ⅎ | .⅄ |

Table based on that produced by Février (p. 447 and 450)

The Ethos of the *Heh*

When we currently read a word that contains an E, such as "evolve," for instance, this letter takes us back to the man at prayer whose arms are no longer turned upward to invoke the deity but sideways, passing from vertical to horizontal, from transcendence directed towards the divinity to transcendence turned to face another person. It is a discovery that the godhead is in every human being, a concept favored by Lévinas. Humility before the grandeur of the other person, translated into "prostration," turns the image from the vertical to the horizontal, from prayer to greeting. The Ɛ becomes ⅄ ⅔ which eventually reverses itself ⅂ to become a vowel in its transition from Hebrew and Phoenician to Greek: *epsilon;* and finally into the E of Western languages.

In the square version, this produces:

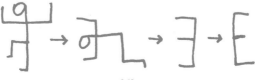

E

1. The grammatical uses of the *heh* result logically from an analysis of the void:

Female in Hebrew is *neqeva*, that is to say, "the gap or void."

There is an empty-full, feminine-masculine sexual dialectic based on the space, "the void," of the female. The direction indicates somewhere to which we are going but which we have not yet reached, somewhere that is still devoid of our presence. The relationship between the void and the question is almost apparent.

We question because there is a gap, a void in our knowledge.

SUMMARY TABLE OF "E" DERIVED FROM *HEH*

E

NAME
E is derived from the proto-Sinaitic *heh;* it is the sound of the breath, the original sound of prayer.

**ORIGINAL FORMS
IN PROTO-SINAITIC**
Man at prayer standing or sitting, both arms raised to the heavens in a gesture invoking the deity.

**CLASSIC FORMS OF
THE HEH IN CLASSICAL AND
MODERN HEBREW**
ה Square script ﬠ Cursive script

ORIGINAL MEANINGS
Breath, cry, prayer, interjection: hey! With the letter *heh* we gain access to the first breath with which a human being can begin his existence, with a rhythm and power that are constantly renewed.

DERIVATIVE MEANINGS
Breathing, to breathe, snore, breath, to blow, soul, wind, life, out of breath and out of energy, the sign of the feminine, of direction, and of a question.[1]

**ACQUIRED MEANINGS PERPETUATED
BY THE HEBREW LANGUAGE**
• here is
• yet
• the definitive article
• interrogative preposition
• suffix indicating the feminine and direction

NUMERIC VALUE
5

E

E

Facing page: heh *in cursive Hebrew. Above: the E of Western alphabets.*

F

The F

The letter vav
The nail
The link

"Sex is always a
vowel."

E. Jabès

The letter F, sixth letter of the alphabet, is derived from the sixth letter of the proto-Sinaitic alphabet: *vav*. Its origins are the same as for the letters U, V, and W in our modern alphabet.

Proto-Sinaitic Script

The *vav* is pronounced like a V as in *vehicle*. In Hebrew *vav* means "nail" or "hook." It is used to join two parties and keep them together. According to Février, the ancient form, which looked like this: Ψ, is also reminiscent of the "bracket that supports a folded ship's mast or the headrest that was used instead of a pillow."[1] In fact, the following form is encountered first, especially in hieroglyphics and in proto-Sinaitic: ? or —o . This signifies a "burden," a sort of hammer, or an "oar." The shape that occurs most frequently, however, is the Y then Ч, a sort of upside-down "h." The evolution of the letter produced an extension of the downward stroke: Ү.

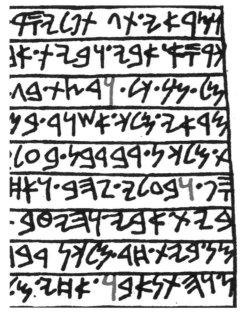

Bar Rakoub inscription

In a script similar to that of the Phoenician alphabet, this letter is clearly discernible in the Bar Rakoub inscription (late eighth century B.C.E.).

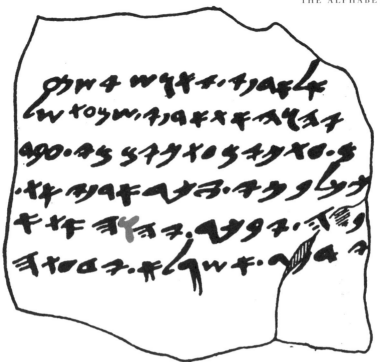

Letter from Tel ed-Duweir

F

Here is a letter from Tel ed-Duweir (early sixth century B.C.E.); the fifth line contains the Tetragramnon *Yod-heh-vav-heh.* The *vav* retains its original shape: Y.

The same expression appears on the second line; the first four letters write the Tetragramnon using a slightly different *vav*, looking more like the upside-down "h" we mentioned: Y. In Classical Hebrew, the shape of the *vav* was simplified and became a mere vertical line with a little curve at the top: ꓶ; or with a tiny circle at the top end, adopting the original proto-Sinaitic form: ꓽ; or, in more stylized form, ꓼ.

The Transition to Greek Script

The transition to Archaic Greek script was quite simple. The Y first became a Y and was bent to the left: ꒓ (Crete); ꒕ (Boeotia). Then the diagonal stroke became detached and dropped, until it was parallel with the upper stroke: ꒓ and ꒕.

In the Etruscan alphabet, the lower stroke is shortened but the two horizontal strokes are slightly at an angle: ꒓. When the letter was reversed from left to right, it took the modern form of F.

REMARK ABOUT THE PRONUNCIATION AND POSITION OF THE LETTER IN THE ALPHABET

The vav Y became ꒕ in Ancient Greek, bearing the name of digamma *and being pronounced "v" as in* vehicle. *The letter* digamma *disappeared from the Classical Greek alphabet and the "f" sound was produced by the letter ꓯ (phi), which was added to the end of the original Phoenician-derived alphabet.*

The Etruscans had an "f" sound, pronounced like the soft "f" in find, stuff. *At first, the Greeks did not know this sound and had no letter to represent it. In the beginning, the Etruscans used the letters for V and H as a rough transcription, but they later introduced a new sign, ꧉, whose origin is obscure. The Latins, however, retained the first element of* vh, *the letter which is now used to transcribe the "f" sound.*

The Etruscan ꒡, digamma, was a bilabial like the W or the Latin V, as in vincit. *There is no "v" sound in Greek; it is replaced by the vowel U but the* upsilon *has retained a memory of the ancient Semitic vav in its shape: Y.*

170

The Greek I can be found today in all the sounds that are close to the "u," the "i," "y," and "oo" and occasionally even "v" or "w."

German illustrates the closeness of vav and F because the German V is pronounced like an "f" as in Volk (people or folk), the "v" sound being rendered by the "double u" ("w"). The shape of the letter V in Latin is a reduction of the Υ from which the bottom stroke has been removed, retaining only the upper V. The � (oar, nail) became Υ, then ᚤ and ᚦ, ᚠ, reversed as the F we know today.

F

1. Février, *Histoire de l'écriture* (Payot, 1984), p. 227.

SUMMARY TABLE OF "F" DERIVED FROM *VAV*

NAME
F is a phonetic variant on the first letter of the word *vav,* which means "nail" in Hebrew.

ORIGINAL FORMS IN PROTO-SINAITIC
The *vav* is firstly an oar that makes it possible to drive the ship or boat and thus link the opposite banks of the river or two continents; it also means a burden or load (less probable meaning).

CLASSIC FORMS OF THE *VAV* IN CLASSICAL AND MODERN HEBREW
� Square script / Cursive script

ORIGINAL MEANINGS
Hook, oar, nail, attachment, suspension.

DERIVATIVE MEANINGS
Coordination, junction, meeting-point, the phallus, channel, pipe, column, finger. According to Benveniste, there is also a concept of light in the *vav,* meaning "vis-

ible, voice, view, illuminate, truth, shine." We have found no reference to these various meanings in the classic texts; neither the shape nor the etymology contain anything to justify this theory.

The Symbolism of the *Vav*
The Kabbalah first analyzes the *vav* in its current graphic form: ﬁ . This vertical line is the sign of the descent of divine energy downward, a meeting point between the transcendence of humans and the immanence of God. On the physical plane, the *vav,* often called *tsinor,* "channel," represents the various conduits by means of which the body can receive from the outside and exchange with the outside; thus the *vav* may represent either the esophagus, the trachea, the artery, or the spine in which nutritional and respiratory energy circulate, as do the nerve pulses. It is also

the male genitalia that permit coitus and build life based on the encounter. The original meaning of the *vav* is probably best preserved in Hebrew grammar. In Hebrew the *vav* performs several grammatical functions.

The first is to indicate the male gender in the third person singular; for example, *lo (lamed-vav)* means "to him" or "for him." In another example, if *yad* means "hand," *yado* (i.e. *yad + vav*) means "his hand." This grammatically masculine letter may be the linguistic translation of a male sex symbol, the phallic symbol used for the purposes of grammar.

The *vav* is also used grammatically as a conjunction, a "junction" or "link." This is the "*vav hahibur*," the connective *vav*; it is the equivalent of the English *and*. It is placed at the beginning of a word, a proper noun or a common noun, verb or adjective. It adds, specifies, and completes the meaning.

Examples

• "The man and his hand": *Ha-adam veyado.*
• "The man and his wife": *Ha-ish veishto.*
• "Heaven and earth": *Et hashamayim ve-et haaretz.*

In hieroglyphics, the phallus, the male genital that enables union with woman, is pronounced *mt* and is drawn: ⟲ (the penis with its two testicles). The *vav* indicates the masculine and the possibility of union. From the grammatical point of view, the *vav* has a third function, which is the inversion of time; this is known as the "conversive *vav*." Placed in front of a verb in the past tense, it converts the verb to a future tense; and placed in front of a verb in the future, it evokes the past. Thus, for example, *haya* means "it was"; *ve-haya (vav + haya)* translates as "and it will be."

ACQUIRED MEANINGS PERPETUATED BY THE HEBREW LANGUAGE
Nail, hook, pious.

NUMERIC VALUE
6

F

Facing page: cursive Hebrew vav. *Above: the F of Western alphabets.*

G

The G
The letter zayin
The letter Z

Confrontation
Face-to-face encounter

"Vowe, in the green
of the streaky stretch of
water.
When the kingfisher dives
the second vibrates."

Paul Celan

The letter G, seventh letter of the alphabet, is derived from the seventh letter of the proto-Sinaitic alphabet: the *zayin*.[1]

From Proto-Sinaitic to Phoenician

Zayin in Hebrew means "weapon" and is pronounced like a "z." In the proto-Sinaitic inscriptions the *zayin* has two forms, either ⌒ or ⌒⊏ . The evolution is fairly plain: the two main lines separate, becoming more or less parallel, and now the vertical line unites or separates them: ⊤ , ⊥, or I . For example, in the Yehimilk inscription found at Byblos and dating from the twelfth century B.C.E., the third letter is a *zayin* in the shape of an ⊥ , which looks very much like the capital letter I of the modern alphabet.

The Elibaal (Byblos) inscription also contains this type of *zayin*. According to Menahem Kasher,[2] the proto-Sinaitic was reduced to two parallel horizontal lines ‒‒ , which are found in the Lakhish scrolls in a more rounded form: ⌒ , or sometimes ⌒ , or even I⌒ . The handwritten copies made by Flinders Petrie[3] and E. Puech[4] offer the version consisting of two parallel horizontal lines: ‒‒ . The most frequently found form is thus that which consists of two horizontal lines, which may or may not be linked by a vertical stroke.

Elibaal inscription (sixth century B.C.E.)

The *zayin* definitely represents a face-to-face encounter between two individuals, two armies, or two situations. This conflict may be translated by putting the weapons to use or by the peaceful resolution of the conflict. Each

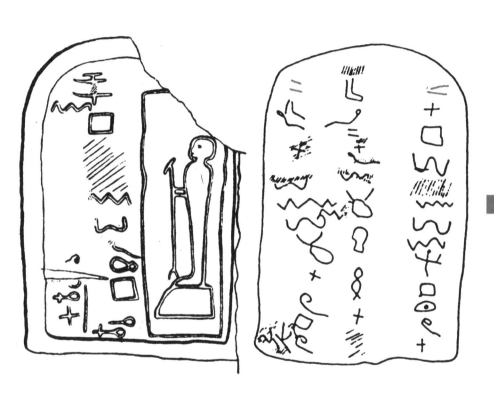

Copies of proto-Sinaitic inscriptions (Petrie and Puech)

G

179

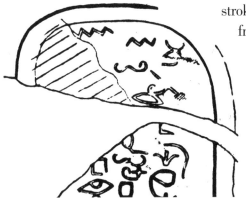

stroke represents an army that confronts its enemy, hence the derivative meaning of *zayin* "to be armed," "to arm oneself." Some scholars have suggested a link between *zayin* and the Egyptian hieroglyphic that represents "skin pierced with an arrow" and which is pronounced "st": .[5]

Proto-Sinaitic inscription

According to this theory, which is quoted by Benveniste, the sign was subsequently transformed into a plain arrow: ; then into an H and into the T that is found in proto-Canaanite (1200–1050 B.C.E.) and ⊥ or ⎓, which is found in proto-Sinaitic (1400 B.C.E.). According to J. Naveh, the development was as follows: based on the hieroglyphic arrow, one encounters I, then I (tenth century B.C.E.), then ⊥ (ninth century B.C.E.). The vertical stroke becomes a diagonal producing our modern letter Z: Z (eighth century B.C.E., Aramaic script).

In Phoenician, the *zayin* is only written in this way from the sixth century B.C.E.; the two horizontal strokes are not of equal length: Z (Phoenician *zayin*, sixth century B.C.E.). This Phoenician Z evolved into N, then M, then into M. The Aramaic Z changed into ∿ ∿, then ∿, and finally ∖.

In Hebrew, it changed from the I to I (eighth century B.C.E.) and then into I (seventh century B.C.E.) and (sixth century B.C.E.) and .

Yehimilk's inscription from Byblos

The Transition to Greek Script

Ancient Greek scripts originally used the classic form of Ⅰ (Corinth, Athens, Argos, Ionia) to become the letter that we know today: Ζ (Classical Greek).

REMARK

In Greek, the zayin *is called* zeta. *There is a clear connection between the words* zayin *and* zeta, *since the Greek letters have used the same letter order as the Phoenician, Canaanite, and Hebrew signs from which they derive, within the alphabetic sequence.* Zayin *is the seventh letter of the Hebrew and Phoenician alphabet, just as* zeta *is the seventh letter of the Greek alphabet.*

From Greek to the Western European Languages

The Ⅰ sign is preserved in the Etruscan alphabets with a few minor variations; there is no Z in Etruscan: Ⅰ (fifth century B.C.E.), Ⅰ, Ⅼ (Etruscan, fourth–first century B.C.E.). After disappearing for two centuries, the sign reemerged in the Greek alphabet of Athens in its classical form, as *zeta*. The character then fell into disuse again in the ancient Latin alphabets due to a change in pronunciation. The censor Caecus deleted it from the Roman alphabet in about 310 B.C.E., replacing it with the letter G.

Linguistic necessity caused the rehabilitation of the Z, which was reincorporated into the modern Latin alphabet. But the seventh place had been taken by G, so it was relegated to last place, as it was an additional letter: Ζ .

G

Vase from Hadra (third century B.C.E.)

Stone stele written in Etruscan originating from Lemnis (sixth century B.C.E.)

SUMMARY OF THE EVOLUTION

$↗$ $↑$ $= I \; I$ or $Z ⊰$ *after the* G *was reversed.*
G *is in seventh place and* Z *is last in the alphabet.*

The route we have taken in this chapter has emphasized the link between the zayin and Z, for which the letter G was substituted. The letter in the Western alphabet that best corresponds to the zayin can thus be either Z or G.

G

1. The letter G is sometimes pronounced as a hard "g," as in "bug" or "guard."
We showed earlier, in chapter 3, how the hard "g" is derived from the letter *gimmel*
(camel). However the "g" sound is a variant of "z" (*zayin* in Hebrew).
The *zayin* changes to *zéta* in Greek and to G in western European languages.
One can only understand the G on the basis of the *zayin*; the fact that G is the seventh letter of the
alphabet like the *zayin* is the best proof of their equivalence, quite apart from the phonetic aspect.
2. Torah Shlemah, pp. 60, 61, ibid., p. 56.
3. Reported by H. Grimme, *Die Altsinaitischen Buchstaben-Inschriften* (Berlin, 1929), Plate III of the appendix.
4. Emile Puech, "Origine de l'alphabet," *Revue biblique* 93 (1986), pp. 161, 213, see p. 188.
5. P. Grandet and B. Mathieu, *Cours d'égyptien hiéroglyphe* (Khéops, 1990), p. 27.
6. Volume I (Jerusalem, 1982), p. 336.

SUMMARY TABLE OF "G" DERIVED FROM *ZAYIN*

G

NAME

G comes from Z, the first letter of the word *zayin*, which in Hebrew means "weapon" or "ornament."

**ORIGINAL FORMS
IN PROTO-SINAITIC**

The *zayin* is firstly an arrow, which is schematically reduced to three lines: \mathcal{I} . It is a weapon, or two armies confronting each other, hence the recurring aspect of two parallel lines.

**CLASSIC FORMS OF THE *ZAYIN*
IN CLASSICAL AND MODERN HEBREW**

ז Square script ﬤ Cursive script

ORIGINAL MEANINGS

The arrow is a weapon, which implies a distance to be traveled; war.

DERIVATIVE MEANINGS

War, conflict, confrontation, revolution, fracture, distance, change, movement, crossing, to cross, quit, to move away, interval, energization, to challenge, questioning inadequacy, the logic of contradiction.

The Hebrew word *zaz* (a double *zayin*) means "to move." The *Even Shoshan*[6] dictionary links *zaz* with *zaazoua*, shock; *zazéa*, to cause to shake.

The *zayin* is also a dimunitive of *zeh* or *zo*, meaning "this [is]" or "that [is]." It is the pointing hand or finger, the indication of a remote object whose distance does not permit it to be perceived immediately.

If the *zayin* represents weapons and war, this is the ontological sense: a shattering of unity, a fundamental multiplicity that deploys time, the seven days of the week, the multiplicity broken down into the figure 70: seventy languages, the Septuagint, seventy faces of commentary.

The numeric value of the *zayin* is seven. War means a rejection of identity, the reduction of the multiple to a single unit, war as a condition of fertile otherness, the right of each person to individual self-expression.

War that is peace since there is distance and closeness, and not confusion. The *zayin* is war, that is to say, paradoxically, the appeasement of violence by recognizing the singularity of the other party.

**ACQUIRED MEANINGS PERPETUATED
BY THE HEBREW LANGUAGE**

Weapon, ornament, a vulgar word for the male sexual organ.

NUMERIC VALUE

7

G

Facing page: cursive Hebrew zayin. Above: the G of Western alphabets.

H

The H
The letter het
Barrier
Enclosure

"He who loses
himself in passion
has lost less than
he who loses
his passion."

St. Augustine

H

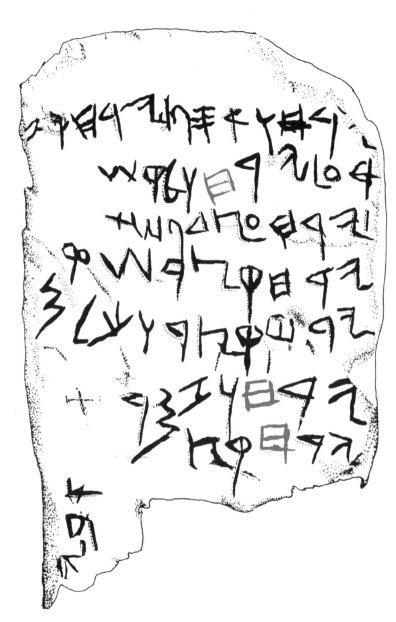

The Gezer calendar (tenth century B.C.E.), which contains a lot of Hs

H is the eighth letter of the alphabet and originates from the eighth letter of the proto-Sinaitic alphabet, the *het*. We do not know why, but the proto-Sinaitic H took the form of a lotus flower: ⌐ or �ↄ.

Closure, Sin, and Enclosure

According to the majority of texts discovered, the original sign on which the H is based was written ⵏ, and it appears as early as proto-Canaanite script (thirteenth century B.C.E.). The pictographic meaning is clear: it means an "enclosure," a "closing," a "barrier," a "wall," which was no doubt designed to stop the *aleph*-ox from escaping.

The Graphic Development of the *Het*

The H has undergone a very simple change and still retains the memory of its original shape. One of the basic changes, which applies to so many letters, is a 90° turn, producing an 目 or 目. Later, the following forms are encountered: 目 or 目. It is a rectangle divided in half by a cross-piece, and the vertical strokes may or may not be longer than the horizontals. This shape tended to disappear and was replaced by this one: 目. A three-bar enclosure often competes with the two-bar form: 目. The following form is often found on Hebraic seals: 目 or 目. The inscriptions on Hebraic coins revert to the barred rectangle: 口口 or 目.

Modern Hebrew has inherited the ladder shape, but only one rung remains and the top ends have been sawn off: 目, H, Π, with the following variations: Π or Π.

Inscription by Zakhur, king of Hamath

Second inscription by Barrekoub (eighth century B.C.E.)

The Phoenician version favors the three rungs with the following variations: 目, 戸 (seventh century B.C.E.), or an S may intervene between the two uprights as in 目 or 目 (sixth century B.C.E.) or even ∥ ∣ (from the fifth century B.C.E.).

The Transition to Greek Script

Greek borrowed the "domino" shape (a barred rectangle): 目 (the Archaic Greek alphabet of Thera), which became the letter we know in the classical alphabet, a one-rung ladder: H. The letter was pronounced "ay" (as in "may") and was called *eta*.

REMARKS

Etruscan offers two forms with minor variations: 目, 目, *or* 目.

Latin and the Western languages inherited the Greek form of the letter, which is pronounced like an aspirated H and is called "aitch." In Greek, the het *was turned into a vowel, but this change was not transmitted to the later alphabets that it influenced. They retained the letter to use as a consonant.*

There is a simple and gradual change from the proto-Sinaitic barrier-enclosure to the contemporary H. After the number of bars had been reduced, the enclosure rotated from its horizontal position into a vertical, passing through phases of barred rectangles in the shape of a domino to produce an H.

H

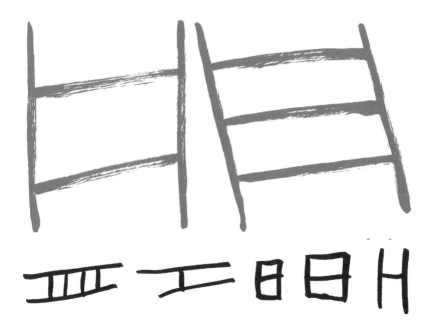

SUMMARY TABLE OF "H" DERIVED FROM *HET*

NAME

H is the initial letter of the word *het*, which in Semitic languages means "enclosure," "wall," "obstacle."

ORIGINAL FORM IN PROTO-SINAITIC

The *het* is an enclosure, a barrier consisting of several bars.

CLASSIC FORMS OF THE *HET* IN CLASSICAL AND MODERN HEBREW

ח Square script ת Cursive script

ORIGINAL MEANINGS

Barrier, enclosure.

DERIVATIVE MEANINGS

Sin, band or strip, the present time, slot, wall, rampart, surface.

The primal force *(aleph)* cannot express itself; it is imprisoned within an area that is enclosed on all sides. As a prisoner of time and space the H man finds himself facing a wall (called *het* in Eastern Aramaic, and in Arabic *hayt*). This barrier stops the human being from realizing his or her potential, from opening up to the future. This catastrophe is expressed by the prophet Isaiah in verse 11 of chapter 47 of the Book of Isaiah as follows:

> *Therefore shall evil come upon thee;*
> *Thou shalt not know from whence*
> * it riseth;*
> *And mischief shall fall upon thee,*
> *Thou shalt not be able to put it off;*
> *And desolation shall come upon thee*
> *suddenly*
> *Shoah, misfortune, destruction,*
> *Which thou shalt not know.*

This magnificent verse heralds the most terrible disaster, the greatest catastrophe that could befall a whole people or an individual, the torment of being stuck in the present *(hoveh)*.

To live is to realize the forces at work in the constant renewal of the world; it is sensing

the advent of a new dawn, a creation that cannot take place without a wrenching, a bursting out from that which existed before (that which we understood in the letter *gimmel*).

H is a letter that signifies evil; it has the same sound as the word *het*, the Hebrew word for "sin." In the Hebrew tradition, "sin" is the result of the impossibility of breaking down barriers and the frontiers of time, the impossibility of an ethic of action. Man falls into the trap of H when he loses the faculty to begin, to under-

take, to take the initiative. Ethical action is the opposite of "conduct," which is merely a repeated gesture, an imitation of a previous gesture, lacking the innovative spirit. H is sin, because like an enclosure, it causes man to forget that the ethic of action is the ability to begin anew, it makes us forget that "human beings must die but they were not born to die but to innovate." The ethical action that breaks through the H enclosure is a birth. It is freedom. *Since we are born, we are condemned to be free.*

Ethical action perceives the world not for what it is, but for what it could be. Man is freedom, and freedom contains within it the promise of "having to be." Man of the future must always be doing something, building something, inventing himself in another way, perfecting himself. Thus the perfection of man resides in his "perfectability," according to the formula of which André Neher is so fond. When this dynamic of invention encounters an obstacle that it cannot overcome, the human being who is thus trapped is in an H situation; there are many ways of extricating oneself that we will mention when we discuss other letters of the alphabet.

ACQUIRED MEANING PERPETUATED BY THE HEBREW LANGUAGE

Sin (by having the same sound as the Hebrew word). Barrier has two meanings: first, obstacle; second, protection.

NUMERIC VALUE

8

H

Facing page: cursive Hebrew het. *Above: the H of Western alphabets.*

I, Y, J

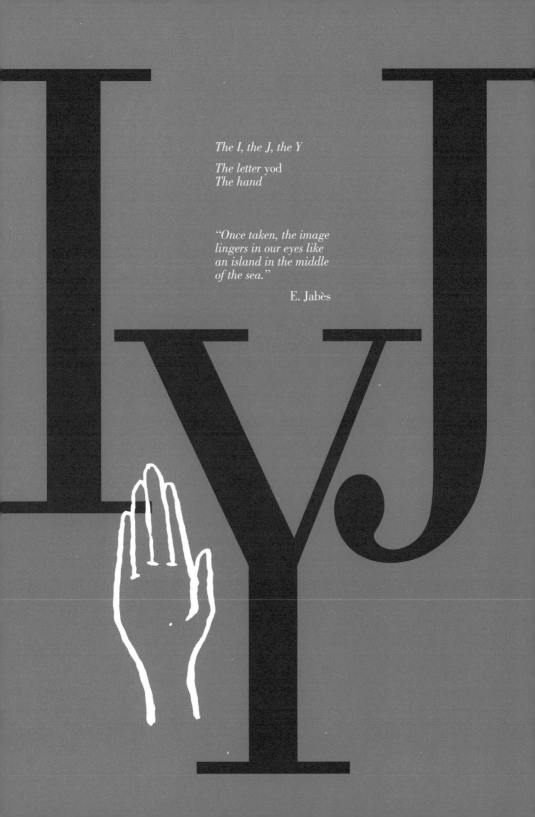

The I, the J, the Y

The letter yod
The hand

"Once taken, the image
lingers in our eyes like
an island in the middle
of the sea."

E. Jabès

I and J are both based on the letter *yod,* the tenth letter of the proto-Sinaitic alphabet.

The Hieroglyphic Sign

The original pictogram was borrowed from hieroglyphics that used a large number of variations based on the shape of the arm, forearm, and hand: ⌐─◻; as well as the gutteral sound *ayin,* which is traditionally pronounced "a" (a uniliteral phonogram). Other pictograms show an arm and a hand holding a piece of bread, representing the sound "mj," the biliteral phonogram ◁─◻ . The determinatives also use this image.

So strength, force, effort, and violence are depicted as ►─◻ , offering and a gift by ◁─◻ . For the action of stopping, the palm of the hand is turned downward: ⌐─◻. Negation is shown by two arms barring the way: ⌐──⌐─, and enveloping and hugging is shown by an embrace: ⟨ ⟩ .

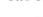

To pray: the arms are raised heavenward: ⌊ ⌋ .

The depiction of the hand alone also exists: ≤ . It is pronounced "tot" and presents the sound "t" or "d." This piece of information is significant because it may explain the origin of the Semitic letter *tet* (and of *theta*), which immediately precedes the *yod.* The Egyptian sign was divided into two sounds: the *tet* ("t") corresponding to the Egyptian sound and the *yod* corresponding to the word for "hand" in Semitic languages; subsequently, the "t" sound was represented by another sign, ⊗ , which depicted a shield (held at the tip of the hand).

The Pictogram in Proto-Sinaitic

Proto-Sinaitic repeats the hieroglyphic shape ⌐⌐ . Some authors, such as Grimme, believe that the original *yod* was

drawn using a sign derived from the Egyptian hieroglyphic for "bundle of papyri": 𒀀, which in hieratic became: ⚲, then ⚲ or ⚲ in proto-Sinaitic. In order to distinguish between *yod*-hand and *yod*-papyrus, scholars designate them *yod I* and *yod II*.

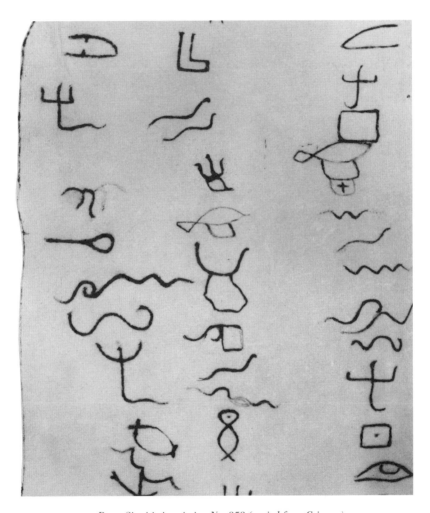

I, Y, J

Proto-Sinaitic inscription No. 353 (copied from Grimme)

We do not understand the logic of the papyrus → *yod* mutation. In Egyptian, the 𝖄 sign is pronounced as "ha" and has no relationship to the *yad* or Y; on the other hand, the sign for a reed or double reed is pronounced *yod* Y: 𝟜 and 𝟜, 𝟜; but the sign for a reed was never adopted by proto-Sinaitic.

Canaanite Inscriptions

The Canaanite inscriptions of the fifteenth–fourteenth centuries B.C.E. show the *yod* as a stylized hand, as in the hieroglyphic.

For instance, on a floor tile found at Tell Nagila and dating from around the fourteenth century B.C.E., according to E. Puech,[1] there are the words *lhwy-y* (with a hyphen between the two letters *yod*). We have an excellent example of a *yod* from the same period that was found in an ostracon discovered at Bet Shemesh. The attentive reader will find that the shard also contains clear examples of *zayin* and *het,* as well as two good specimens of an *aleph.*

From the letter shaped like an arm, a forearm, or a hand, the letter evolved into the shape that it would adopt officially for several centuries in various scripts derived from Canaanite (Phoenician): ‿— . The letter is more compact and has been rotated 90° (as has happened to so many other letters): *ʃ* ; then the wrist is reversed and is "broken" at 90°: ⌐ ⌐ .

This shape was subject to a whole series of minor variations; there is ⟍, then ⟍ and ⟍ or ⟍, or even ⟍ or ⟍. The tablet from Gezer (ninth–tenth century B.C.E.) contains a good selection of *yod* shapes. The document is an agricultural calendar in which the word for "month" recurs constantly, as in harvest month, sowing month, etc. In Hebrew, the word for "month" is *yerakh,*

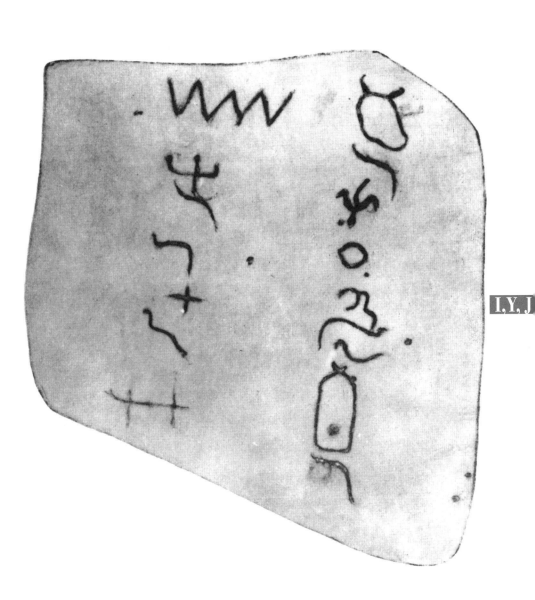

Proto-Sinaitic inscription No. 356

based on the word for "moon," *yareakh* (the Hebraic calendar being basically a lunar one). The *yod*, the first letter of *yerah*, appears at the beginning of each first line.

The Greek Inheritance

The archaic alphabet (from Thera) inherited the y*od*-hand but reduced it to three lines, emphasizing the articulations of the elbow and wrist, as well as reversing the direction in which it was written: ⟨, ⟩ (*iota* in Archaic Greek).

The eastern alphabets of Miletus and Corinth present a simplified form, represented by a single vertical stroke: | (*iota* in Western Greek), and a complex form that would later be abolished due to its close resemblance to the *sigma:* ⟨, ⟨ (*iota* in Eastern Greek). The western alphabets (from Boeotia) and the classical alphabet adopted the simplified form of the vertical stroke: | (Western Greek *iota*).

I, Y, J

Etruscan mainly opted for the vertical stroke; one of the alphabets found at Nola (a town between Naples and Capua) contains the form ⌐ (Etruscan).

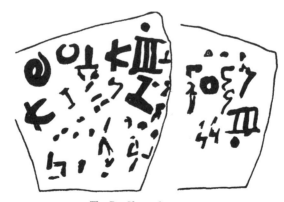

The Bet Shemesh ostracon

So this appears to be the general development of the letter *yod*:

This eventually evolved into the modern I:

REMARKS

The yod *is pronounced like the Y in* year, joy, *and* mayonnaise. *The Y (the Greek I) is an additional letter, which belongs to Ionian Greek. It was added in the time of Cicero (50 B.C.E.). As for the J, it split away from the I in the sixteenth century on the initiative of Petrus Ramus. The Latin J is pronounced like a Y, as in* de jure *(day yuray), but it has a soft "g" sound in other languages, English and French for example. German retained the Latin pronunciation of J, as in* ja = *"ya" ("yes").*

The prophet Jonah's name is really Yona or Iona. *Jasmin comes from the Arabic and Persian* yasmin. *The stone called* jasper *comes from the Latin* iapsis. *Thus Jesus' name was originally* Yeshu, *a variation on* Yehoshua *(Joshua). In Classical Hebrew, the* yod *is represented by two bent fingers:* . *The sign is stylized by tapering the ends:* . *We have shown the link between the* yod *and the Greek letter* iota, *which became I and J and whose meaning is also inherent in the Y.*

I, Y, J

1. E. Puech, "Origine de l'alphabet," pp. 183, 184.
In the Semitic and Greek alphabets, the letter following *hèt* (or H) is *têt*, or *téta*. As the sound of this letter is presently the sound of T, we comment on it in the chapter devoted to T. With the letter I, we move into a new level of the alphabet's structure. For the first nine letters—a, b, c, d, e, f, g, h, and tet—are units: they correspond to 1, 2, 3, 4, 5, 6, 7, 8, and 9. Starting with I, we enter the tens: i (and j), k, l, m, n, o, and p correspond to the numbers 10, 20, 30, 40, 50, 70, and 80. The 60 and 90 correspond to *samèkh* and *tsadé*, letters that have disappeared from the Western alphabet in use today. We will examine these letters under the headings of S and T.

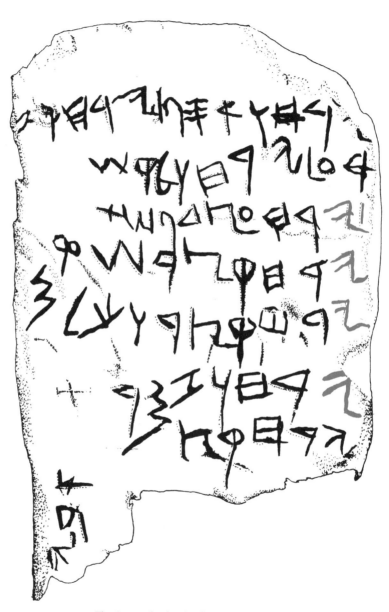

The Gezer calendar (tenth century B.C.E.)

SUMMARY TABLE OF "I," "Y," AND "J" DERIVED FROM *YOD*

I, Y, J

NAME

I, Y, and J are the initial letters of the word *yod*, which comes from *yad* and which means "hand" in Hebrew, either the whole hand or just the fingers.

**ORIGINAL FORMS
IN PROTO-SINAITIC**

A stylized bundle of papyrus reeds, and an extended arm with an upward-facing open palm.

**CLASSIC FORMS OF THE *YOD*
IN CLASSICAL AND MODERN HEBREW**

Square script Cursive script

ORIGINAL MEANINGS

Hand, take, give.

DERIVATIVE MEANINGS

Demonstration, commandment, to show, exhibit, to command, to count, time, multiplicity, benediction.

**ACQUIRED MEANINGS PERPETUATED
BY THE HEBREW LANGUAGE**

Hand, sleeve, extension.

NUMERIC VALUE

10

I, Y, J

Facing page: square Hebrew yod. *Above: the I of Western alphabets.*

K

The K

The letter kaf
The palm of the hand

*"That is why
People like dragonflies . . ."*

F. Kafka

The letter K, eleventh letter of the alphabet, is derived from the eleventh letter of the proto-Sinaitic alphabet: the *kaf*. Semitic languages distinguish between two parts of the hand; the part consisting of the fingers, which comprises fourteen phalanxes and is called *yad*, and the part consisting of the palm of the hand, called *kaf*.

The hieroglyphic also distinguishes between the arm, forearm, and the hand itself.

In Semitic languages, sign I developed into the *yod* and sign II developed into the letter *kaf* ("palm"). The hieroglyphic is pronounced "d" like the D in *delta*. The hieroglyphic is pronounced "mj." In proto-Sinaitic, the hand looks like a handprint on the sand, the outline of a hand, with the fingers turned upward: . There is an excellent example in inscription No. 349. The *kaf* developed through the simplification of the number of strokes: ; and eventually only the three central lines were retained and were joined together: , , or \// (Byblos). The central stroke was lengthened, , or the right-hand stroke was lengthened, . The right-hand stroke became more vertical: ; sometimes the two strokes making the angle were filled in and became a triangle: or (Arad ostracon, sixth century B.C.E.). The triangle sometimes turned

Stele of Mesha, king of Moab (ninth century B.C.E.)

Proto-Sinaitic inscription No. 349

Funerary inscription of Tabnit, king of Sidon (fifth century B.C.E.)

Fragment of the second inscription
of Bar Rakub, late eighth century B.C.E.

into a square or rectangle: (fragment of Leviticus, second century B.C.E.). In some scripts the *kaf* loses one of its strokes. The *kaf* thus begins to look like a Greek I; and are also encountered.

The Transition to Greek Script

The transition from Phoenician to Greek was a simple one. The angle formed by the two strokes gradually moved until it was in the center of the vertical stroke: , ; then, as with other letters, the *kaf* was reversed when writing changed direction and became right-facing.

K (in all the Greek alphabets) has a few variations: K (Thera), K (Miletus), K or K (Corinth).

Latin, and subsequently the Western alphabets, inherited the Greek letter *kappa*, which became a K (pronounced "ka")[1] of which the classical form is K, or *k* in cursive script.

1. *Kaf* produces the letter K. There is sometimes confusion between the letters K, Q, and C.
A classic example of confusion in transcriptions is the name Kafka, which should be written in Hebrew with a *kaf* but is always transcribed with a *qof* (Q) as if the name in German were *Qafqa*.

K K K

K K K

K

VARIOUS GREEK ALPHABETS

700 B.C.E.

650 B.C.E.

550 B.C.E.

650 B.C.E.

550 B.C.E.

500 B.C.E.

SUMMARY TABLE OF "K" DERIVED FROM *KAF*

NAME

K is the initial letter of the Hebrew word *kaf*, which means "palm of the hand."

ORIGINAL FORMS IN PROTO-SINAITIC

Palm of the hand, and an allusion to the five fingers.

CLASSIC FORMS OF THE *KAF* IN CLASSICAL AND MODERN HEBREW

כ Square script כ Cursive script

ORIGINAL MEANINGS

Take, give, cupped hand.

DERIVATIVE MEANINGS

Take, give, exchange, trade, open, to caress, time, to bless, to cover.

ACQUIRED MEANINGS PERPETUATED BY THE HEBREW LANGUAGE

• palm of the hand
• like
• when

NUMERIC VALUE

20

K

Facing page: cursive Hebrew kaf. *Above: the K of Western alphabets*

L

L

The L
The letter lamed
Study
Teaching

"I was told, when I was little, you will see when you are older. I am an old man, but I still have not seen anything."
Erik Satie

The letter L, the twelfth letter of the alphabet, is derived from *lamed*, the twelfth letter of the proto-Sinaitic alphabet. The original form of this letter in proto-Sinaitic script represents an ox goad. It consists of a sort of handle and a pointed stem, which would prick the animal and cause it to move: ⁓◯. In the earliest inscriptions, the direction is not yet fixed, and the following forms are found:

L

On the front of a statuette of a sphinx, below the face, an inscription contains the *lamed* four times (inscription No. 346). Some consider the ⁓◦ to represent a rope or a scepter: 𝇋.

Copy of inscription No. 346 (Grimme)

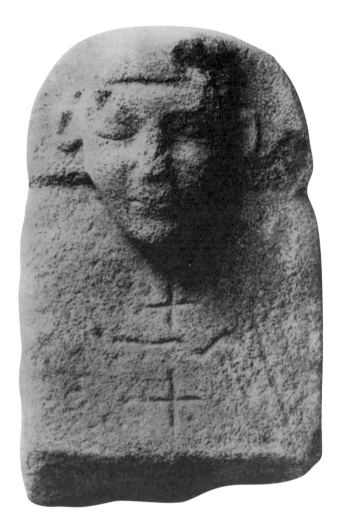

L

This famous sphinx, which revealed the first known proto-Sinaitic inscriptions, displays two *lamed* letters in the expression "dedicated to Baalat," *yihud lebaalat*. There is a *lamed* facing a different way in the words *mehaev baalat*, "lover of Baalat." Baalat was the name of the goddess. It is interesting to note that this form persists to the present day in the Modern Hebrew cursive alphabet.

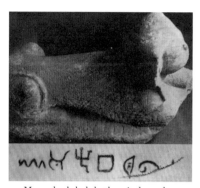

Mem aleph heh beth ayin lamed—
mehaev baalat "lover of Baalat."
Inscription No. 345 (right-hand side)

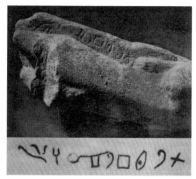

Lamed beth ayin lamed tav—
le baalat "for Baalat."
Inscription No. 345 (left-hand side)

In fact, the shape ⏤ᴐ was rotated 90° to produce ᶑ. A proto-Canaanite form that rounds the tip of the goad has also been found: ℮ ϭ; this letter from the thirteenth century B.C.E. did not survive in later scripts. In the ninth century B.C.E. the variation ⎤ ? appeared. This form stabilized by directing the point upward as follows: ∠ ⌊ ⌊. A few other variations appeared in the course of the centuries: ∕ ⌊ (Phoenician, eighth century B.C.E.) and ∟ (Phoenician, seventh and sixth centuries B.C.E.), ⌊ (Phoenician, sixth century B.C.E.). This was gradually altered into the form that eventually passed into Greek and Latin: ∕ (sixth century B.C.E., Ancient Hebrew), ∠ (third century B.C.E., Ancient Hebrew).

Letter on an ostracon from Lakish
(sixth century B.C.E.)

Alphabet on an ostracon, Arad
(sixth century B.C.E.)

The stele of Mesha, king of Moab (ninth century B.C.E.)

L

The Aramaic alphabets introduced an important variant in the fifth and fourth centuries B.C.E. The letter was prolonged and the horizontal stroke began to be curved. The progression is as follows: ∟, ∟, ∠, ∟, ∿. This last shape would stabilize and would be transmitted to Modern Hebrew: ל .

Three alphabets from the sixth century B.C.E. Top: A papyrus from Saqqarah (Aramaic); middle: Ostracon from Lakhish (Hebrew); bottom: graffiti from Ipsambul (Phoenician).

This linear descent of the letter is of great interest because it shows how central it was to the alphabet. As the twelfth letter, it is almost in the middle of the alphabet. It is like the vertical post on a pair of scales. It is certainly on this basis that the Cabalists attributed this letter to the zodiacal sign of Libra, the scales.

The Transition to Greek Script

Let us continue our investigation into the *lamed*. To summarize, we have: ⌒ (proto-Sinaitic), which becomes ᵔ or ⌠ then ∠, ∠ then ∟, ∠, ∕, ∠ then ∟, ∫ then ∟, ∿. Then, based on Aramaic characters: ∿. Greek introduced the *lamed* in its Phoenician phase in the eighth and seventh centuries B.C.E. and turned it around until it became √ or ⌡ (Archaic Greek). The same form exists in the Etruscan alphabet from Marsiliana. Then the curve is positioned upward: ⌐ or ⌒ or ∕, sometimes with a tick on the end that is reminiscent of the ∟ form (Boeotia), which finally stabilized into the classical alphabet in a letter called *lambda:* ⋀ .

L

The Latin form is inherited here from the Etruscan, which faces in the opposite direction ∨, ∟ and stabilized as ∟ , our L ("ell"). The evolution can be summarized as starting with ⌒, but it is as if the various metamorphoses have taken us back to the original form (𝅘, 𝅗), since the Phoenician *lamed* of the tenth century B.C.E. is written as 𝓁 𝓁 and the paleo-Hebrew of the same era is ∟ ∟ . For example:

Greek written as a boustrophedon

The first line is read from right to left and the second from left to right. We know that the first line of the inscription says "Heracles."

Greek written as a boustrophedon

The E *(epsilon)* indicates the direction of the script. The names include those of Hippolyta, Achilles, Athena, Antiochos, Heracles, and Glaukos. The *lambda* letters are written in the form of ∟ or ∨ .

SUMMARY TABLE OF "L" DERIVED FROM *LAMED*

L

L

NAME

L is the initial letter of the Hebrew word *lamed*, which represents an ox goad.

**ORIGINAL FORMS
IN PROTO-SINAITIC**

Ox goad or rope or scepter.

**CLASSIC FORMS OF THE *LAMED*
IN CLASSICAL AND MODERN HEBREW**

Square script Cursive script

ORIGINAL MEANINGS

Promote, cause to move, change from rest to activity.

DERIVATIVE MEANINGS

Study, learn, teaching, to teach, raised arm, upward, overtaking, expansion, extension, height, arm raised in interdiction, to oppose, opposition, in the direction of, scepter.

**ACQUIRED MEANINGS PERPETUATED
BY THE HEBREW LANGUAGE**

- learn
- study
- teach
- in the direction of

NUMERIC VALUE

30

L

Facing page: cursive Hebrew lamed. *Above: the L of Western alphabets.*

M

The M

The letter mem
Water

"My God . . .
Take pity on these waters in me
which are dying of thirst!"

Paul Claudel

The letter M, the thirteenth letter of the alphabet, is derived from *mem*, the thirteenth letter of the proto-Sinaitic alphabet. The original form in proto-Sinaitic writing represents a "stream of water" or "waves in the sea": ᨏᨏᨏ . This sign, pronounced "m," means "water" in Hebrew, *mayim*.[1] The sign ᨏᨏ is borrowed from the Egyptian hieroglyphic[2] that has almost the same form: ᨏᨏ . However, in Egyptian it was pronounced "n" as in "Nefertiti." It is a very common sign.

For example, in this proverb: *"The fortune of the unjust is not preserved and his children do not find the rest of it."*

The hieroglyphic ᨏᨏ sometimes appears doubled as ᨏᨏ ; this is pronounced "n n" as in

w n n—to exist, to be.

M.

There is even a triple form, ᨏᨏ, which is pronounced "moo" (m w) and means "water," "the waters." In Egyptian, "water" is not used in a dual form (as it is in Hebrew), although such a form exists in Semitic and Egyptian to indicate objects that normally occur in pairs.

The triple form ᨏᨏ is a determinative to indicate water, liquids, and action relating to liquids (as a determinative it is not spoken).

j b t *thirst*

c h m
Quench (thirst)
Extinguish (a fire)

H c p y, hāpy
Personification of the Nile in flood

s w j, *drink (bed)* s m w, *harvest*

Thus, the form ∿ and the word for "water" are almost exactly the same in both hieroglyphics and proto-Sinaitic; there is also a phonetic similarity between *mayim* and *moo*.

The Transition from Proto-Sinaitic to Phoenician and Ancient Hebrew

The development of this letter is perfectly simple. The first major change lies in the switch from horizontal to vertical: ∿ ξ.

On a bronze bowl dating from the eleventh century B.C.E. found at Tekke near Knossos in Crete, the inscription reads from right to left. The *mem* is the fifth letter from the right. The inscription reads: "Bowl of Shema', son of L . . ."

The name Shema', *shin-mem-ayin,* is clearly readable.

Copy of the upper part of inscription No. 352

236

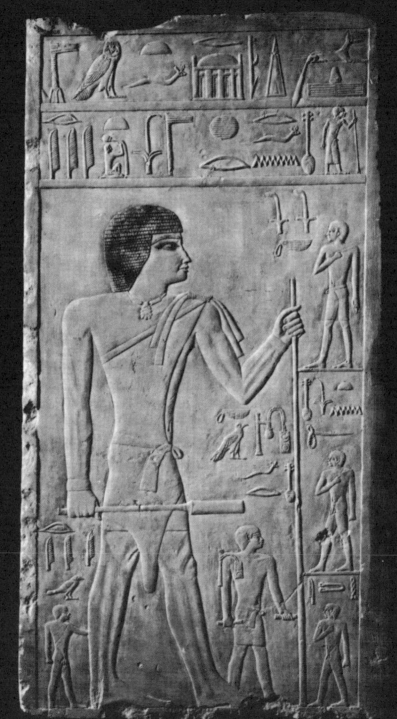

The Phoenician inscription on the sarcophagus of Ahiram, king of Gebal, discovered in Byblos, which dates from the thirteenth century B.C.E., offers a number of vertical *mem* letters.

On the inscription of Yehimilk, the *mem* is also vertical but less regular and more erratic.

The Yehimilk inscription (twelfth or tenth century B.C.E.)

Transcription and translation of the inscription of Yehimilk:

1. BT./ZBNY/YHMLK/MLKKGBL
 Temple built by Yehimilk, king of Gebal

2. (Z) Z'T/HVY/KL/MPLT/HBTM
 This is (?) who has restored (?) all of the ruins of these temples

3. 'L/Y'RK/B'L/SMN/WB'L
 May Baal Samim and Baal extend

4. GBL/WMPHR/T/'LGBL
 Gebal and all of the holy gods of Gebal

5. QDSM/YMT/YMHLK/WSNTW
 The days of Yehimilk and his years

6. 'LGBL/KMLK/SDQ/WMLK
 To Gebal, since he is just and a king

7. YSR/LPN/'LGBL/QDSM
 Straight before the holy gods of Gebal

Over the centuries, the *mem* remained vertical but the bottom stroke was extended: Ϟ, Ϟ̌ . An excellent example can be seen on the Gezer tablet (tenth century B.C.E.) written in Ancient Hebrew (line 6):

The rotation and pivoting of letters continues; the *mem* returns to the horizontal while retaining its previous modification, namely the extension of the lower line: ϟ, ⋈ . The rules for these transitions from vertical to horizontal, and reversal of direction, remain relatively obscure. In fact, in comparison with the alphabet of only a century earlier, only the letter *mem* has been rotated; the other letters have stayed in the same position.

Line 6: YRHW ZMR = Yareho zemer ("month of pruning the vine")

M

Gezer alphabet (tenth century B.C.E.)

Alphabet, the Mesha stele

The ⋈ shape was to undergo several changes. The long stroke was sometimes curved around to produce ⋈ . But it was the shape of the "little waves" at the top that were greatly simplified: ⋈, ⋈ or ⋈ or ⋈ or ⋈.

M

There is a very nice mem *on this statue of the Pharaoh Osorkon 1 (fourth century B.C.E.). Elibaal, the king of Byblos who sent this statue to his ruler, the pharaoh Osorkon 1, had it engraved in Archaic Phoenician (tenth century B.C.E.) with a dedication to the goddess of his city ("the Lady of Byblos"). Some letters retain the form found on the sarcophagus of Ahiram; others look like those found in the stele of Mesha, king of Moab, who ruled until c. 830 B.C.E. (see the Bible, Kings II, chaps. iii–iv).*

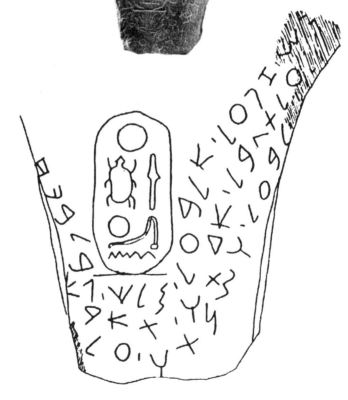

Inscription by Elibaal, king of Byblos

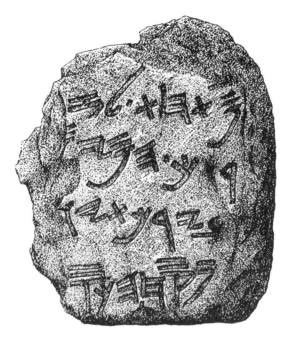

Inscription on a stone from Jerusalem

M

*Hebrew alphabet of the eighth
century B.C.E.*

Alphabet of the Siloam inscription

A very interesting seventh-century B.C.E. variant offers the form
. An analysis of this development makes it possible to under-
stand the birth of the Aramaic form that is behind the Modern
Hebrew form . The actual progression goes as follows:

241

Aramaic alphabet on papyrus from Saqqarah *Modern square Hebrew*

Cursive Hebrew has retained the memory of the "wavelets" formed by the current. As we have stressed on numerous occasions, the cursive form is often closer to the original proto-Sinaitic pictogram: *N* (Modern Hebrew cursive).

The Transition to Greek Script

Greek borrowed the shape directly from the tenth–ninth century B.C.E. Phoenician using the same process of reversal of the direction from left to right that was noted for the other letters: ᒧ becomes ᴎ. We then witness a reduction in the number of "wavelets," and the line farthest to the right disappears: ᴹ (the Archaic Greek alphabet from Thera), ᴧ (Corinthian Greek alphabet). The two vertical strokes become more or less parallel: ᴍ (Boeotian alphabet), then the right-hand stroke is extended until the strokes are of equal length, the ᴍ (classical alphabet). This is the Greek *mu*. In this form, it passed into Latin and thence to western European alphabets. The cursive form retained the memory of the primitive form after reversal: ᴘ (cursive Greek *mu*).

The Etruscan alphabet was subject to the same change from Phoenician as was the Greek but contains several interesting variations. For example, the following forms are found: ᴧᴧ (Etruscan

from Caere, Cerveteri, northwest of Rome); direction of writing →
as well as ⋏⋏ (Etruscan script, Bomarzo alphabet); direction of
writing: ← or again ⋈ (Etruscan script, the Nola alphabet); direc-
tion of script: ←.

REMARK

*Etruscan had a sibilant (S) shaped like our modern M. It was
interposed in the Etruscan alphabet between P and Q. The mem pro-
duces an M that has retained traces of the waves in our cursive "m."*

M

1. In Hebrew "water" is always in the plural: "waters."
Even more specifically, one can translate *mayim* as "dual water," the "duality of waters," or the "two waters."
Words ending in *im* indicate a masculine plural, but those ending in *ayim* indicate a "dual": two eyes, two
ears, two hands—whatever comes in pairs. Thus, *mayim* is not water, nor is it waters, but a "pair of waters."
Are these the waters that were under the firmament and the waters that were above the firmament,
mentioned in the first chapter of Genesis? "And God . . . divided the waters which were under the firmament
from the waters which were above the firmament."
Would this be because water always leads us elsewhere and lets us dream? We are here and over there, duality
and travel. The relationship between water and "yonder" is also found in the Hebrew word for heaven, sky,
or firmament, *shamayim*, which the sages of the Talmud read as *sham-mayim*, "yonder there is water"
(*sham* means "yonder, over there").
Is it because water changes color as the heavens change?
They are blue, gray, green, black, or transparent.
2. See Pierre Grandet and Bernard Mathieu, *Cours d'égyptien hiéroglyphique* (Khéops, 1990), p. 64.

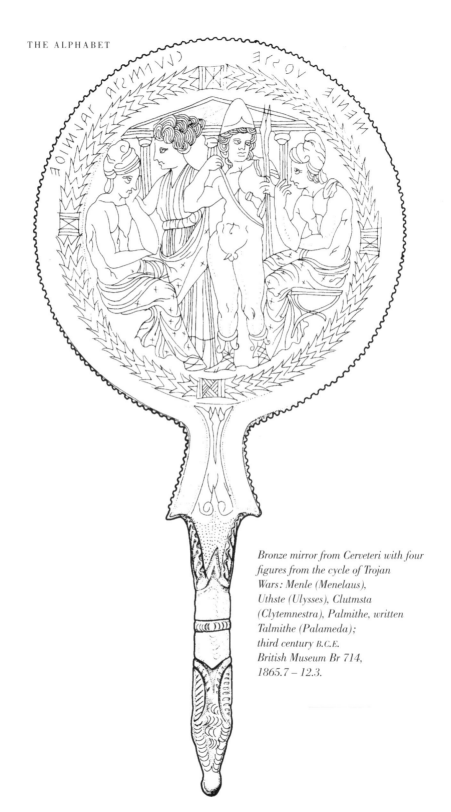

M

Bronze mirror from Cerveteri with four
figures from the cycle of Trojan
Wars: Menle (Menelaus),
Uthste (Ulysses), Clutmsta
(Clytemnestra), Palmithe, written
Talmithe (Palameda);
third century B.C.E.
British Museum Br 714,
1865.7 – 12.3.

M

Calligraphy by Lalou
The letters mem *and* heh, *which spell the word* ma, *meaning "what?"*

SUMMARY TABLE OF "M" DERIVED FROM *MEM*

NAME
M is the initial letter of the Hebrew word *mayim*, which means "water."

ORIGINAL FORMS
IN PROTO-SINAITIC
Stream of water, wavelets on the surface of the water.

CLASSIC FORMS OF THE *MEM*
IN CLASSICAL AND MODERN HEBREW
מ Square script *N* Cursive script
Note that there is a "final *mem*" used when the *mem* is the last letter of the word.
ם Square final *mem* *P* Cursive final *mem*

ORIGINAL MEANINGS
Water, waters.

DERIVATIVE MEANINGS
Movement, dynamism, current, questioning of identity, identity in movement, unanswered question (the word *mayim* or *mem* consists of *mi* twice, one written from right to left and the other from left to right).

Mi or *my* in Hebrew means "who?" questioning an identity. The Greek letter *mu* is pronounced similarly to *mi* and retains this notion of questioning identity; desire, will; extending toward. The evolution of the letter and its transition from vertical to horizontal and the opposite might be seen as modifications to the subject being questioned as to identity. The vertical *mi* ⌇ is a theological interrogation aimed at God, "Who are you?" The horizontal *mi* ∼∼∼ is anthropological: "Who are you, what person are you? What are your origin and roots?"

As explained at the beginning of this section, the letter *mem* designates water, a stream of water, or the current, even a river. The basic concept attached to this letter is thus one of movement, flow, flowing, the dynamic of an existence without

interruption, a continuous progress to elsewhere, a metaphorical and physical way of being. Water also expresses the possibility of *purification.* Over and above the problems of hygiene, purification is linked to life as movement and moving forward; it is also linked to the clear recognition that we are mortal beings. Despite this awareness that we are creatures who are destined to be finite, we must not allow ourselves to sink into despair. *Impurity is the confrontation with one's own mortality when one believes there is no way out.* Purity and more precisely purification is a labor that consists in overcoming the illusion "of an unbearable heaviness of being." By entering and dipping oneself in the living, flowing, dynamic waters of a river, the human

being regains the consciousness of the interior dynamism that is the foundation of life, the existential "fountain of youth" and "water of life." It is interesting to note that in Hebrew tradition, one cannot purify oneself in stagnant water. Only rainwater or a flowing water course (a river, the ocean, etc.) can be used.

ACQUIRED MEANINGS PERPETUATED BY THE HEBREW LANGUAGE

Water, waters, sign of the masculine plural *im* (at the end of a word), prefix indicating provenance or origin (*ani ba me:* I come from).

NUMERIC VALUE
40

M

Facing page: cursive Hebrew mem. *Above: the M of Western alphabets.*

The N
The letter ṅun

Game fish
Fish
The cobra

"Give sense to your speech,
give it shade . . ."

Paul Celan

The letter N, the fourteenth letter of the alphabet, is based on the fourteenth letter of the proto-Sinaitic alphabet—*nun*. The original form in proto-Sinaitic script represents a serpent, snake, water serpent, or eel.

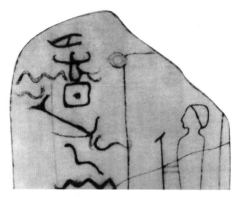

Fragment of proto-Sinaitic inscription No. 354

N

This sign is derived directly from the Egyptian hieroglyphic representing a cobra which is pronounced like the English "j" or "dy" as in the word *Jew* or *dew*. Here is an example of a sentence that includes the "cobra" sign 𓆓 (determinative of a queen or goddess). Hieroglyphics contain three other forms that are similar to the "j" but which do not seem to be the direct origin of the letter *noon*.

WN = K JM = S R HD.T-T3?
Can you be there until dawn?

In its passage from proto-Sinaitic to Phoenician and ancient Hebrew, the "serpent" form became more complicated, The curves became deeper and the angles more acute: ꓽ ꓹ or ꓲ ꓾ (proto-Canaanite of c. thirteenth century B.C.E.). The three-stroke "snake" lasted, with a few varia-

Inscription on the sarcophagus of Ahiram, king of Gebal (tenth century B.C.E.)

tions, until the first century B.C.E. For instance, the sarcophagus of King Ahiram clearly shows a *nun* with this shape. At a time when the *mem* was rotating from the vertical to the horizontal: ⌇, ⌇, the *nun* was undergoing the same transformation: ⌇, ⌇. Subsequent stages are: ⌇, ⌇, ⌇.

The Mesha stele displays a more angular *nun*: ⌇. There is also the variation ⌇ (ancient Hebrew, tenth century B.C.E.). There are a *mem* and a *nun* in an alphabet based on a fragment of the Book of Leviticus (Qumran, c. third century B.C.E.).

A script dating from the early sixth century B.C.E. (the Arad ostraca) in ancient Hebrew depicts an elongated, semihorizontal variant of the *nun* and *mem*: ⌇, ⌇, ⌇ (*mem*), ⌇, ⌇, ⌇ (*nun*).

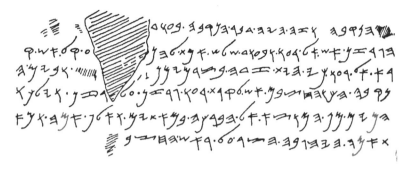

Siloam inscription, ancient Hebrew (late eighth century B.C.E.); the reign of King Hezekiah (see Kings II xx:22 and Chronicles II xxxii:30)

The ancient Hebrew inscription tells the story of how King Hezekiah diverted a water course. A translated extract reads: "Here is the tunneling and this was the history of the tunneling. . . . On the day of the breakthrough, the miners struck the rock one meeting the other, pick against pick, and the waters flowed from the spring to the pool over [a span of] 1200 cubits, and the height of the rock above the heads of the miners was 100 cubits."

Ancient Hebrew alphabet (late eighth century B.C.E.)

The modern Hebrew form is an almost direct adaptation of the hieroglyphic and the proto-Sinaitic, with a few minor distortions: ך ן נ ן ﬡ (modern cursive *nun*), נ (modern square *nun*). There is also a final form of the *nun,* which retains the memory of the snake-shape, the serpent that Moses turned into a rod: ן (modern cursive final *nun*), ן (modern square final *nun*).

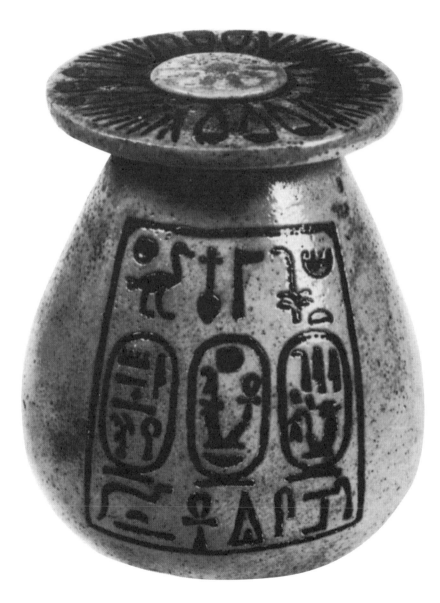

*Cosmetic jar decorated with cartouches of King Amenophis III and his wife Tiy;
reign of King Amenophis III (c. 1400 B.C.E.)*

N

The Transition to Greek Script

Greek borrowed from the Phoenician and from ancient Hebrew of the eighth century B.C.E., if the Mesha stele is used as an example, but a vertical stroke is added that curves at the bottom: ; and the bottom stroke is shortened: И . The direction of the script was later reversed, turning the letter into N (the Greek *nu*). Here are a few examples of the Greek letter *nu*:

N

Ancient form of the name Appolon

Ancient Greek script

The Greek N passed into Latin and western European alphabets as N. The *nun* became the Greek *nu,* N in our own, Western alphabets.

Greek scripts

SUMMARY TABLE OF "N" DERIVED FROM *NUN*

NAME
N is the initial letter of the Hebrew word *nun.* It represents a fish, a sea snake, or a game fish.

ORIGINAL FORMS IN PROTO-SINAITIC
Water snake, cobra, serpent.

CLASSIC FORMS OF THE *NUN* IN CLASSICAL AND MODERN HEBREW
נ ן Square script, *nun* and final *nun*
ן ן Cursive script, *nun* and final *nun*

ORIGINAL MEANINGS
That which is hidden in the ocean depths, a fish.

DERIVATIVE MEANINGS
Hidden, intimate, feminine, place where one can crouch, place that contains, fish, fetus in the waters of the fetal sac, spark of life, life, forthcoming birth, infant, growth, production, product, advent, continuation, to grow, to stretch, to push, opening, twisted, to twist.

We mentioned the hieroglyphic "water snake" or "cobra"; the logic of alphabetic order places the *nun* immediately after the *mem* (*mayim* = water) and is a strong argument for translating the *nun* as "fish," or "game fish" in general, rather than as "serpent" or "snake." Further support for this theory comes from the fact that *nun* is one of the words that can be used to indicate a fish in Aramaic. One of the other meanings of *nun* is "the hidden." When one looks at the waters of a river, the sea, or a pool, one cannot see all of this mysterious world that is concealed beneath the water. The *nun* hints at hidden depths that cannot be seen. This explains the tradition of hanging up a fish against the evil eye.

ACQUIRED MEANINGS PERPETUATED BY THE HEBREW LANGUAGE
Fish, grandchild.

NUMERIC VALUE
50

N

Calligraphy by Lalou
Halom: *"Dream"*

259

Facing page: cursive Hebrew nun. *Above: the N of Western alphabets.*

o

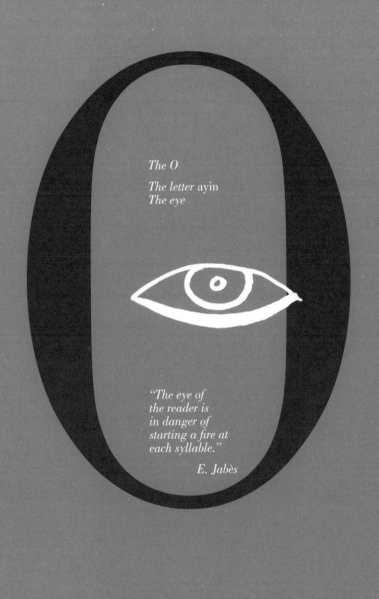

The O
The letter ayin
The eye

"The eye of
the reader is
in danger of
starting a fire at
each syllable."

E. Jabès

The letter O, fifteenth letter of the alphabet, is derived from the sixteenth letter of the proto-Sinaitic alphabet—*ayin.* The original form in proto-Sinaitic script represents an eye. The *ayin* can be found here in the word *Baalat* (name of the goddess), which we encountered in the inscriptions on the sphinx (No. 345) in a horizontal script.

Here again, the relationship with the hieroglyphic seems evident: ⟨eye⟩ ⟨eye⟩ determinative; eye, actions of the eye; actions or states of the eye. The ⟨eye⟩ sign on its own means "to do, to enable." Examples of words with the sign ⟨eye⟩ are:

rmj, "to weep"

rmw = in the future, "sometimes"

Proto-Sinaitic offers the following variations with or without the pupil:

The development of this letter based on proto-Sinaitic is extremely simple. The eye is rounded and is shown with or without a pupil: O ⊖ ⊙ .

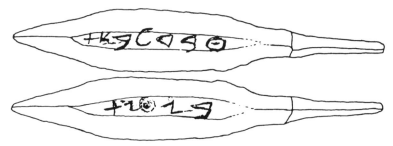

Arrows dating from the eleventh century B.C.E. Proto-Canaanite script.
The lower one reads, "Ben Anat: son of Anat."

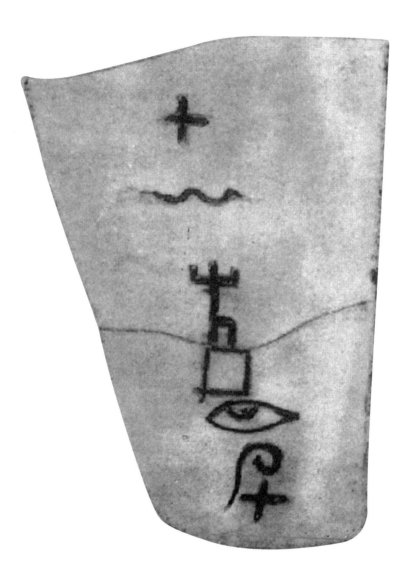

O

Proto-Sinaitic: fragment of inscription No. 354

Sometimes the circle is not quite round: O (ancient Hebrew, sixth century B.C.E.), ☐ (ancient Hebrew, seventh century B.C.E.), ⟁ (ancient Hebrew, third century B.C.E.). Aramaic introduced an innovation by drawing only a lower half-circle: ∪, ∪, ∨. The contemporaneous form in Hebrew appears for the first time in the so-called "Jewish" script (first century B.C.E.). The drawing only traces the lower part of the eye, with a vertical line to indicate the pupil: ⌣ . The shape rotates and moves to an upright position: ⌣ ⌣, to end up in the classical shape ⌣.

The Transition to Greek Script

Greek borrowed directly from the Phoenician and ancient Hebrew. The earliest Greek alphabets included a remnant of the pupil: ⊙ (Greek *omicron*).

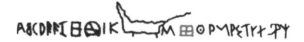

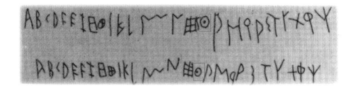

Greek alphabets dating from 650 B.C.E.

The pupil is clearly visible in the O here, but disappears toward the sixth century B.C.E.:

VΑΙΡΕVΑΡΟΝ
ΟVDIΣΤVΚΑΚΟΣ
ΛΕCΕΙΟVDΕ⊕Ⓜ
ΝΟΝΤΑΠΟΛΟΣ
ΑΝ⊕ΡΟΠΟΝΛV
ΣΑΜΕΝΟΣ
ΚΑΜΑΤΟ

266

The Western Greek alphabets (Boeotia) contain an interesting variation: ◇. Benveniste mentions the existence of a square-shaped *omicron*: □. *Omega* ("capital O"), ⊞, is a letter that was added to the Miletus alphabet and the standard Greek alphabet. It is the last letter of the alphabet, whence the well-known expression "the *alpha* and the *omega*."

Latin inherited the *omicron* as a circle without a pupil, which occasionally takes on an elliptical shape: ⊖ ○.

REMARK

In the ancient alphabets, the letter theta, *based on the Hebrew letter* tet *(the ninth letter of the alphabet), adopts several shapes:* ⊕ ⊗ ⊞ ⊖ *and* ○. *But in the early alphabets it is shown as* ☉.

ABΓΔECIⒽ⊙IKL Mᘔ⊞O----

Greek alphabet (sixth century B.C.E.)

It could thus be confused with an omicron. *However, wherever* theta *is written* ☉, *the O does not contain a dot.*

Summary of development: 👁 *(hieroglyphic),* 👁 *(proto-Sinaitic),* 👁 ⊙ *(proto-Canaanite). The proto-Canaanite is the basis for the Greek and Latin forms:* ⊙ ○ . *The proto-Sinaitic would develop into Aramaic and classical Hebrew:* 👁 ⌣ ⌣ ⊻ *(Hebrew). So* ayin *produced the O via the Greek* omicron. *The shape of the O is that of the orb of the eye.*

SUMMARY TABLE OF "O" DERIVED FROM *AYIN*

NAME

O is the initial of the Hebrew letter *oyin* or *ayin*, which designates the eye and a spring or source of water.

ORIGINAL FORMS IN PROTO-SINAITIC

Eye with or without a pupil

CLASSIC FORMS OF THE *AYIN* IN CLASSICAL AND MODERN HEBREW

ﬠ Square script ﬠ Cursive script

ORIGINAL MEANINGS

See, look, gaze, consult.

DERIVATIVE MEANINGS

To appear, "appear-disappear," visible, "visible-invisible," spring (water), "interior-exterior," ring, around, circle, cycle, globe, orb of the eye, obscure, opaque, shade, spherical, hole, orbit, outer ear (Benveniste), eardrum.

The *ayin:* everything in sight, visible, it is the gaze, the look and apparition. But what can be seen can also be hidden or concealed. Thus, the *ayin* represents moving from the interior to the exterior, from the murky, hidden depths of the earth to the brightness of the sun-drenched world. The *ayin* is the water source, the point at which subterranean water springs forth from the earth into the light of day. It is the point of revelation simultaneously with concealment. A human is never entirely revealed; appearance is only part of the whole. With the *ayin* the world becomes plural, multiple, revealed, and secret. This would explain why *ayin* has the numeric value of 70, the number of secrecy and multiplicity; the word *secret* is *sod* in Hebrew, the numeric values of the letters being 60 + 6 + 4 = 70.

When Hebrew wishes to express a multiplicity, it uses the number 70: seventy nations, seventy tongues, etc.

This dialectic of multiplicity and of the visible-invisible is supported by a second dialectic, that of seeing and hearing. *Shema*, "listen," is written *sham-ayin*, "the eye over there." Hearing is a way of seeing farther, beyond the simple apparition that can only be perceived from nearby.

ACQUIRED MEANINGS PERPETUATED BY THE HEBREW LANGUAGE

Eye, spring, apparition, multiplicity, resemblance, to look, to examine, to read.

NUMERIC VALUE

70

O

Calligraphy by Lalou
Letter aleph

O

Facing page: cursive Hebrew ayin. *Above: the O of Western alphabets.*

P

P

The P
The letter peh
The mouth

"Nothingness is at the
heart of existence, a trace of
the infinite, the kernel of the
possibility of sense, of white,
the void, the birth of
hope, the smile
of God . . ."

(after Rabbi Levi Itshaq
of Berditchev)

The letter P, the sixteenth letter of the alphabet, is based on the seventeenth letter of the proto-Sinaitic alphabet, *peh,* "the mouth." The original form in proto-Sinaitic script represents a mouth. The scribes of proto-Sinaitic encountered the problem of confusion between two signs: if they had derived the *peh* from the corresponding hieroglyphic, they would have drawn the sign ⬯ , which indicates a mouth and is pronounced "r" in Egyptian. However, this shape was already in use to indicate the eye in proto-Sinaitic, so they had to invent a new sign or a variation of an existing sign. They chose a rectangle, which is reminiscent of the opening of the mouth but cannot be confused with the eye (the square being reserved for *beth,* "the house"). ▭ : the rectangle also exists in hieroglyphics but is drawn as a vertical and is pronounced "p" and means "seat." The proto-Sinaitic sign is thus a mixture of the sign for "mouth" and the "p" sound in hieroglyphics. Inscription No. 349 is a good example to show all the various signs together, ⬯ (eye), ▭ (mouth), ▢ (house).

LINE 1

From right to left (the head of the ox indicates the direction of the writing) it reads: *aleph, nun, het, tav, shin, peh, shin, mem, shin.* Grimme interprets it as follows: I *(an)* Hatshepsut was born *(mesh).* Hatshepsut is probably the name of the queen who lived in the eighteenth dynasty and reigned from 1479 through 1458 B.C.E., but this might refer to someone else of the same name.

LINE 2

Two houses ▢ and an eye ⬯ can be discerned. The attentive reader will also have noticed two water snakes ∿ and a stream of water ⌇ . The first letter is the profile of a head (this is the letter *resh,* which will be considered later). After the first snake, there is the head of an ox.

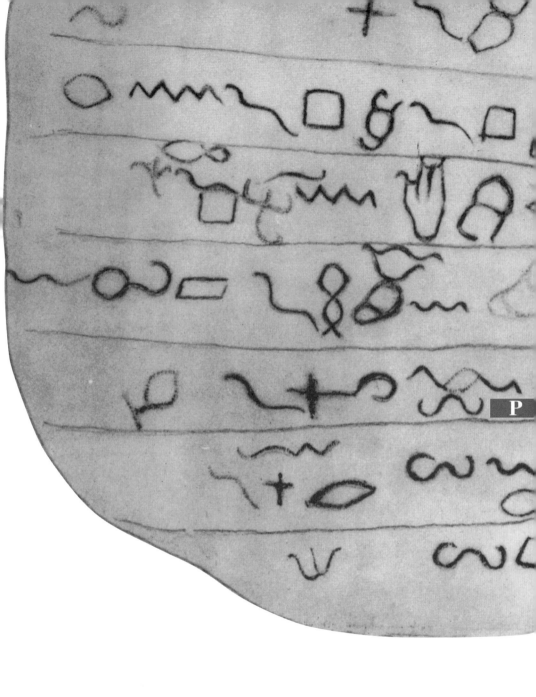

Proto-Sinaitic inscription No. 349

However, we have in fact misread the phrase. The last letter is not an eye at all but a knot in a rope. There is a difference between the eye ⌒ , which is narrower, and the knot ◯ , which is one of the forms of the *vav*. So line 2 should read: R B N A B N M U.

LINE 4

From right to left:
Oxhead / *aleph*
Serpent / *nun*
Serpent / *nun*
(above the second head)
Oxhead / *aleph*
Hank of linen / *shin*
Serpent / *nun*
Rectangle: mouth / *peh*
Tooth, knot / *shin-vav*
Serpent / *nun*

thus: A N N A S H N P C HU N

LINE 7

Three letters:
Rectangle: mouth / *peh*
Tooth / *shin*
Bundle of reeds / *yod*

Which then reads: P CH Y

REMARK

Neither Phoenician nor Hebrew contains a sign that could be construed as a graphic adaptation of a rectangle.

*According to certain researchers, there are some alternatives:
either the* peh *does not exist at all in proto-Sinaitic writings, or it
has another shape, which we identified earlier as representing a
gimmel* ⌐ *but which is in fact a stylized mouth this way up:* ⋎
*(at the top of inscription No. 353), or there may be a difference
between the eye* ⌒ *and the mouth* ⌒ *, which may after
all not be a knot as we thought earlier.*

Development of the Letter *Peh*

Until the first century B.C.E., all the inscriptions used a *peh*
of almost exactly the same shape and without any difference as
to the direction in which it faced. On the coffin of Ahiram, king
of Gebal (c. 1000 years B.C.E.), the *peh* takes the following form:
)).

P

In the Gezer calendar (tenth century B.C.E.), the letter becomes
more vertical and the upper curve is more clearly rounded, giving
it the shape of a cane: ⌐.

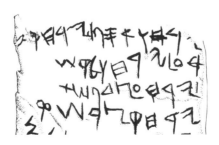

On the Mesha stele (ninth century B.C.E.), the *peh* has become angular once again: ⅃. It should not be confused in the same inscription with the *gimmel,* which looks like this: ⅂ or ⅂ or ⅂.

The *peh* then starts to look like this: ⅂ ⅃ ⅃ \ , finally becoming ⅂ ⅂ in modern Hebrew (square script, the normal and the final forms), ∂ ƒ (cursive script, normal and final forms).

The Transition to Greek Script

Greek borrowed, directly from Phoenician and ancient Hebrew of the tenth century B.C.E., the cane shape ⅂.

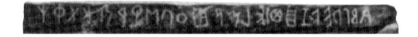

P

With the reversal of the direction of writing, ⅂ became Γ, then the hook closed into a loop: Γ P P (Greek alphabet of the seventh century B.C.E.). This is the letter P of our modern alphabets.

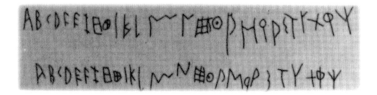

REMARK ABOUT THE DEVELOPMENT OF THE GREEK *PI*

The Greek pi *developed in a manner that distanced it from the shape that Latin would ultimately adopt.*

Based on the Γ *(pi in the archaic Greek alphabet from Thera), it became more angular and squared:* Γ *(Eastern Greek alphabet from Miletus and Corinth). The right vertical was prolonged:* Π *(Western Greek alphabet from Boeotia). The horizontal line was extended:* Π *(the classical Greek alphabet).*

The archaic Etruscan and Latin alphabets contain all the forms already seen, plus the following variation: ⌐ *(Picenian).*

Latin borrowed its letters from seventh-century B.C.E. *Greek, ignoring the second change, which has just been explained (the reason why is unknown), and produced the letter that we know today:* P *.*

Peh *belongs to the series of seven Hebrew letters that designate parts of the human body:*

| | | |
|---|---|---|
| heh | | *body at prayer* |
| yod | | *hand* |
| kaf | | *palm of the hand* |
| ayin | | *eye* |
| peh | *or* | *mouth* |
| resh | | *head* |
| shin | | *tooth* |

The mouth is linked with food, breathing, love, and language. Commentators on Talmudic and Midrashic traditions strongly emphasized the power of speech possessed by humans, their ability to talk with the mouth, using the organ-letter peh.

P

Peh *produces the Greek* pi, *which is based on the sign* ⊏⊐ *, and* phi, *based on the sign* ⌒ *, crossed by a vertical line* ⟡ *(Benveniste). We have shown how the sign for "smile"* ∨ ⌐ ⌐ ⌐ *ended up as the western European letter P.*

P

SUMMARY TABLE OF "P" DERIVED FROM *PEH*

NAME
P is the initial of the Hebrew word *peh*, which means "mouth."

**ORIGINAL FORMS
IN PROTO-SINAITIC**
A horizontal rectangle or mouth at right angles, smile.

**CLASSIC FORMS OF THE *PEH*
IN CLASSICAL AND MODERN HEBREW**
ף ‎פ‎ Square script: final and normal
ﬡ ﬡ Cursive script: final and normal

ORIGINAL MEANINGS
Mouth, to speak, to eat, to breathe.

DERIVATIVE MEANINGS
To disengage, to evacuate, to exhale, orifice, opening, exit, speech, content, breathing, split, gap, female genitalia (mouth below), orally transmitted memory, the oral law, book as an item that is read, reading, interpretation, hermeneutics.

**ACQUIRED MEANINGS PERPETUATED
BY THE HEBREW LANGUAGE**
Mouth, opening, oral law.

NUMERIC VALUE
80

P

Facing page: cursive Hebrew peh. *Above: the P of Western alphabets.*

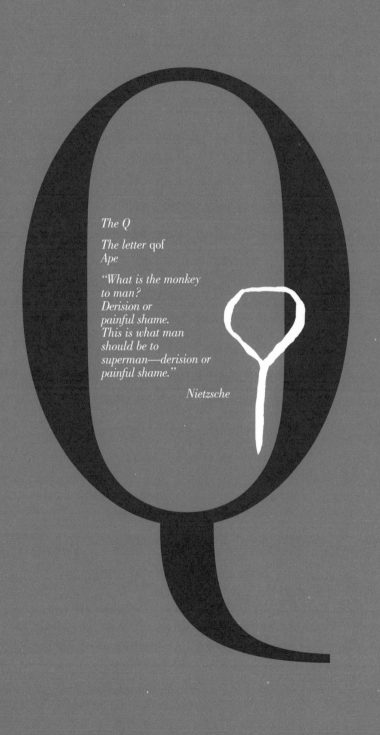

The Q

The letter qof

Ape

"What is the monkey
to man?
Derision or
painful shame.
This is what man
should be to
superman—derision or
painful shame."

Nietzsche

The letter Q, the seventeenth letter of the alphabet, is derived from *qof,* the nineteenth letter of the proto-Sinaitic alphabet. The original form in proto-Sinaitic script is as follows: ⟨⟩. Scholars are divided as to the original meaning of this letter. A few interpretations could be mooted based on the various hieroglyphics from which *qof* may derive. If the "tennis racket" theory is discarded, the following hieroglyphics could be considered to be the possible origin:

(h)—vulva of a cow (?)

(cz)—tent peg laid on the ground

(da)—fire stick

(mj)—vase in a net

(tj)—pestle

(3b)—scissors

(mn)—foot of a chair or table

(hr)—face looking forward

(oud)—rope wrapped around a stick

(hd)—club

(cnh)—sandal buckle

(nfr)—heart and trachea

(ntr)—stick wrapped in cloth

If the sign is hieroglyphic in origin, three options are available. The first is that of a head seen face on: ⟨⟩. The simplified form is similar to the shape of the sign: ⟨⟩. Furthermore, the logical sequence of the letters favors this choice.

In fact, we can see that some letters have the same meaning, such as *yad* and *kaf* (hand and palm of the hand), *nun* and *samekh* (fish and fish); and others have meanings that are closely connected: *ayin* et *peh* (eye and mouth), hence perhaps *qof* and *resh* (face viewed from the front and from the side).

The second possibility follows the same logic. *Qof* would be an organ or set of organs related to the head. This also includes the sign of the "heart and trachea": ♂. The final option is that of the club or baton: ?. It is difficult to distinguish between this character and the rope wrapped around a stick: ?.

The Hebrew word *qof* suggests several interesting possibilities:
• firstly, *qof* means "ape" (see the book of Kings I, x:22 and Chronicles II, ix:21)
 • the verb *quf* produces the word *heqif*: "to sell on credit"
 • the word *qof* means "the eye of a needle" and "the blade of an ax," meanings that would be particularly apt in relation to the proto-Sinaitic sign: ?.

There is a word that would appear to derive from *qof*, which is *qofits*, "hatchet" or "cleaver." The verb *qafats*, "slice," "cut," has the dual meaning of "leaping," "jumping," or "closing." There is also the verb *qafa*, which means "freeze," "petrify," "stagnate," "coagulate"; the ideas of interruption and of cutting that are to be found in *qafad* and *qapad*.

It should be noted that *qofits*, cleaver, is called *kopis* in Greek. *Qof*, ape, is called *kepos* in Greek; *gif, gof,* or *gouf* in Egyptian; *qofa* in Aramaic; and *uqupu* in Akkadian. Hindi uses the word *qapi*. Some authors believe that the original word was *qav* (rope, line) rather than *qof*.

If the proto-Sinaitic inscriptions are studied carefully, it can be seen that there is a sign for "heart and trachea" and a sign whose

287

Bottom of proto-Sinaitic inscription No. 353

shape is somewhere between the "cow's vulva" and the "tent peg" in the horizontal position. So what should it be? Only by practicing archeography can the various possibilities be considered as to their relevance, unless this is a letter whose semantic scope is particularly wide.

Development of the Letter *Qof*

In the Gezer calendar (tenth century B.C.E.), the *qof* takes the following form: ⸙. On the Yehimilk inscription from Byblos the rounded part is clearer and more pronounced: ⸙ ⸙ ⸙. This development follows the process of iconic reduction: the left-hand loop becomes smaller, only to disappear completely in modern scripts: ⸙ (Siloam), ⸙ ⸙ (Samaria). The left-hand loop turns into a straight line:

Ostracon from Lakhish (sixth century B.C.E.)

The final result in classical Hebrew is ק (ornamental), ק (liturgical), ק (cursive), ק (classic).

The Transition to Greek Script

Greek borrowed directly from the Phoenician and ancient Hebrew of the tenth and ninth centuries B.C.E. A shape similar to the original proto-Sinaitic was adopted: ⸙ ⸙ (archaic Greek alphabet from Thera), ⸙ (Eastern Greek alphabet from Corinth), ⸙ ⸙ (Western Greek alphabet from Boeotia). This letter is called *koppa* but should not be confused with *kappa* (K). *Koppa,* which actually ought to be written *qoppa,* never entered the classical Ionian alphabet. The classical Greek alphabet skips straight from *pi* to *rho.* Etruscan contains the Q as follows: ⸙ ⸙ ⸙ P ⸙ ⸙ .

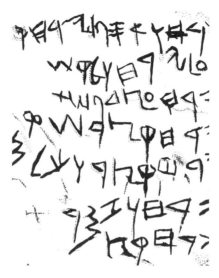

Gezer tablet (tenth century B.C.E.)

The Mesha stele (ninth century B.C.E.) contains several qof *letters.*

From Etruscan the letter passed into the Italic alphabet, then into Latin in the form Ⴓ Ⴓ. The form Ⴓ was reversed when the direction of writing changed: Ⴖ. This resulted in the Latin and Western alphabet forms Ⴖ Q (cursive and capital letter).

The *koppa* uses the form Ⴓ; note that the letter *phi* is similar in shape: φ.

Inscriptions in Archaic Greek, showing two clear examples of koppa

The *qof* produces the Q, whose shape is almost directly derived from proto-Sinaitic. Greek has a corresponding letter, *koppa*, which disappeared in Classical Greek. Through Etruscan it passed into Latin and thence into western European languages.

SUMMARY TABLE OF "Q" DERIVED FROM *QOF*

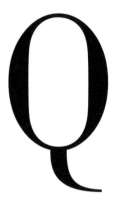

NAME

Q is the first letter of the Hebrew word *qof*, which means ape or monkey, a root that can be found in the Greek *kepos*, in the Akkadian *uqupu*, and in the Hindi *qapi*. *Qof* also means the eye of a needle.

ORIGINAL FORMS
IN PROTO-SINAITIC

Needle and eye of a needle, club, face seen from the front, cleaver, hatchet, ax.

CLASSIC FORMS OF THE *QOF*
IN CLASSICAL AND MODERN HEBREW

ρ Cursive script

ק Sephardic liturgical script

ק Ashkenazic liturgical script

ORIGINAL MEANINGS

Ape, monkey, eye of a needle.

DERIVATIVE MEANINGS

First we tried to discern the original meaning of *qof* from its original graphic. We took

various routes, starting with the monkey and ending with the club via the heart and trachea, scissors, the eye of a needle, the face looking forward, and the cleaver. We tried to narrow the meaning by confining the semantics to those words beginning with the letter *qof*.

In Aramaic, the word *qa (qof-aleph)* is a verbal preposition placed in front of a verb to indicate the present limitation of an action "being in the process of doing"; this conveys the idea of limitation, cutting, interruption, non-totality, non-infinity. In Hebrew:

• *Qaa (qof-aleph-heh)* means "to vomit," "vomit." This is the idea of the impossibility of doing everything, unassimilability.

• *Qav (qof-beth)* is a crutch.

• *Qavav (qof-beth-beth)* is the verb "to curse, execrate, cover, shelter."

• *Qavats (qof-beth-tsadeh):* gather together, assemble. There is the idea of separating

the elements of a whole to create a specific part, delimitation and cutting.

• *Qavar (qof-beth-resh):* to bury. Life is limited, finished, cut.

• *Qadoch (qof-daleth-shin):* saint, holy. *Ain qedusha ela bemaqom havdala:* "There is no holiness except in a place where there is separation."

• *Qadima (qof-daleth-mem):* forward, onward, to separate, remove oneself from somewhere to go elsewhere.

• *Qava (qof-vav-heh):* to wait, to hope, to feel oneself separated from a time to come but nevertheless to create a link with it; the dialectic of separation-reunion.

• *Qatsats (qof-tsadeh-tsadeh):* chop, cut down.

• *Quitub (qof-tet-vav-beth):* polarization-separation and opposition of two elements.

• *Qatum (qof-tet-vav-mem):* truncate.

• *Qataf (qof-tet-heh):* pick.

• *Qatuf (qof-tet-vav-pheh):* pick in haste (not extended in time).

• *Quetata (qof-tet-tet-heh):* dispute, altercation, two individuals who cannot agree.

• *Qatal (qof-tet-lamed):* kill, murder, massacre, interrupt life.

• *Qata (qof-tet-ayin):* cut, amputate.

• *Queta (qof-tet-ayin):* piece, section, passage, text.

• *Qanah (qof-nun-heh):* to buy.

• *Qafats (qof-pheh-tsadeh):* to cut, to chop, to leap, to jump.

• *Qatsav (qof-tsadeh-bet):* cut, trim, slice.

• *Qatsa (qof-tsadeh-ayin):* cut.

• *Qatsir (qof-tsadeh-yod-resh):* harvest.

• *Qara (qof-resh-aleph):* to read, cry, shout, call, appoint, invite, produce, arrive (for an event). The idea of cutting off and separating a part from the whole. The anonymous individual emerges from the mass to take a name; the event is remarkable because it extricates everyday things from the mass.

• *Qerev (qof-resh-beth):* interior, extremity. Individual existence is separate, cut off from the outside world.

• *Qar (qof-resh):* cold. Cold as in freezing, stopping the process of life, interruption, arresting the continuity of time.

• *Qarush (qof-resh-vav-shin):* frozen, fixed, iced, petrified.

• *Querah (qof-resh-het):* ice, baldness, interruption of the growth of hair.

• *Qarats (qof-resh-tsadeh):* cut, pull out.

• *Qara (qof-resh-ayin):* tear, cut.

Conclusion

A large number of words beginning with the letter *qof* contain the idea of cutting, separation, interruption, which implies the meaning of "hatchet," "cleaver," "ax." We thus consider that this meaning should take priority, though without excluding the possibility of other meanings.

Summary

Cut, slice, chill, freeze, interrupt, separate, truncate, section, dig, dig a hole, imitate, excavate the depths, transmit life, kill, break, sharp, knife, sword, split, blade, pick, shave, reduce, diminish, the present time, a moment separated from the flow of time.

ACQUIRED MEANINGS PERPETUATED BY THE HEBREW LANGUAGE
Ape, monkey, eye of a needle.

NUMERIC VALUE
100

Q

Facing page: cursive Hebrew qof. Above: the Q of Western alphabets.

R

The R

The letter resh
The head

*"The only way in
which to welcome a
creation, is to create it
again and perhaps to
be re-created with it."*

R. Juarroz

Proto-Sinaitic inscription No. 349

The letter R, the eighteenth letter of the alphabet, is derived from *resh*, the twentieth letter of the proto-Sinaitic alphabet. Its original form in proto-Sinaitic script is that of the profile of a head. *Resh* means "head"; in Hebrew it is *rosh*. The shape of the letter is taken directly from the hieroglyphic: "head seen in profile" wearing a scarf, which is pronounced "tp": ⸱ .

Evolution of the Letter *Resh*

The evolution of this letter remained relatively simple. This is another "iconic reduction." The scarf disappears, as does the tip of the nose. All that remains is a profile in the form of a circle or triangle and a vertical line to indicate the neck.

REMARK

The resh *must be distinguished from the* beth, *since at first glance they look identical. With practice, they can be distinguished immediately: the* resh *has a straight vertical stroke and the* beth *has a vertical stroke ending in a loop:* ⸱ ⸱ ⸱ (resh); ⸱ ⸱ (beth).

R

Yehimilk inscription in Phoenician (twelfth century B.C.E.)

As regards the arrowheads of the first half of the eleventh century B.C.E., *the* resh *and the* beth *side by side clearly show the difference. This*

reads: hts grb'l, *meaning* "Guer Ba'al's arrow."

Another example:

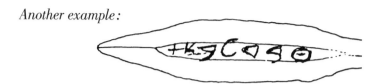

This reads: hts zkr b ('l), *meaning "Zakharbaal's arrow."*
Zakharbaal or Zakarbaal was the king of Amuru.

In these inscriptions one can recognize the heh ⊟, the zayin ⊥, the kaf ⋁, the ayin ⊙, and the resh ⁊, which is next to the beth ⊿. The Gezer calendar (tenth century B.C.E.) offers numerous examples of the letter resh because the central word in the text is yerah: "month." The form of the resh is ⁊ or ⁊ or ⍭. The Mesha stele contains the same distinction between the resh and the beth (see line 16, for example). On the Lakhish ostracon (sixth century B.C.E.), the resh is written ⌐ and the beth ⁊. Aramaic developed the resh by opening up the head: ⁊ ⁊ ⌐. The upper curve tends to turn into a horizontal stroke, resulting in ⌐ ⌐, from which the modern form of the Hebrew letter evolved: ⌐.

The Transition to Greek Script

Greek borrowed directly from the Phoenician and the Hebrew ◁, the direction changing with the general change in the direction of the writing: ℙ. In Greek, confusion is possible with the letter *pi*. In some cases, the distinction is made as follows: ⋂ *(phi)*, ℙ *(rho)*, ℙ *(phi)*, ℙ *(rho)*.

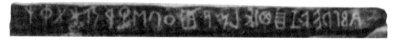

Inscription written from right to left

In a particular piece of Greek script the R is always written differently from the P.

ΒΡΑΚΛΕΣ
ΡΕΤΟΣ

The name "Heracles" is clearly readable in this inscription written from right to left, in which the *rho* looks like a looped *resh*: ꟼ . In the inscription below, the P has the standard *pi* shape of ⊓ and the *rho* looks like a looped *resh* but faces right (on the fifth line). The same inscription contains an important variation; the vertical line has moved to the right: Ρ Ꝛ (Western Greek alphabet, Boeotia), which can be encountered in the mixed form of: Ᵽ . The classical (Ionian) form of the Greek *rho* is Ρ (classical Greek *rho*).

The Etruscan alphabet offers variants of which the most typical are ◁ , ◁ , and ▷ . The remaining Etruscan Rs take the form Ρ Ρ ꟼ ꟼ . In the Mesapian alphabet (a pre-Latin Italic alphabet dating from the fifth century B.C.E. to the first century B.C.E. in which inscriptions have been found in Apulia and Calabria in southeastern Italy), the Rs take the following form: Ρ Ρ Ᵽ Ᵽ . It is on the basis of this form that Latin inherited the R that we know today: R . The *resh* produces a *rho* in Greek, then the R in Latin and in Western languages.

R

VAIΡEVAΡON
OVDIΣTVKAKOΣ
ΛECEIOVDE⊕▨
NONTAⴖOΛOΣ
AΝ⊕ΡOⴖONΛV
ΣAMENOΣ
KAMATO

Ancient Greek script

SUMMARY TABLE OF "R" DERIVED FROM *RESH*

R

NAME

R is the initial letter of the Hebrew word *resh*, which means "head," beginning.

**ORIGINAL FORM
IN PROTO-SINAITIC**

Head in profile with hat or scarf.

**CLASSIC FORMS OF THE *RESH*
IN CLASSICAL AND MODERN HEBREW**

ר Square script ר Cursive script

ORIGINAL MEANINGS

Head, beginning.

There is no problem with the original meaning of this letter. It means "head" and, by extension, that which comes at the head of a sequence, "beginning." Thus, for example, there is the first word of the Bible, *Bereshit*, "in the beginning," or as André Chouraqui translates it, "at the head." The letter *resh*, "head," conveys the meaning of origin. It poses the question "whence?" Where do we come from? One day, we started to exist: what is a beginning?

The *resh* inaugurates an archeological movement that brings us back to the emergence of the world. Not because such a return offers us the original beginning, in which lies the sense of existence that 303simply needs to be reappropriated as something that has been lost. The beginning is not content but strength. Returning to the origin implies the strength to make a fresh start each time, to realize the fundamental fact in which "living is being born at every moment." Arranging a meeting with the beginning involves a meeting with the inaugural force, that which makes it possible to begin.

"Man was created so that there could be a beginning" (St. Augustine, *The City of God*, xii:20).

Each person is a new beginning and each person has to accept the difficult and demanding task of creating time from a new beginning. The letter *resh* is primarily an encouragement to begin, to under-

take, to take an initative as well as to enter into the action.

"The life of man is a rush toward death, it inevitably brings ruin in its wake, the destruction of all that is human, were it not for his faculty of interrupting this course and starting afresh, a faculty inherent in action, a sort of constant reminder that although men have to die, they are not born to die but to innovate." Rabbi Nachman constantly repeats, *tasrikh kol pa'am lehathil mehadash*: "One must each time begin anew," which he himself paraphases in this extraordinary statement: "It is forbidden to be old."

DERIVATIVE MEANINGS

Brain, cranium, creation, create, begin, summit, head, to preside, to the end, new, first, branching, priority, genesis.

The dictionary contains some surprising meanings: *rosh* means "venom," "poison"; the Hebrew word is written exactly the same way as the word "head," *resh-aleph-shin*. If an *ayin* replaces the *aleph* the word *ra'ash* is obtained, meaning "noise," "tumult," "din," "agitation," "unrest," "to shake," "to tremble."

If the *aleph* is replaced by a *yod*, the word

resh (resh-yod-shin) continues to mean "head" but also "poverty" and "want." *Rash* is a poor man, a pauper. This ambivalent meaning is found in the verb *yarash*, which means "to inherit" and also "to become poor."

Rishush means "destruction" and "ruin." *Rashesh:* "weak" and *reshesh:* "a clod of earth."

Reshresh: make a small noise, to rustle. *Rashut*: authority as well as poverty.

These examples illustrate the fact that *rosh* or *resh* means "extremity" rather than "head." This produces extreme opposites such as:

• top and bottom
• rich and poor
• first and last
• authority and powerlessness
• master and slave

And so on, continuing the idea of "end," "extreme."

ACQUIRED MEANINGS PERPETUATED BY THE HEBREW LANGUAGE

Head, first, top, extremity, leader.

NUMERIC VALUE

200

R

R

R

Facing page: cursive Hebrew resh. *Above: the R of Western alphabets.*

S

The S

The letter shin
The tooth

"Dawn created the rooster."
E. Jabès

The letter S is the nineteenth letter of the alphabet. It is derived from the twenty-first letter of the proto-Sinaitic alphabet: the *shin*. *Shin* means "tooth" and is pronounced *shen*; the plural is *shinayim*. The original proto-Sinaitic form represents a stylized tooth: ⊔ . On proto-Sinaitic inscriptions, the shape is more rounded: ∽ . An attempt to relate this to the hieroglyphic signs on which the proto-Sinaitic form is based reveals fewer possibilities than in the case of the *qof*. The "dw" sound, found in the Egyptian word for "mountain" and "bad" takes the following form: � . However, there does not appear to be any relationship between the *shin* and "dw" despite the similarity in shape.

The Development of the *Shin*

The *shin* is a letter that has changed very little. The first change was a more angular and incisive look to the character. The ∽ shape became ⋁⋁ .

Yehimilk inscription (tenth or twelfth century B.C.E.)

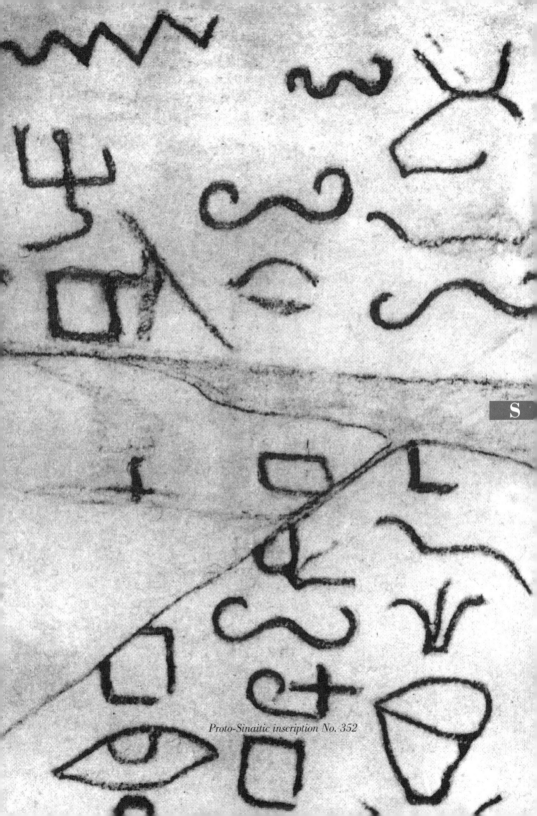

Proto-Sinaitic inscription No. 352

S

The earliest variations can be found in Hebrew of the sixth century B.C.E.: 〰 , 〰 , or 〰 . Samaritan has the characteristic shape. The *shin* looks like an E turned on its side (not to be confused with the proto-Sinaitic *heh*): ⊔⊔ . Aramaic introduced a real change, a transition from 〰 to ∨ or ∨ or ∨ (first century B.C.E.),

sixth century B.C.E.

fifth century B.C.E.

eighth century

twentieth century, modern scripts

twentieth century, modern scripts

resulting in contemporary Hebrew writing, which is similar to the scripts of the sixth and fifth centuries B.C.E.

REMARK

The shin *can be pronounced in two different ways: "sh" or "s." In classical and modern Hebrew, a period or point is placed at the top of the letter on the right or left side, which indicates which pronunciation is to be used.*

"S" pointed to the left, "sh" pointed to the right

In traditional texts, which have no points or periods, the word needs to be known in advance in order to know whether the letter should be pronounced "sh" or "s."[1]

The Transition to Greek Script

Greek, faithful to its origins, took its S-sound, to which it gave the name of *sigma* from the Phoenician form but stood it on end, taking it from the horizontal to the vertical: ∨∨ ⟩ . When the alphabet began to be written in the opposite direction, it became the classical *sigma*: ⟨.

Other versions are Σ (Eastern Greek alphabet, Miletus) and ∫ (Western Greek alphabet, Boeotia) resulting in the Greek sign Σ (*sigma* in classical Greek).

The Etruscan alphabet contains the following forms: ⟨ ⟩ ⟩ ⟨⟩ ⟩⟨ . The northern Etruscan alphabets contain variations such as those in the Lugano inscriptions: ⟨ ⟨ ∫⟨ , which are also found in pre-Latin Italic alphabets. In the Siculian alphabet, for instance (Sicula is in eastern Sicily), there are the forms ⟨∫⟨S , which entered Latin and western European languages as S .

To summarize, the development from the proto-Sinaitic was as follows: ∽ ∨∨ ⟩⟨ Σ , simplifying the strokes to ⟩⟨⟨ and, when the direction was reversed, ⟨∫S .

Ionian script (fifth century B.C.E.)

1. The *shin* produces a "sh" sound (as in "shape") and the "s" (as in "salad"). Note the resemblance to the Cyrillic ⊔⊔ (sh) and Russian ⊔⊔⁄ (shch).

311

SUMMARY TABLE OF "S" DERIVED FROM *SHIN*

NAME
Shin is a tooth *(shen,* in the plural *shinayim).*

**ORIGINAL FORMS
IN PROTO-SINAITIC**
Shin has the shape of a tooth or bow.

**CLASSIC FORMS OF THE *SHIN*
IN CLASSICAL AND MODERN HEBREW**
𐤔 Square script 𐤏 Cursive script

ORIGINAL MEANINGS
Chew, reduce, analyze, grind, crush, shoot with a bow and arrow.

DERIVATIVE MEANINGS
Attract, tear, detach, dispense, dispenser, emanate, emit, emission, send, jet, throw, launch, to project, push, spread, withdraw, extend, pull, bulge, transmit.
In its original form, the *shin* represents a tooth, but according to certain writers

it represents a bow in the sense of a bow and arrow.

Tooth Bow and arrow

The image of a tooth implies the idea of grinding, crushing, breaking, reduction, enabling the external world to be assimilated into the internal world. The reduction of a nutrient in order to enable it to be assimilated contains the concept of analysis in the intellectual sense, the splitting of the whole into several parts. There is also a focus on the element of a barrier to the mouth, one that protects the entrance, a gatekeeper that can bite.
The image of the bow also seems to retain this basic meaning.
As to its position in the Hebrew alphabet,

the *shin* is the third letter of the hundreds (300), the structural equivalent of the *lamed* (30) and the *gimmel*.

If, as we have shown, the *gimmel*, camel, makes it possible to cover vast distances and the *lamed* expresses the transcendental movement of beyond, the *shin*-bow is that which makes it possible to launch the arrow into the beyond: movement and distance.

Two complementary notions exist within the bow, the potential movement and the actual movement.

All the concepts connected with the bow are to be found in the *shin*, the concept of detaching, detachment, emitting, dispensing, sending, throwing, launching, projecting, expelling, etc.

ACQUIRED MEANINGS PERPETUATED BY THE HEBREW LANGUAGE
Tooth, the relative pronouns "which," "that."

NUMERIC VALUE
300

S

s

Facing page: cursive Hebrew shin. *Above: the S of Western alphabets.*

The T

The letter tav
A sign

"The perfection
of man is
his
perfectibility."

André Neher

The letter T is the twentieth letter of the alphabet. It is based on the twenty-second letter of the proto-Sinaitic alphabet, the *tav*. In Hebrew, the *tav* means "mark"or "sign." It is very commonly found in proto-Sinaitic inscriptions in the form of two crossed sticks: + or ×.

This sign is the simplified form of the hieroglyphic "heart and trachea," which is pronounced "nfr": ☦. It hardly changed at all when it passed into the Hebrew and Phoenician scripts, and can easily be identified on almost all the inscriptions.

Inscription of Yehimilk
(thirteenth century B.C.E.)

Inscription of Hasdrubal
(twelfth century B.C.E.)

Ostracon from Samaria (ninth century B.C.E.)

Fragment of proto-Sinaitic inscription No. 346

T

Mesha stele (ninth century B.C.E.)

The transition from the Hebrew and Greek to the Aramaic form extended one of the bars: ╳ ╳ , which produced an ╱ . This latter form was then rounded out ◠ to produce the *tav* that square Hebrew script inherited: ♫ ♫ ♫ .

The Transition to Greek Script

Greek copied the Hebrew and Phoenician ╳ and turned it around slightly until it was vertical: ┼ . The top line was deleted, resulting in the Greek *tau,* ⊤ , the final form of which can be seen in the classical Ionian alphabet as τ ⊤ (the Greek *tau*).

Etruscan offers variations that appear to go off on a tangent:
ㅜㅏㅜㅏㅏ✗✗✗.

The Latin form is derived from Greek and Etruscan: ⊤.

The original crossbar survives in modern European lowercase and cursive scripts: t t t.

The + or X becomes T in Greek and Latin, and produces the letter T that we know today.

T

SUMMARY TABLE OF "T" DERIVED FROM *TAV*

T

NAME
T is the initial of the Hebrew word *tav*; it means "mark," "sign," "symbol."

ORIGINAL FORM
IN PROTO-SINAITIC
Two crossed sticks.

CLASSIC FORMS OF THE *TAV*
IN CLASSICAL AND MODERN HEBREW
♪ Square script ♫ Cursive script

ORIGINAL MEANINGS
Sign, mark of alliance.
According to Benveniste, there is an Egyptian determinative X representing two crossed sticks, a frequently used sign to indicate the act of breaking or splitting. This represents a "mark" in general, as well as the mark of an alliance. The reference to the hieroglyphic "heart and

trachea" gives this sign the basic idea of life made possible through blood and breath. The *tav* thus incorporates the idea of a path to perfection, in other words, perfectibility.

The letter *tav* thus has a meaning that can be interpreted either positively or negatively. Perfection as well as completion: death. Sometimes, in order to attain perfection that which is lacking must be completed. The *tav* also represents completion, two parts of a whole that are put together. That is, in fact, the definition of a symbol (*sunballein*, "put together").

Tav means "sign." Hebrew has another word meaning "sign," the word *ot* (*aleph-vav-tav*), whose meaning is the same as that of *tav*. The word *ot* also conveys the idea of two crossed sticks. In the Bible the word *ot*

designates a rainbow, circumcision, and the Sabbath—signs of the partnership between God and man. The idea that is common to these signs is the need to withdraw from the totality. The man who is circumcised becomes perfect because he has removed a symbolic part of his body. His perfection lies in his imperfection, that is to say the possibility of continuing to perfect himself: "The perfection of man lies in his perfectibility" (A. Neher). Similarly, in the world of creation, God withdraws and invents rest, the seventh day, a void, a vacuum, a space, which is necessary for the heart of the human being. A void is needed in the body in which to breathe, eat, allow the circulation of energy, in order to make play and movement possible.

DERIVATIVE MEANINGS
Mark, symbol, meeting, alliance, completion, to complete, complete, whole, mutual, perfect, perfection, precision, trace, breath and blood, vital energy, end of a process, withdrawal, loss, creative vacuum.

ACQUIRED MEANINGS PERPETUATED BY THE HEBREW LANGUAGE
Sign, mark, musical note.

NUMERIC VALUE
400

T

FIRST APPENDIX TO THE LETTER "T": THE LETTER *TET*

There is a second letter in Hebrew that produces the "t." It is the letter *tet*, the ninth letter of the Hebrew alphabet, which produced the letter *theta* in Greek and in Etruscan, but which did not pass into Latin and the scripts of western Europe. The *tet* is thus, with the *tav*, the origin of the "t" sound. There is no trace of this letter in the proto-Sinaitic inscriptions. It can be seen on the inscription on the sarcophagus of Ahiram in the form of ⊕ ⊗ .

The two crossed sticks, X and +, inside the circle are no doubt reminiscent of the letter *tav*. There may have originally been a phonetic difference that was later lost. The *tet* may well have been pronounced like the soft "th" in English (as in *think*). Greek inherited this sign without alteration, and it is used in all the alphabets with a few variations: ⊕ (Greek *theta*, archaic alphabet from Thera), ⊗ (Greek *theta*, Eastern Greek alphabet from Miletus and Corinth), ⊕ ⊞ ⊖ (*theta*, in the Western Greek alphabet, Boeotia), ⊖ (*theta*, classical Greek alphabet, Ionian); the form ⊙ *(theta)* is also encountered.

REMARKS

The theta *should not be confused with* omicron, *which is sometimes written in the same way; however, in the Greek alphabet, when*

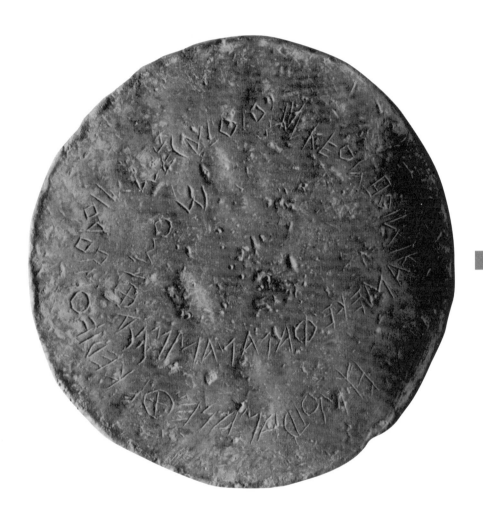

Bronze disk dedicated to Dioscures (550–525 B.C.E.)

the omicron *takes the form* ⊙ , *the* theta *takes the form* ⊗ *or* ⊠;
and when theta *takes the form* ⊙ , *the* omicron *takes the form* ○.

 Etruscan offers the following variations: ⊗ ⊕ ⌀ ◇ ◈ ⌂ ⊠ ⊙ .

 In Etruscan and in Greek the sign ⊠ *is used for writing the let-*
ter samekh.

 In Hebrew, the cross inside the circle disappeared and the
circle opened up: ⊗ ○ ◐ ◔. *This is similar to the shape used in*
cursive script and in the square form for writing the letter tet: ט טטט
(square script), ᚷ *(cursive script). The* tet *became* theta *in Greek and*
in Etruscan but never found its way into Latin, which only kept the
tau *to denote the "t" sound.*

T

SUMMARY TABLE OF "T" DERIVED FROM *TET*

NAME
The word *tet* does not mean anything in Hebrew.

ORIGINAL FORM IN PROTO-SINAITIC
Two crossed sticks in a circle

CLASSIC FORMS OF THE *TET* IN CLASSICAL AND MODERN HEBREW

Square script Cursive script

ORIGINAL MEANINGS
Shield, protection
The *tet* ⊗ is the symbol of the shield. In Egyptian hieroglyphics, the sign ⊗ is a determinative that indicates a conurbation, an inhabited place (village, city, town, country), i.e., a place protected, no doubt by fortifications. The same idea of protection is to be found in the shield; *tet* also represent a snake and a snakeskin with which a shield was covered. *Tet* also has the shape of a snake biting its own tail.

Léon Benveniste makes an important point. The sign is extremely rare in the proto-Sinaitic inscriptions. "Is it merely by chance," he adds, "that the letter *tet* does not appear in the sacred text of the Ten Commandments?" (Exodus xx:1–14). As the crow flies, Mount Sinai is not far from Serabit el Khadim (the place where the proto-Sinaitic inscriptions were found). There is every reason to believe that the Decalogue was originally engraved in the script in use at the time: proto-Sinaitic.

DERIVATIVE MEANINGS
Covering, cover, place, preserve, protection, resistance, rampart, safety, roof

ACQUIRED MEANINGS PERPETUATED BY THE HEBREW LANGUAGE
None

NUMERIC VALUE
9

SECOND APPENDIX TO THE LETTER "T": THE *TSADEH*

If *tet* is the ninth letter in the sequence of units, a letter called *tsadeh* is the ninth letter in the sequence of tens. The *tsadeh* is pronounced "ts." It is a variation of *tet* and *tav*. Like the *tet*, the *tsadeh* is rarely found in the proto-Sinaitic inscriptions.

The word *tsadeh* in Hebrew means "fishhook," from the root *tsud*, "to hook," "to snare." It is the harpoon but it is also the shape of the anchor that prevents the ship from moving. Some authors, such as David Driver, believe that it is a stylized representation of the grasshopper. The evolution was as follows: ꓓ (tenth century B.C.E.), ꓤ (Aramaic, fifth century B.C.E.), ꓩ (so-called Jewish script, first century B.C.E.), �章 (Jewish script), ꓭ (Jewish script, first century B.C.E.), which finally took the classical Hebrew form of ꓮꓰꓱꓲ.

Greek borrowed the Phoenician form used in the eighth century B.C.E.: ꓩ. As was the case with the *mem*, the letter sought a balance and so created another parallel stroke: ꓟ ꓟ. The letter closely resembles an M but is called *san* and is pronounced "s."

Ancient Greek script

The letter *san* exists only in the archaic Thera alphabet and in the eastern alphabet of Corinth. The ꓟ became ꓟ *(mu)* and the *san* ꓟ disappeared. The letter *san (tsadeh)* exists in Etruscan in the following variations: ꓟ ꓥ ꓟ ꓝ. The letter never made it into Latin and so does not belong to any western European alphabet. The *tsadeh* represents the "ts" sound and is close to our letter T.

Harpoon, fishhook

Grasshopper

*The Gezer calendar
(ninth century B.C.E.)*

SUMMARY TABLE OF "T" DERIVED FROM *TSADEH*

NAME
Tsadeh is linked to the concept of a fishhook, an anchor.

ORIGINAL FORMS IN PROTO-SINAITIC
Fishhook, harpoon.

**CLASSIC FORMS OF THE *TSADEH*
IN CLASSICAL AND MODERN HEBREW**
צ Square script ﾠ3 Cursive script

ORIGINAL MEANINGS
To hunt, to fish, to capture.
The *tsadeh* is the fishhook and the anchor.
The image of the anchor is quite visible in
the cursive Hebrew form.

Anchor *Tsadeh* in cursive
Thus the *tsadeh* conveys the idea of stopping movement.

DERIVATIVE MEANINGS
Capture, prepare an ambush, observe,
seduce, captivate, to fish, to hunt, prison,
stopping the future, hindrance, to detain.
But also target, goal, objective (at which
the harpoon is thrown).

**ACQUIRED MEANINGS PERPETUATED BY
THE HEBREW LANGUAGE**
Fishhook, hunt, capture, snare.

NUMERIC VALUE
90

T

Calligraphy by Lalou
El: *"the name of God"*

331

Facing page: cursive Hebrew tav. *Above: the* T *of Western alphabets.*

We showed in the *chapter on "F"* how the letters *U, V,* and *W* derived from the *vav.*

U,V,W Turn back to pages 167–75.

Have a safe trip!

The X

The letter samekh
The ladder
The support

"Of all the clear waters
poetry is the one which
lingers the least at the
reflections of its bridges."

René Char

The letter X is the twenty-fourth letter of the alphabet and is derived from the fifteenth letter of the proto-Sinaitic alphabet, *samekh*. In Hebrew, *samekh* means "support," "the act of supporting." According to numerous authors, the origin in proto-Sinaitic is a fish (Driver, Grimme).

This image does not quite match the meaning of the letter *samekh*, "support"; for this reason, some authors (including Benveniste) claim it derives from the Egyptian determinative that represents a column imitating a bunch of plant stalks 𓊽 and which is pronounced "dd." This stylized tree shape appears regularly from the thirteenth century B.C.E. onward in almost all inscriptions in the form 𓊽 𓊽 𓊽 𓊽.

Inscription from the sarcophagus of Ahiram (eleventh century B.C.E.)

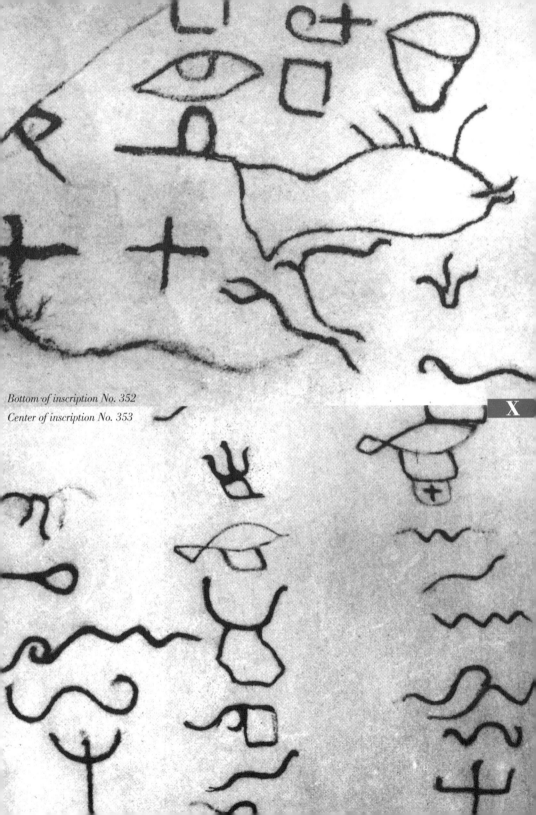

Bottom of inscription No. 352
Center of inscription No. 353

X

The Mecha stele (ninth century B.C.E.)

Gezer (tenth century B.C.E.)

X

If one is to reconcile the theory of the fish with that of the tree that looks like a ladder offering support ⧘⧘⧘ , it could be imagined that the letter represents a fishbone that has lost the head and tail ⧘⧘⧘ and which by reduction has become ⧘⧘⧘ , which after being upended produces the classic form of ⧘ . The shape developed like this: ⧘ ⧘ ⧘ , then ⧘ , and ⧘ ⧘ .

The Transition to Greek Script

Greek borrowed the Hebrew and Phoenician letter in its ∓ form and used it in the following variations: ∓ ∓ ⵀ (Argos alphabet), Ξ (classical alphabet).

In the Greek alphabet, the xi *stays in the fifteenth place it occupies in the Hebrew and Phoenician alphabet.*

In the Etruscan alphabet and Greek alphabets found in Italy (at Cumes) the xi *takes the following form:* ⊞ *(Etruscan and Italian Greek). Hence the shape of the X in our own alphabet! In the Athens alphabet, it was pronounced "ksi" like* xi *and it was written* Χ Ϟ *. When it passed into Latin, the S was lost and all that remained was the X, which is pronounced "k" in Greek. Since Latin already possessed a "k" sound, the X was used to represent the sound "ks" (despite the absence of an S).*

X

The samekh *is the fifteenth letter of the Hebrew and Phoenician alphabets, which became the* xi, *the fifteenth letter of the Greek alphabet. This transformed itself into the Latin X, which occupies the twenty-fourth place in our alphabet.*

The samekh *is an "s" sound, which is equivalent to the* sigma *(whose shape comes from the* shin*). The cursive* sigma *looks very much like the modern Hebrew form, though in reverse:* ס σ *.*

X

SUMMARY TABLE OF "X" DERIVED FROM *SAMEKH*

NAME
S*amekh* has the same root in Hebrew as "support."

ORIGINAL FORMS IN PROTO-SINAITIC
A fish, a tree with branches (pine tree or cedar of Lebanon).

CLASSIC FORMS OF THE *SAMEKH* IN CLASSICAL AND MODERN HEBREW
ס Square script O Cursive script

ORIGINAL MEANINGS
Support, sawhorse, infrastructure, skeleton of vertebrate fish, as opposed to an invertebrate fish like the *nun* (snake).
The *samekh* (S) was the origin of the fish, that is to say the skeletal sawhorse that makes it possible to firmly support an organism. It is the framework of a house,

which supports it, something to rely on. Perhaps the ≠ shape is a schematic representation of a spine and rib cage. The framework becomes a cane that gives support when one walks. The mark of a stick on the ground, its imprint, would provide the shape of the *samekh* in contemporary Hebrew (from the first century B.C.E.).

DERIVATIVE MEANINGS
Framework, infrastructure of an organism or system, skeleton, ladder, cane, wood, piling, support, to support.

ACQUIRED MEANINGS PERPETUATED BY THE HEBREW LANGUAGE
Support, to support, to trust.

NUMERIC VALUE
60

X

Facing page: cursive Hebrew samekh. *Above: the* X *of Western alphabets.*

see the *chapter on K* (pages 211–19) for *"Y"*

see the *chapter on G* (pages 177–87) for *"Z"*

Y.Z

Enjoy the search!

PART THREE

THE
ARCHEOGRAPHIC
REVOLUTION

The Memory of Letters

That is the central theme of this book. Behind each of the letters with which we are so familiar lies a history, changes, mutations based on one or more original forms, letters that once took the form of pictures, more or less elaborate representations of the images, drawings of different degrees of complexity representing the basic categories of existence. These images tell of life, home, travel, sexuality, conflict, the human body, the hand and the gift, the mouth and speech, the eye and the gaze, water and the unconscious life, the hunt and food, breathing, and praying.

These drawings do not belong only to the past, to an ancient civilization, one that is dead and marginalized; they are living and continue their unconscious existence beneath the way in which we think and talk and the meaning we give to the world. Each word we use in modern languages such as English, French, German, Greek, Spanish, or Italian contains at least three different cultural viewpoints, and the meaning of the word is the result of a game of dialectics between these viewpoints.

The first viewpoint is etymological, the external relationship with other, older languages such as Greek or Latin, or even older ones, such as Hindi. The second viewpoint is an internal one, covering how the language developed, its phonetic peculiarities, and its unique way of thinking and interpreting existence. The third viewpoint is that which is commemorated through the shape of the letters, their names, and the meanings they originally had when they were invented more than 3,500 years ago. It is this which has been handed down to our own time, an essential part of a civilization at the crossroads of Egypt and its hieroglyphics, the Hebraic world and its proto-Sinaitic graffiti. The word *woman*, for instance, is different from *femme*, *Frau*, or *mujer*.

First, the etymology of a word is specific to each language, although it sometimes overlaps.

Second, meaning within each language is contextual; saying *femme* is not the same thing as saying *mujer.*

Third, F is a letter that, as has been seen, expresses union, sexuality, an inversion of time, while M evokes the fluidity of water, the womb and motherhood, and other concepts that do not necessarily reside in the memory of F. It is the quest for these original forms and study of the implications of their meanings which we have called *archeography.*

We hesitated in the choice of a term. At the start of our investigations, we used the term *etymography,* as a parallel to etymology. But the deeper we delved, the greater our impression of seeking a hidden treasure, and the more we felt ourselves to be involved in a game of "Raiders of the Lost Alphabet," an exciting game that consists of unearthing the traces of the origin of letters and understanding how they evolved. We became "archeographers"! Archeography is not merely a branch of history. It covers a number of fields, from archaeology through psychology, via ethnology, maths, ancient and modern languages, architecture, esthetics, philosophy, the history of thought processes, epigraphy, linguistics, and visits to museums! However, it must be said that fortunately the most difficult and demanding part of the job had already been done for us by others.

This means that we did not have to visit the ancient sites of Byblos, Tell el-'Amarna, Mari, ancient Babylon, or the turquoise mines of the Sinai Peninsula. By reading numerous works on archaeology, paleography, history, and the history of writing, we acquired the basic information that was needed to complete the

task on which we had embarked. All the authors and all the titles of the books we consulted are quoted in the bibliography.

The Principle of Archeography

DEFINITION

Archeography is the invented word we suggest to designate the analysis and interpretation of words based not only on their etymological roots but also on the original graphic form of the letters of the alphabet, as it was first encountered in proto-Sinaitic script, whose discovery we described, and the origins and development of that first alphabet. The proto-Sinaitic alphabet pioneered the combination of image and letter, of pictogram and alphabetic sign. It can be read from the shape of the image or from the sound it has come to represent, which incorporates the spatial and pictorial dimension of the sign. Archeography takes the opposite path to the development of writing and tracks it back from the letter to the image in order to find new meanings in words, meanings that enrich the purely etymological meaning or the meaning acquired through normal language. Archeography does not reject etymology, it complements it through a dialogue and a dialectic that plays a game between "the eye and the ear," in which the eye listens and the ear can see clearly what it is all about. Archeography is a sort of commentary on the enigma of the biblical verse: "And all the people saw the voices ['thunderings' in the King James version]" (*vekol-ha'am roim et ha-qolot*, Exodus xx:18).

The vision of the voices, the understanding of a speech through vision, may lie behind this pictographic form embedded from time immemorial in each of the letters of the alphabet.

"SCRAMBLING WORDS
THROUGH WHICH TO HERALD
ONE STEP
BEYOND LANGUAGE."

MAURICE BLANCHOT

The Forbidden Image

The history of meaning is the history of forgetting the image, the history of a suppression of the visible. No doubt there are good reasons for this. In his book *Moses and Monotheism* Freud claimed that "the prohibition on making an image of God—the compulsion to worship a God whom one cannot see . . . meant that a sensory perception was given second place to what may be called an abstract idea—a triumph of intellectuality over sensuality."[1]

Through this extrapictorial image, "The new realm of intellectuality was opened up, in which ideas, memories and inferences became decisive in contrast to the lower psychical activity which had direct perceptions by the sense-organs as its content. This was unquestionably one of the most important stages on the path to hominization."[2]

For Freud, a departure from the visibility of the divine represented the dematerialization and deterritorialization of the sacred, the transition from the sacred-pagan to the holy.

This movement eventually resulted in a transition from the stone-built place of worship (the Temple) to worship through the book, a transition from the cult to the cultural.

The prohibition on graven images also applied to writing and the shape of the letters. The fact that images could not be depicted

may well have been the mechanism that caused the alphabet to change so radically from its pictographic form to the abstractions of the alphabetic form. It is not going too far to consider, as did L. Benveniste, that "writing was born on Sinai."[3] On the basis of these considerations, it would appear that the abstract form of the letters of the alphabet have a superior status to that of the pictorial form as we encountered it in proto-Sinaitic. However, we believe that it is important to take the trip back to the original image and that this step is required if we are to be able to link up with our most ancient and deeply buried memories. This is not a violation of the prohibition on representation, as long as we are in a dialectic mode and seeking the meaning and we do not fall into the trap of being stuck in the rut of "this means that and that alone"!

A THOUGHT WITHOUT AN IMAGE CAN ALSO BE IDOLATROUS IF IT CAPTURES AND IMPRISONS THE FREEDOM OF WORD AND MEANINGS.

The Dialectic of "to Say" and of "Said"

The ban on the image is a ban on the static form of being. Being, the primal force, or *aleph* in our terms, pursues a dangerous course. Once spoken, being risks falling into the trap that *said* exercises over *to say* and risks becoming an oracle in which the *said* element becomes fixed. The immobile *said* becomes a visible sense, idea and idol. The force of *to say* at the heart of *said* must always be maintained in order for the *said* to avoid becoming a theme.

Due to the risk of immobilization of the process of meaning within *said*, one must go back from the *said* to the *to say*, to rediscover the dynamic power of meaning at the very heart of the state

at which language has become static; the *said* must be *unsaid*. The *said* of words coagulates the fluency of time into a "something," turns it into a theme, lends it meaning, adopts a position in relation to something fixed in the present, represents it, and thus tears down the fallibility of time. "Words that have been said" become said already; the diachrony of time synchronizes into memorable time, and becomes the theme. The memory of the form that lives within the word is the difference between the word's present and its past, its origin; memory is distance and the dynamic time at the heart of the *said*. Memory is a mode of temporality that illuminates and resonates for "the listening eye."[4]

The Archeographic Difference

DEFINITION

What we call the archeographic difference is the differential work operating in the interaction between the original form and the current form of the letter. This is an archeological journey back that coincides with a perception of the future and the construction of the letter. "A letter always has several ages."[5]

The archeographic difference engraves the movement of meaning on the heart of the letter, which means that the meanings of the letter and the word are unstable and cannot manifest themselves in the clarity of a definitive presence.

Between the completely inaccessible original form, with the exception of a few archeological vestiges, and the present form, the letter has retained an element of the past and is already becoming imprinted with the mark of its relationship with the future element. The letter thus becomes a "trace"—neither present, nor past, nor future, but the dynamic movement between these three times,

without any logical progression between them. Archeography is a descent into the resonances it awakens in the reader of the original images.

More precisely, the image restores the *to say;* it calls upon us to come out of ourselves and to move into the stirring experience offered to us by its commemorative dimension.

THE IMAGE IS MORE OPEN THAN THE WORD, FOR EVEN IF IT REFERS TO AN OBJECT, THERE ARE A THOUSAND WAYS OF PERCEIVING AND UTTERING THAT OBJECT.

The Image Is Full of Enigmas . . .

The image is full of enigmas. It is plastic. It thus makes it possible to emerge from "our stiffness, that is to say the certainty of our world, the opinionated nature of our culture."[6] Our encounter with the image produces the possibility of not feeling ourselves enclosed in judgments that are too true, and which encourage us to other speech, knowing well that any encounter supposes a multiplicity of paths. Perhaps there is nothing more glorious in the word than the image, because it is its secret and its depth, its infinite reserve. As regards the image, speech is not yet alienated.

The image lends itself to writing, at the same time as it resists and remains foreign. "The image is an enigma, as soon as, through our indiscreet reading thereof, we make it emerge and become public by extracting from it the secret of its measurement. In that moment, the enigma itself poses enigmas. It does not lose its richness, its mystery, its truth. On the contrary, by its air of questioning it solicits all of our ability to reply by enhancing the assurances of our culture, the interests of our sensitivity. . . . The image is essentially dual. Not only sign and signified, but figuring and unfigurable, the form of the formless, ambiguous simplicity addressed to whatever is double within us and reanimating the duplication by which

we are divided, we reassemble indefinitely. . . . The image trembles, it is the trembling of the image, the frisson of that which oscillates and vacillates. It constantly comes out of itself; that is because there is nothing where it should be itself, always outside itself and always already outside of this outside, at the same time as a simplicity which renders it simpler than any other language and is in the language of the source from which it 'emerges,' but this source is itself the power of 'emerging,' the renewal of outside inside (and through) writing." [7]

This admirable passage from Blanchot about the image lays the foundations of our archeographic approach. The image that we discover, that we stress, does not introduce a meaning, but the possibility of multiple meanings. The archeographic approach is a path leading from the already stated meaning to the image of the meaning, to the clarity of perception to the vacillation and trembling of the outlines of things and of being, which captures the vibration of meaning, the freedom, the *libration*. . . .

Archeography deciphers the palimpsest
The script beneath the script
The words which are coiled within the entrails of the words
The words which are sprayed by the wash of words.

New words
Bridge against oblivion. . . .
It gives the ear the opportunity of the unheard
It gives the eye the flexibility of the forbidden.
It gives the mouth the breath of the new
It gives the hand the drunkenness of a poem. . . .

Archeography and Bibliotherapy

In a previous book entitled *Bibliothérapie: Lire c'est guérir* (Bibliotherapy: reading is healing),[8] we dealt with the role of reading and interpretation in the process of psychic training and maturity,

as well as the effects of reading on our state of mind and our health. We showed how reading and interpretation unravel the knots of language, then the knots of the soul, obstacles to the flourishing of life and the deployment of the creative force. We stressed the existence of the force of the book, whose effects are preventive and curative; the work of opening that consists in reopening the words in their multiple, expanded senses that make it possible for each individual to escape from confinement and lassitude to reinvent himself, to live and be reborn at each instant.

As part of this bibliotherapy or cure-through-the-book, we showed the fundamental relationship that exists between the book and the name. In fact, according to the Book of the Zohar, the "book" and the "name" have the same numeric value in Hebrew, that of 340.

WHAT IS A NAME?

In Hebrew, the word for "name" is *shem,* two Hebrew letters, *shin-mem,* which are rich in associations and meanings. The Hebrew root of the word *shem* is *sham,* which means "yonder." To have a name, to bear a name, is to be born "beyond" oneself, to become part of a movement of transcendence, of moving beyond oneself, of projection. In this sense, to have a name is literally "to exist" in the etymological sense of "maintaining oneself outside," outside any content one can give oneself.

At birth, each human has the potential of two dimensions, a "being here" and a "being there." The "being here" is the passive situation of birth in which I am here without ever having arrived here, expired in myself like a debt that I never incurred. This is the "here" of failure into which I find myself hurled, the heritage of my ancestors, of destiny. The opposite of "being here" is "being there," that is the *sham* and the *shem,* the "NAME." To be a man means

to be at . . . , to be there, *sham;* that is to say, to be within a project, in an opening to the future. The "over there" of the "name" makes it possible to escape the destiny of a life that has already been written, already imprinted. Through the name as a project, life becomes an adventure. . . . Rabbi Nahman of Bratslav was quite right in saying: "Never ask the way from someone who knows it because then you cannot get lost." [9]

The art of bearing a name means that one then has the capacity to bear oneself, to be transported, to become a "metaphor" for oneself in the etymological sense of the word, which means "to carry beyond." The name is not a sound capsule that covers an individual in order to enclose him in a definitive identity, but quite the opposite: the name in the human being is the set of forces that cause him to invent, in an infinite process of being and of "un-being," of identification and of "de-identification," of meaning and "un-meaning" of self. One can thus speak not of a personal identity, but of a dialectic of personal identity that oscillates between the sameness of self and the otherness of self. Bearing a name is bearing oneself toward one's name. If the name is given at birth, that is because it has the task of constantly reminding us that we must be born and reborn an infinite number of times. The name one receives at birth is a formidable gift, that of bearing within oneself the memory of the very moment of such birth. The art of bearing a name is to feel this event of birth, which is always with us. The name is a "memorial of childhood," part of the infant being born, which is born within oneself like a gift, the gift of existence itself.

This brings to mind the poem by Louis-René des Forêts:

Tell yourself that we never cease to be born
But that the dead are those who have finished dying . . .

And again:

That the voice of the child is never silent within him, that it falls like a gift from heaven offering to dessicated words the outburst of his laughter, the salt of his tears, his all-powerful savagery.[10]

Living is trying to inhabit one's name, to hear the vibrations of the letters of which it consists, to see the liberty of signs in deleted memory, to feel the *libration* of images that have known the power of their origins and the hesitation of the Beginning. We therefore understand the relationship that the therapist may have with archeography as being a particularly effective tool in investigating the potential of an individual.

The archeography of the name makes it possible to analyze the existential potential and horizons of a human being. Obviously, it is not a case of revealing the truth or the secrets of an individual, but only of updating his internal dynamic, which exists or may exist on the basis of the forces of meaning at work in the memory of each of the letters of which his name consists. It should be noted and stressed that an archeographic analysis has a structural or rather a restructural vocation, one of dynamization and redynamization, but never of destructuring or of blocking the existential dynamic. Each name, the very act of bearing a name, is already an extremely positive and enriching event. Only the fact of not being able to be called by a name contains an element of trauma. In other words, each letter possesses one or two meanings that can never be negative.

Each letter is a structuring and positive function. There is no good or bad in letters; the alphabet does not belong to the world of morals. It is the relationship between the human being and the letter, the human being in the sense of the letter that may or may not be assumed. The role of a therapist who uses archeography is to make the harmonics of a name resonate, as a practiced musician will be able to use all the techniques of his instrument in the best

way possible. The five strings of the violin do not constitute an instant sonata. The skill of the artist and his long years of practice and experience must be added in order to be able to hear the miracle of music. Thus the existence of the letters of the alphabet, and even a knowledge of the equivalences between letters and the original images they represented, is not sufficient to produce and offer an interpretation.

Archeography is not a key to dreams, a matrix of preestablished interpretations, a simple table that can be translated term for term or word for word. If we take the example of the name Emmanuelle, it can be transcribed archeographically as follows:

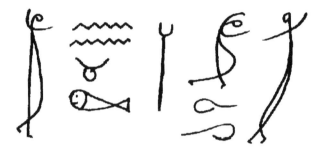

The archeographic translations produce the following semantic sequence: Man praying, water, ox head, water prey, neck rest, nail, man praying, spur of desire, spur of desire, man praying.

This sequence still requires a lot of work in analysis, articulation, dialogue with the person who bears this name, a major effort at construction, suggestions of meaning that are never settled and definitive. Archeography has numerous applications; every reader will discover them as he or she reads this book.

Here as an ending is a proposed proto-Sinaitic alphabet, which can be varied based on the mood of the writer-calligrapher.

A WORD ABOUT THE ALPHABET (© Mark-Alain Ouaknin)

1. The letters can be upright (roman) or slanting (italic), angular or rounded.

Example of the E:

Example of the B, a house with a pointed or rectangular roof, with or without a chimney, with or without smoke, with or without a path.

2. The letters can be put into play-activity contexts such as a fish in an aquarium who could add messages inside bubbles.

3. Letters can be made to face either right or left.

4. The R is denoted by a sign-image

5. The A by

6. The N by a fish and neither by a cobra nor by water prey.

7. The S could be ⋀ or

THE PROTO-SINAITIC ALPHABET
IN A MODERNIZED VERSION BY M.-A. O.©

A Head of an ox

B House

C Camel

D Door

E Man praying

F Nail, masthead, neck rest (pillow)

G Two crossed swords

H Barrier, enclosure

I Hand

J Hand

K Palm of the hand

L Ox goad, the spur of desire

M Water, water course, river, waves

N Fish

O Eye

P Mouth

Q Load, ax, hatchet

R Head

S Tooth (it is also the sound "sh," "shch")

T Cross, shield (*tav* and *tet*)

U Nail, masthead, neck rest (pillow)

V Nail, masthead, neck rest (pillow)

W Nail, masthead, neck rest (pillow)

X Tree, fishbone, skeleton

Y Hand with dot

Z Crossed swords (like G)

The letters or fonts we have designed for modern proto-Sinaitic M.-A. O.©
or Sinai M.-A. O. are protected by copyright covering the letters and any possible variations thereof.

1. Sigmund Freud, *Moses and Monotheism: The Advance in Intellectuality* (Hogarth Press, 1974), p. 113.

2. Ibid.

3. Léon Benveniste, *L'Alphabet est né au Sinai* (Paris, 1967), photocopied thesis.

4. See Exodus xx:16 ff.

5. Jacques Derrida, *De la grammatologie* (Editions de Minuit, 1967).

6. Maurice Blanchot, *L'Entretien infini* (Gallimard, 1969), p. 471.

7. Ibid.

8. Le Seuil, 1994.

9. See Likutei Moharan and Hayei Moharan, *Complete Works* (Jerusalem: Hassidei Bratslav Publications, 1990).

10. Quoted by Maurice Blanchot in *Une Voix venue d'ailleurs* (Ulysse-Fin de Siècle, 1992).

We believe that reading is a game; but it is the more so when it is a matter of reading shapes, deciphering an unknown alphabet, which is hidden beneath forms that habit and use have rendered commonplace. One could ask oneself how to write a word, a sentence, or one's name in proto-Sinaitic in order to discover new pathways and a new meaning to one's profound existence. One could also create puzzles to be solved. Do not worry if one day you receive the following message:

THIS MEANS: "LIFE IS BEAUTIFUL."

EXERCISES

Any word or name can be written in proto-Sinaitic, even those not directly derived from Hebrew. Here are a few examples that will enable the reader to work on the archeography of his or her own name.

CHRISTOPHER

DEBORAH

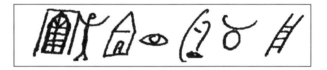

ELIZABETH

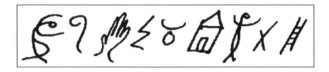

JAMES

JENNIFER

JESSICA

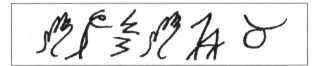

JOHN

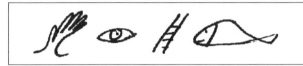

JOSHUA

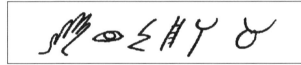

MICHAEL

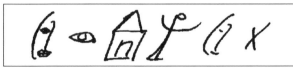

ROBERT

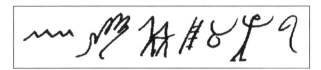

SARAH

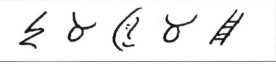

APPENDIX

This method has been tried on both children and adults. After only an hour or an hour and a half of this training, students with no prior notion of Hebrew can correctly copy texts written on the blackboard by the teacher.

The method is based on four basic letters:

1. The *ayin* family consists of four letters.

2. The *resh* family consists of fourteen letters.

3. The Latin C family consists of four letters.

4. The *yod* family consists of five letters.

REMARK

It is vital to learn the letters from right to left, to acquire the direction of the stroke of the basic letter in the first family before going on to the other letters in the family. Only then do you go on to the second basic letter and to the second family, and so on.

BIBLIOGRAPHY & ACKNOWLEDGMENTS

Aharoni, Y. *The Arad Inscription*. Jerusalem, 1981.

Albright, W. F. *The Proto-Sinaitic Inscriptions and Their Decipherment*. Cambridge, Mass.: Harvard University Press, 1966, 1969.

Allouche, J. *Lettre pour lettre*. Paris: Erès, 1984.

André, B., and Ch. Ziegler. *Naissance de l'écriture*. Exhibition catalog. Paris: Grand-Palais, 1982.

Aubier, D. *Le Principe du langage ou l'alphabet hébraïque*. Editions du Mont-Blanc, 1970.

Avigad, N. *Hebrew Bullae from the Time of Jeremiah*. Jerusalem, 1986. See also *Qedem 4*, 1976.

Babylonian Talmud (Talmud Bavli). Standard edition and Steinsaltz-Even edition, Israel.

Bachelard, G. *La Philosophie du non*. PUF, 1940.

———. *La Poétique de l'espace*. PUF, 1975.

Bauer, H. *Das Alphabet von Ras Shamra*. 1932.

Benveniste, L. "L'Alphabet est né au Sinai." Paris, 1967 (photocopied thesis).

Ben-Yehuda, E. *Thesaurus totius hebraitis*. Jerusalem-Tel-Aviv, vols. 1–4, 1909–39. *Le Rêve traversé, l'autobiographie du père de l'hébreu en Israël*, preceded by *La Psychose inversée* by Gérard Haddad and with an afterword by Michel Masson, *La Renaissance de l'hébreu*. Editions du Scribe, 1988.

Beuchat, H. *Manuel d'archéologie américaine*. 1912.

Blanchot, M. *L'Entretien infini*. Gallimard, 1969.

———. *L'Espace littéraire*. Gallimard, 1955.

———. *Le Livre à venir*. Gallimard, 1986.

Bordreuil, P. *Epigraphies phoeniciannes sur bronze, sur pierres et sur céramique*. Archéologie du Levant, Collection of R. Saidah. Lyons, 1982.

Bottéro, J. "De l'aide-mémoire à l'écriture," in *Ecritures: Systèmes idéographiques et pratiques expressives*, 1982.

Brun, J. *La Main et l'esprit*. Sator, 1986.

Butin. "The Serabit Inscriptions." *Harvard Theological Review* 21, 1928.

Calvet, L. J. *Histoire de l'écriture*. Plon, 1996.

Cantineau, J. *Le Nabatéen*. Paris, 1932.

Celan, P. *Œuvres complètes*. 5 vols. Frankfurt, 1983.

Champollion, J.-F. *L'Egypte*. Paris, 1839.

———. *Précis du système hiéroglyphique*. 1824.

———. *Principes généraux de l'écriture égyptienne*. Paris, 1836; republished by the Institut d'Orient, 1990.

Cohen, D. *Dictionnaire des racines sémitiques ou attestées dans les langues sémitiques*. Including a comparative file by J. Cantineau, booklet 1. Mouton, 1970.

Cohen, M. *La Grande Invention de l'écriture*. Paris: Imprimerie Nationale, 1958.

Corpus Inscriptionum Semiticarum, ab academia inscriptionum et litterarum humanorium conditur atque digistus. Ten volumes of text and ten volumes of plates, heliogravures by Dujardin. Paris: Imprimerie Eudes, 1889–1954, CNRS.

Cohn, M. M. *Nouveau Dictionnaire hébreu-français*. Larousse, 1976.

Cowley, A. *Aramaic Papyri of the 5th Century B.C.* Oxford, 1923.

Cowley, A. E. *Journal of Egyptian Archeology* 15, 1929.

Cross, F. M. "The Origin and Early Evolution of the Alphabet." *Eretz-Israel* no. 8, 1967.

———. *Canaanite Myth and Hebrew Epic*, Cambridge, Mass.: Harvard University Press, 1937.

———. BASOR 238, 1980.

Dagognet. *Ecriture et iconographie*. Vrin, 1973.

Dagognet and Nelson Goodman. *The Languages of Art: An Approach to a Theory of Symbols*. Indianapolis: Bobbs-Merrill, 1968.

Davies, W. V. "Les Hiéroglyphes égyptiens." In *La Naissance des écritures*, Seuil, 1994.

Derrida, J. *De la grammatologie*. Minuit, 1967.

Didier-Weill, A. *Les Trois Temps de la loi*. Seuil, 1995.

Diringer, D. *The Alphabet*. New York, 1948.

———. *The Origin of the Alphabet*. Chicago, 1954.

———. *The Alphabet: A Key to the History of Mankind*. Hutchinson, 1968.

———. *A History of the Alphabet*. Unwin Bros. Ltd., 1977.

Driver, G. R. *Semitic Writing, from Pictograph to Alphabet*. Oxford University Press, 1948, 1954; new edition, 1976.

Dugan, W. *How Our Alphabet Grew: The History of the Alphabet*. Golden Press, 1972.

Du Mesnil du Buisson, R. *Inventaire des inscriptions palmyréniennes de Doura Europos*. Paris, 1939.

Dunand, M. *Byblia gammata*. Beirut, 1945.

Dussaud. *Les Découvertes de Ras Shamra et l'Ancien Testament*. Paris, 1941.

Even-Shoshan, A. *Hebrew-Hebrew Dictionary*. Jerusalem: Kiriyat Sefer, 1987; expanded and updated edition (four volumes).

Fazzioli, E. *Caractères chinois, du dessin à l'idée, 214 clés pour comprendre la Chine*. Flammarion, 1987.

Février, J.-G. *Histoire de l'écriture*. Payot, 1984.

Freud, S. *Oeuvres complètes*. PUF, 1990.

Friedrich, J. *Zeitschrifft der deutschen morgenlandischer Gesellschaft*. 1937.

Gardiner, A. H. *Egyptian Grammar*. 1966.

———. "The Egyptian Origin of the Semitic Alphabet." *JEA* no. 3, 1961.

Garel. *D'une main forte, manuscrits hébraïques de la bibliothèque nationale*. Seuil, 1991.

Gelb, I. C. *Pour une théorie de l'écriture*. Flammarion, 1973.

Gelbert, G. *Lire, c'est vivre*. Odile Jacob, 1994.

Gibson, J. C. L. *Textbook of Syrian Semitic Inscriptions, III: Phoenician Inscriptions*. Oxford, 1982.

Grandet, P., and B. Mathieu. *Cours d'égyptien hiéroglyphique*. 2 vols. Khéops, 1993.

Grimme, H. *Die altsinaitischen Buchstaben-Inschriften, auf Grund einer Untersuchung der Originale*. Berlin: Reuther und Reichard Verlag, 1929.

———. *Althebraïsche Inschriften vom Sinai*. Hanover, 1923.

Hadas-Lebel, M. *L'Hébreu: Trois Mille ans d'histoire*. Albin Michel, 1992.

Haley, A. *Early History, Evolution and Design of the Letters We Use Today*. Watson-Guptill Publications, 1995.

Haralick, R. M. *The Inner Meaning of the Hebrew Letters*. Jason Aronson, 1995.

Hassine, J. *Marranisme et hébraïsme dans l'œuvre de Proust*. Minard, 1994.

———. *Esotérisme et écriture dans l'oeuvre de Proust*, Minard, 1990.

Healey, J. F. *Early Alphabet* (*Reading the Past*, vol. 9). University of California Press, 1991.

Higounet, C. *L'écriture, "Que sais-je?"* PUF, 1965.

Husserl, E. *L'Origine de la géométrie*. Introduction and translation by J. Derrida. PUF, 1974.

Jabès, E. *Le seuil le sable*. Gallimard, 1990.

———. *Oeuvres complètes*. Gallimard, 1957–1990.

Jardin, A. *L'Île des gauchers*. Gallimard, 1995.

Jean, G. *Writing: The Story of Alphabets and Scripts*. Harry N. Abrams, 1992.

Kantor, P. *L'Ecriture chinoise, les idéogrammes trait par trait*. Assimil, 1984.

Kasher, M. *Tora Shlemah*. Jerusalem, 1982.

Kramer, S. N. *L'histoire commence à Sumer*. Paris, 1957.

La Naissance des écritures: Du cunéiforme à l'alphabet. Seuil, 1994.

Lalou, F. *Apprendre à calligraphier l'hébreu*. Edifra, 1992.

———. *Thèmes et variations*. Syros, 1993.

———. *La Calligraphie de l'invisible*. Albin Michel, 1995.

———. *Les Voyelles du désir*. Calligraphy by Lalou as a dialogue with the poetry of Marc-Alain Ouaknin. Fata Morgana, 1994.

———. *Le Colloque des anges*. Calligraphy by Lalou as a dialogue with an epic poem by Marc-Alain Ouaknin. Fata Morgana, 1995.

Lamb, S. M., and D. E. Mitchell. *Sprung from Some Common Sources: Investigations into the Prehistory of Languages*. Stanford University Press, 1991.

Leaf, R. *Hebrew Alphabets: 400 B.C.E. to Our Days*. Bloch, 1976.

Leibovitch, J. *Mémoire présenté à l'institut d'Egypte*. 1934.

Lemaire, A. *La Naissance de the alphabet Phénicien et les dernières découvertes archéologiques*. Nice: Editions Alphabets, 1993.

Lidzbarski, M. *Ephemeris für semitische Epigraphik*. Vols. 1–3. Giessen, 1902–15.

Massoudy, H. *Calligraphie arabe vivante*. Flammarion, 1981.

Mathieu, B. *See* P. Grandet.

Millard, A. R. "The Cannaanite Linear Alphabet and Its Passage to the Greeks." *Kadmos* no. 15, 1976.

Moorhouse, A. C. *The Triumph of the Alphabet: A History of Writing*. H. Schuman, 1953.

Morais, J. *L'Art de lire*. Odile Jacob, 1994.

Naveh, J. *Early History of the Alphabet*. Magnes, 1987 (in English and Hebrew).

Neher, A., and R. Neher. *Histoire biblique du peuple d'Israël*. Maisonneuve, 1982.

Ogg, O. *The 26 Letters*. G. G. Harrap, 1949.

Onians, J. *Art and Thought in the Hellenistic Age: The Greek World View, 350–50 B.C.* Thames and Hudson, 1979.

Pardee, D. *Handbook of Ancient Hebrew Letters.* Chico, Calif., 1982.

Peacey, H. *The Meaning of the Alphabet.* Murray & Gee, 1949.

Perec, G. *La Disparition.* Denoël, 1969.

Petrie, F. W. M. *The Formation of the Alphabet.* London, 1912.

Pognon, H. *Inscription sémitiques de la Syrie, de la Mésopotamie et de la région de Mossoul.* Paris, 1907.

Pommier, G. *Naissance et renaissance de l'écriture.* PUF, 1993.

Powell, B. B. *Homer and the Origin of the Greek Alphabet.* Cambridge University Press, 1991.

Pritchard, J. B. *Hebrew Inscription and Stamps from Gibeon.* Philadelphia, 1959.

Puech, E. "Origine de l'alphabet." *Revue biblique* no. 93, 1986.

Rabbi Nahman of Braslav. *Complete Works.* Jerusalem, 1981.

Rabbi Tsadoq Hacohen Milublin. *Complete Works.* Jerusalem, 1972.

Reichelberg, R. *"Don Quichotte" ou le roman d'un juif masqué.* Philippe Nadal, 1989.

———. *"Jonas, menteur de vérité" ou l'Aventure prophétique.* Albin Michel, 1995.

Riceur P. *Du texte à l'action.* Seuil, 1986.

Robinson, A. *The Story of Writing.* Thames and Hudson, 1995.

Rosén, H. B. *L'Hébreu et ses rapports avec le monde classique, essai d'évaluation culturelle.* Etudes chamito-sémitiques, supplément no. 7. Geuthner, 1979.

Ryckmans, J. "L'Ordre des letters de the alphabet sud-sémitique," in *l'Antiquité classique* 50, 1981.

Saadya, Gaon. *Commentaire sur le Séfer Yetsira ou "le livre de la création."* Translated by Mayer Lambert. Paris: Bibliophane.

Sass, B. *The Genesis of the Alphabet and Its Development in the Second Millennium B.C.* Wiesbaden, 1988.

Senner, W. N. *The Origins of Writing.* University of Nebraska, 1991.

Sethe, K. *Nachrichten von der Gesellschaft und Jugendbildung.* 1916.

Sholem, G. *La Kabbale et sa symbolique.* Payot, 1975.

Sirat, C. *La Lettre hébraïque et sa signification.* Paris: CNRS.

Souzenelles (de), A. *La Lettre, chemin de vie.* Albin Michel, 1993.

Sprengling, M. *The Alphabet: Its Rise and Development from the Sinai Inscription.* Chicago, 1931.

Torczyner, H. (Tur-Sinai). *Lachish, I: The Lachish Letters.* London, 1938.

Van den Branden. *Les Inscriptions protosinaïtiques.* Oriens Antiquus 1, 1962.

Vernant, J.-P. *Mythe et pensée chez les Grecs.* Maspero, 1965.

Warburton, L. *The Beginning of Writing.* Lucent Books, 1990.

Weill, R. *Recueil des inscriptions égyptiennes du Sinai.* Paris, 1904.

Yardeni, A. *The Book of Hebrew Script.* Jerusalem: Ktav Haivri, 1991.

Yeivin, S. *The History of the Jewish Script.* Jerusalem, 1939.

Zohar. Jerusalem: Hasulam Publishing, 1990.

ACKNOWLEDGMENTS

This book, written between 1993 and 1996, is the result of many years of research conducted through the Aleph Center (Jewish Research and Study Center, Paris) and more recently through the Department of Comparative Literature at Bar-Ilan University. The results set down in this book were also used as teaching materials—courses and lectures—and some parts were published in the form of articles in various journals.

I should first like to acknowledge Dory, my faithful companion and loving mother of our children, patient and understanding, whose constant presence and help have enabled me to continue year after year to delve more deeply into the mysteries of the thought process, and through whose encouragement, critical analysis, and willingness to meet every challenge—a set of qualities that she uses for her own research and work as an author—has made it possible for this book to exist.

I should like to thank my father and mentor, the great Rabbi Jacques Ouaknin, who always instilled in me and handed down to me a passion for the Hebrew characters and script, a passion and talent for teaching that have found a small part of their expression in the quick teaching method for learning cursive Hebrew that is presented as an appendix to this book.

Thanks also to my mother, Eliane-Sophie Ouaknin, whose attentive and joyful encouragement runs like a thread through the pages of this book.

Special thanks to Mercedes and Paul Garboua and to their children, Sandrine and Mickaël Garboua, for their exceptionally warm and friendly hospitality, their encouragement, and their judicious advice in the field of archeography.

I would also like to express my thanks to Myriam and Sabine Pfeiffer, who have always received me with deep friendship and who offered me the opportunity to express myself more freely and joyously.

The publication of each new book affords me the renewed pleasure

of expressing my thanks to all those, near or far, who helped in the friendly and scholarly gatherings of the Aleph Center and other study groups.

Monique Sander, who has been so generous with her time and skills for so many years and whose kindness is only equaled by her efficiency, has made the Aleph Center such a pleasant, lively, and hospitable place to be; Michèle and Claude Kaminsky, directors of the Spinoza course, whose friendship and dynamism have succeeded for many years in giving the Aleph Center, which they allow to use their premises, such a friendly atmosphere; Judith Klein, who through her teaching talent has succeeded in transmitting to and instilling in so many people her passion for the Hebrew language.

I should also like to express my gratitude and friendship to all those who listened to my thoughts as they were taking shape, and who, through their sympathetic attention and input, opened up new paths to a living meaning and productive study.

I should like to thank my friend Frank Lalou, an extremely talented calligrapher, who shared his passion for the letter with me and was kind enough to be associated with our work and produce Hebrew calligraphy especially for this book.

I should like to thank my colleagues in the Department of Comparative Literature of Bar-Ilan University—and especially Professor Ruth Reichelberg, Dean of the Faculty of Humanities—each of whom encouraged me in his or her own way, to pursue these interdisciplinary researches as a dialogue with literature.

I should particularly like to thank my colleague and friend Jacques Adda, of the Department of Economics and Political Science of Bar-Ilan University, whose critical remarks were particularly judicious and who channeled my research into richer and more original directions.

The thoughts expressed in *The Mysteries of the Alphabet* have been the subject of many lectures and frequent seminars.

I should very much like to thank all those who welcomed me into their homes or the various institutions in which they worked over the last

few years so that we could discuss this research, thus giving them such a positive and deep dimension:

Noëlle and Georges Meyer (Association of Friends of Youth Aliyah); Myriam and Sabine Pfeiffer (Accord Mobile Association for Teaching the Feldenkreis Method, Paris); Odette Chertok (Association of Friends of Youth Aliyah); Michaël Williams (rabbi of the synagogue in the Rue Copernic, Paris); Hélène Attali (Association of Friends of Youth Aliyah); Mary and Lazare Kaplan (Tuesday Evening Study Circle); Simone and David Süsskind (CCLJ, Brussels); Robert Fery (Church of Saint Theresa, Metz); Jeanine Chamond and Dr. Gassiot (Association of Rodez Psychiatry Seminars); and Arié Bensémhoun (Le Forum des Cadres Juifs de France, Toulouse).

I should like to acknowledge the help of all those people who were kind enough to offer me hospitality each time I stayed in Paris, and who by their warmth and great friendship offered me an exceptional place for creativity, meetings, and exchanges of ideas, feelings, and experiences: Déborah Chock, Emmanuelle Adda, Philippe Périmon, Evelyne Périmond, Raphaëlle et Rivonne Krygier, Sophie and Shaoul Benchimol.

Behind every book there is a team of people who share the same enthusiasms and the same adventure; my thanks are due to the team at my publishers, Editions Assouline, whose attitude toward me was always patient and smiling.

Thanks to Grégoire Gardette and Jérôme Salado for their skill and patience.

Thanks to my publisher, Martine Assouline, for the time she spent with me, her friendship, and the benevolent yet firm authority she displayed in order to ensure that this book saw the light of day.

And, of course, thanks to Prosper Assouline; he will understand.